# Tony Bennett

## in the Studio

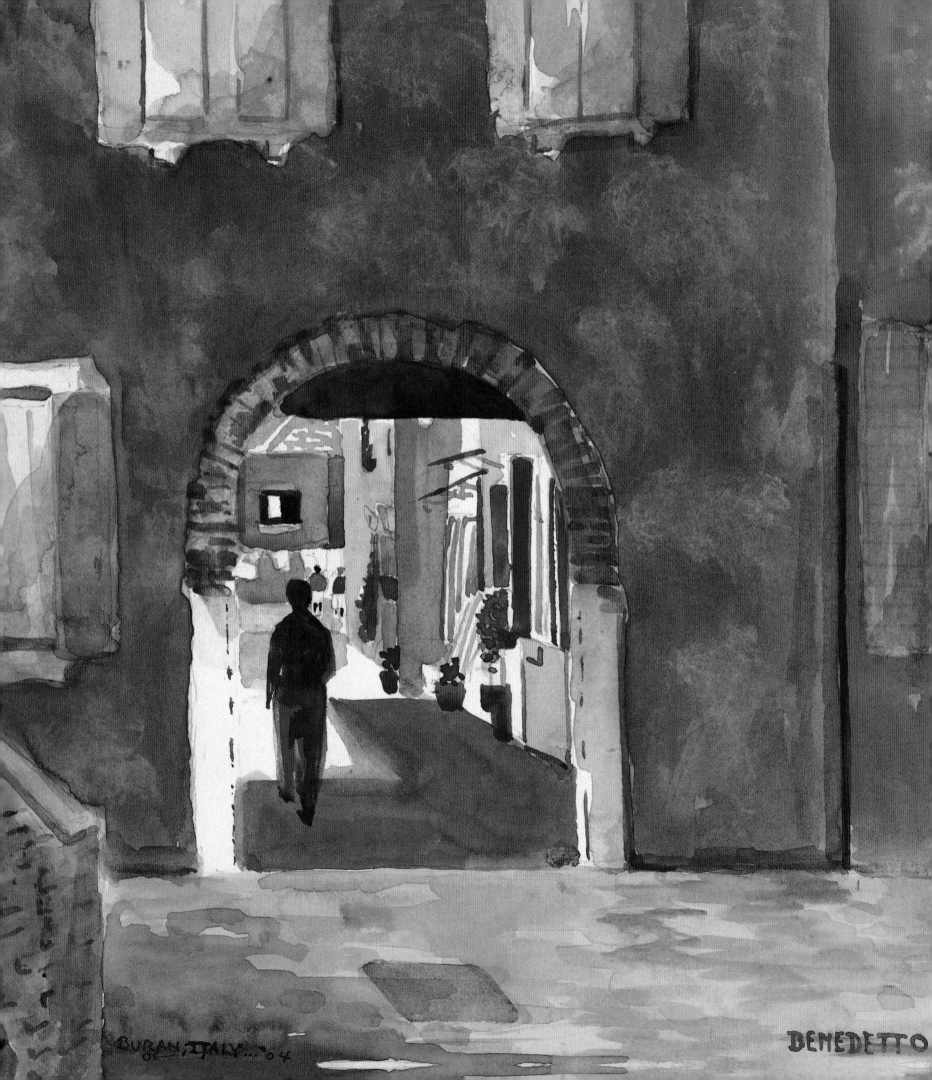

BURAN, ITALY...'04

BENEDETTO

*Tony Bennett*

# in the Studio

## A LIFE OF ART & MUSIC

**TONY BENNETT**

with **ROBERT SULLIVAN**

Foreword by **Mitch Albom**

Preface by **Mario Cuomo**

STERLING

New York / London
www.sterlingpublishing.com

STERLING and the distinctive Sterling logo are
registered trademarks of Sterling Publishing Co., Inc.

Library of Congress Cataloging-in-Publication Data Available

1 2 3 4 5 6 7 8 9 10

Published by Sterling Publishing Co., Inc.
387 Park Avenue South, New York, NY 10016

©2007 by Benedetto Arts, LLC
Foreword ©2007 by Mitch Albom, Inc.
Preface ©2007 by Mario Cuomo

Distributed in Canada by Sterling Publishing
c/o Canadian Manda Group, 165 Dufferin Street
Toronto, Ontario, Canada M6K 3H6
Distributed in the United Kingdom by GMC Distribution Services
Castle Place, 166 High Street, Lewes, East Sussex, England BN7 1XU
Distributed in Australia by Capricorn Link (Australia) Pty. Ltd.
P.O. Box 704, Windsor, NSW 2756, Australia

Book design and layout: *tabula rasa* graphic design

*Printed in China*

Sterling ISBN-13: 978-1-4027-4767-0
         ISBN-10: 1-4027-4767-5

Sterling ISBN-13: 978-1-4027-5233-9 (limited edition #1)
         ISBN-10: 1-4027-5233-4 (limited edition #1)

Sterling ISBN-13: 978-1-4027-5312-1 (limited edition #2)
         ISBN-10: 1-4027-5312-8 (limited edition #2)

For information about custom editions, special sales, premium and
corporate purchases, please contact Sterling Special Sales
Department at 800-805-5489 or specialsales@sterlingpub.com.

**Page ii:** *Burano, Italy,* watercolor, 11½ x 11 inches
**Page vi:** *Musicians,* ink on paper
**Page vii:** *Central Park Skyline,* watercolor on paper, 6½ x 15 inches

A wandering minstrel I—
A thing of shreds and patches,
Of ballads, songs and snatches,
And dreamy lullaby!

—from Gilbert and Sullivan's *The Mikado*

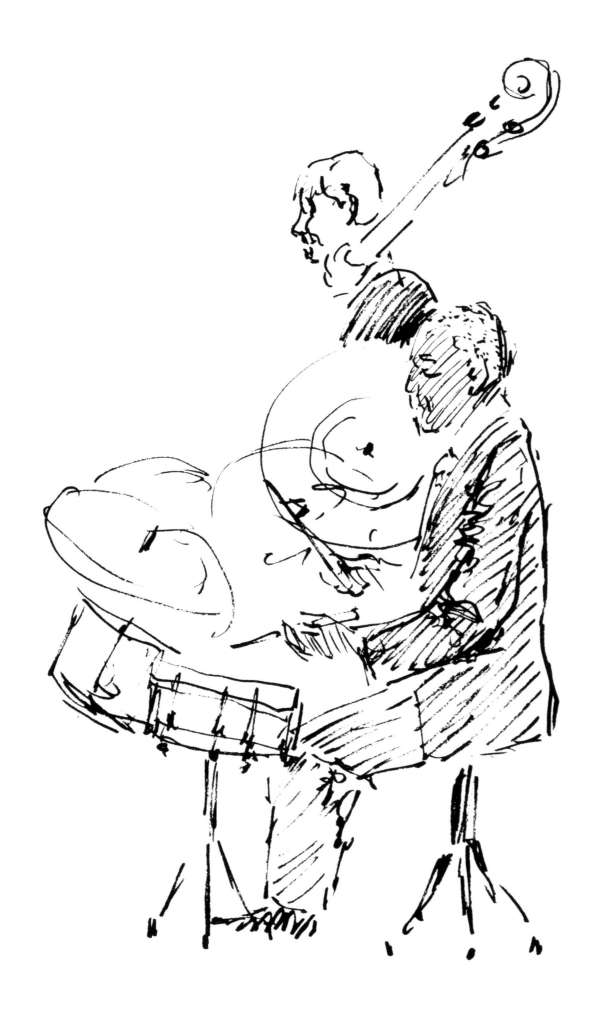

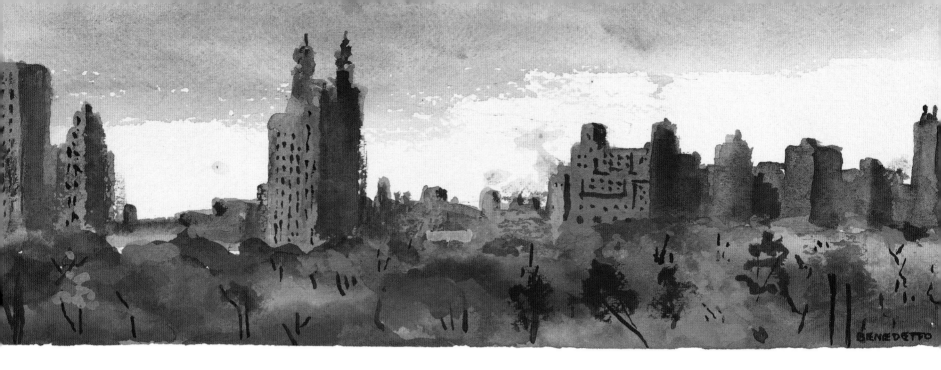

# CONTENTS

# FOREWORD

So I walk into Tony Bennett's apartment (he doesn't own a home and never has) and, having never met him, I'm expecting a giant. You have to understand, I had listened to everything by this guy—everything—the early recordings when his voice was as powerful as a velvet-sheathed wrecking ball, the big hits, including "Rags to Riches" and "I Left My Heart in San Francisco," the nuanced jazz records when he waltzed around to Count Basie's band or Bill Evans's magical piano playing, all the way up to his 1990s MTV stuff. You have that much music in your head, you expect a man you can spot from an airplane.

But here, down the hallway, came a smiling Tony Bennett, trim, compact, dressed, at ten A.M., in a smooth blue suit and neatly knotted tie, an ambassador of taste, a crinkly-eyed emissary of understatement. And we sat down to breakfast.

He was, in every way, less than I expected.

And I say that with the highest regard.

Less boastful. Less self-absorbed. Less possessed of any of the entitlements you would expect a man of his accomplishments to be. Instead, he was humble, at peace, hopeful only that the day would bring him a new muse, a lyric, a melody, a brushstroke. His apartment surroundings were a collage of inspiration: a beautiful piano all but cooing his name; paintings everywhere—on the walls, leaning against furniture; a view of Central Park that all but drew you to a canvas, if not a prayer book.

And the first thing we spoke about was roller skates.

It's true. He told me how, as a kid, he used to roller-skate over the Triboro Bridge and up sometimes into Harlem. He said he mostly remembered the feeling, on skates, of being "content." And now, in his eighties, he was enjoying that feeling again.

So there's an image you might not have had, right in these early pages: Tony Bennett on little wheels.

He also told me about his father, who, as a child, had such a wonderful voice that he used to sing from the hilltop to his Italian village below. I love that story, because in the sixty-plus

*Self-Portrait,* pencil on paper

years that Tony Bennett has been creating, he, too, has ascended like his father, and his talent has feathered down to the world.

But it hasn't been only his voice.

It has been his art. His taste. His unshakable dedication to finding the beautiful, not the commercial. Many think Bennett was a music-first guy, but one of his early turning points came when he made chalk drawings in the streets of Astoria, and an art teacher, James MacWhinney, spotted them and invited him to come paint in a nearby park. It was the beginning of Bennett finding the magical in anything—the streets of Queens, or roller skates in Harlem. And for the next seven decades, he has never stopped.

Few artists can claim roaring popularity in both the 1950s and the 2000s. For a man who once recorded 78s to have a

number one CD is remarkable. So you would allow Bennett, at this point, a healthy ego, right?

You'll never see it. He rarely sings a song without telling you who wrote it. He rarely paints a picture without telling you who—or what—inspired it. His willingness to give credit elsewhere is not some phony aw-shucks humility. It is the artist's understanding that his work is part of a timeline of human contribution.

Everything, for Bennett, is an influence. His family's early poverty influenced his appreciation of small things. His mother's love influenced his heart (he still wears one of her rings around his neck). His time in the army influenced his worldview—and the GI Bill provided his teachers when he came back from the war. Bob Hope influenced his name—suggesting "Bennett," trimmed down from Benedetto. Sinatra and Nat King Cole influenced his musical IQ. Duke Ellington influenced his view of art and commerce—particularly when Ellington was told by his record company that he was being dropped because he wasn't selling enough records.

"Excuse me," Bennett recalls the Duke answering, "but it's my job to make the records. It's your job to sell them."

Like Ellington, Bennett has always understood what it means to be an artist. He has ridden that leaping horse to its highs and its lows, clinging to its neck, never succumbing to the easy, the quick, the cheap, or the exploitative. As a result, he can now truly intone those famous Sinatra words, "I did it my way," and not just be singing a popular song.

It doesn't surprise me that the recent years have been among Tony's most fruitful. It seems that as he ages, he just keeps getting better, with generations of fans who want to know more. This book is a good start on that—in fact, there is now so much to share of his life, his music, his painting, his world, that one book could scarcely contain it all.

But this one—broken down into sections that parallel the phases of his life—is a worthy work. It reminds me of a quote from Ellington, who said when he was asked to compose some sacred music, "Now I can say loudly and openly what I have been saying to myself on my knees."

Now Tony Bennett can say, loudly and openly, what his heart has learned, what his music has taught him, what his canvas has inspired. Since that morning in his apartment, I have come to call Tony a friend. I do so proudly. He once did me a great favor, appearing in Detroit at a benefit for the homeless. He had a cold. It was late. But he was generous with his time and his conversation, and at the end of the night, in the confines of the storied Fox Theatre, he sang a lovely song with his piano player. Then he put down the microphone, walked to the edge of stage, and sang, without accompaniment or amplification, "Fly Me to the Moon."

I have never heard a crowd so silent. I have never seen mouths fall so open. I have never known a man in his eighties capable of filling the open space of a giant theater with a voice so strong and passionate you could feel it bouncing off the rafters.

All I know is when he finished, the crowd exploded, sprang to its feet, and the night was done. Nothing could possibly follow that. Nothing should.

Tony Bennett is a work of art. He will never tell you that. But I will. And so will anyone who knows him or experiences him. He graces us every day, and I hope you experience through these pages what I have been privileged to experience in person: a man who is less of everything he is entitled to be, and more than anyone could expect.

—Mitch Albom
Author of *Tuesdays with Morrie,*
*For One More Day,* and
*The Five People You Meet in Heaven*
January 2007

# PREFACE

Upon seeing Tony Bennett's still handsome, ageless face, people all over the English-speaking world—and some even beyond that—instantly remember him as what has been called "the Golden Voice." He continues to charm audiences after more than half a century. That's no surprise on this increasingly globalized planet tied together by television, radio, and iPods. His recognition as a great performer is so bright and powerful that it has partially eclipsed another of his great gifts—his painting. Ever since he began drawing chalk pictures on the sidewalks of Astoria, Queens, seventy-five years ago, he has painted—and sung—he says, "Because I have to. I've got to sing. I've got to paint. The only two things that have excited me since I was a child were being able to sing and being able to paint." As the pages that follow demonstrate, despite the dominant popularity of his singing, his excellence as a painter among the cognoscenti is also well recognized.

When I first met Tony and learned of his proficiency as a painter, I was intrigued, as are most people upon discovering his versatility. After a while I began to wonder about what the source of these extraordinary talents was. Now, after a quarter of a century, I think I know.

I've known Tony Bennett much longer than he has known me.

I enjoyed listening to him sing "The Boulevard of Broken Dreams" on a jukebox in 1949. In 1954, I danced with Matilda to the strains of "Stranger in Paradise" on our honeymoon at the Condado Beach Hotel in San Juan. And for the next three decades Tony remained my favorite popular singer. He had a great voice, but I was also impressed by the fact that he and I were both from Queens, both had two siblings, and both were sons of poor Italian immigrants who ran a grocery store and struggled to keep the family together.

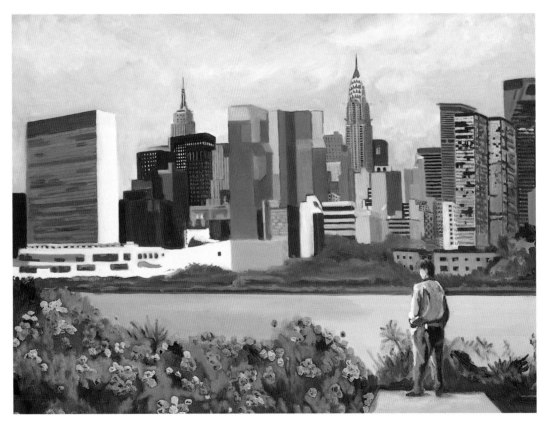

*View of NYC—Astoria Dreaming,* oil on canvas, 24 x 30 inches

We never met until my political career was looking up, at about the same time that Tony, with the help of his son Danny, who has an extraordinary mind for business, was starting his amazing resurgence as a celebrity of legendary proportions with the MTV generation. It wasn't a static celebrity. It was and continues to be, almost miraculously, a heightened and widened respect and affection that continues to reach more and more deeply into America's consciousness. I've enjoyed watching this unique phenomenon from up close ever since 1982, when I became governor of New York. It's not unusual for governors to meet celebrities, but I had the rare privilege not only of meeting Tony but of getting to know him well. During my twelve years as governor and for twelve years since then, we have been friends, and over that period my respect for Tony has grown far beyond my admiration for his talent as a performer and painter. I know Tony as an extraordinary human being, an intelligent man of refined sensibilities and deep compassion. I know him as a committed citizen of our nation—and in a real way, of the world. In dozens of conversations over the years, I've heard Tony express, often with great eloquence, his sadness and occasionally his anger at our nation's inability to meet the needs of our poorest citizens in places such as New Orleans, and around the world. He cannot tolerate discrimination, hypocrisy, or unfairness of any kind. Tony's story of his challenging a bigoted army officer, his superior, during the Second World War—because the officer had insulted his good buddy, a black soldier—is well known to his friends. So is the fact that he marched with Martin Luther King Jr., that he supports actively the political causes that are most important to him, whether they are popular or not, and that he has done hundreds of events for good causes of all kinds all over the world, despite his incredibly heavy schedule of performances and appearances.

For the last few years he has been raising millions of dollars for a public arts high school for talented children of New York City. That's a project he conceived and inspired, and today it's only a few years from moving into a brand-new, modern facility like none other in the history of New York City's public schools. He has done it all without publicity, compensation, or anything but the satisfaction of knowing he is helping to create careers for children whose talent might otherwise go unrealized. In dozens of ways, Tony feels the world's pain and does all he can to soothe it, with music, with painting, with advocacy, and always . . . with great love. Once Tony said to me that sometimes when the sound of a standing ovation is ringing in his ears, or he receives another honor for one of his paintings, or he's sitting with Susan quietly enjoying a blissful moment, "I think to myself, 'This is heaven.'" I asked him, "But then, what comes after heaven?" He said, "I can't even imagine; I'm just going to keeping going for as long as I can."

I can't imagine either what comes after heaven. But I know this: What gives Tony's music the sweetness, the emotion, and the power that makes it so moving—and what gives his painting the insight and sensibility that are so apparent—is not his throat, or his eye, or all his hard work. It's his heart. And his soul. Tony is a lover of all that is good and beautiful, and that makes him a great singer, painter, and philosopher. More than that, it makes him a truly beautiful human being. John Keats got it right. "A thing of beauty is a joy forever: / Its loveliness increases; it will never / Pass into nothingness." Never. "The Best Is Yet to Come." That's Tony. God bless him!

—Governor Mario M. Cuomo
January 29, 2007

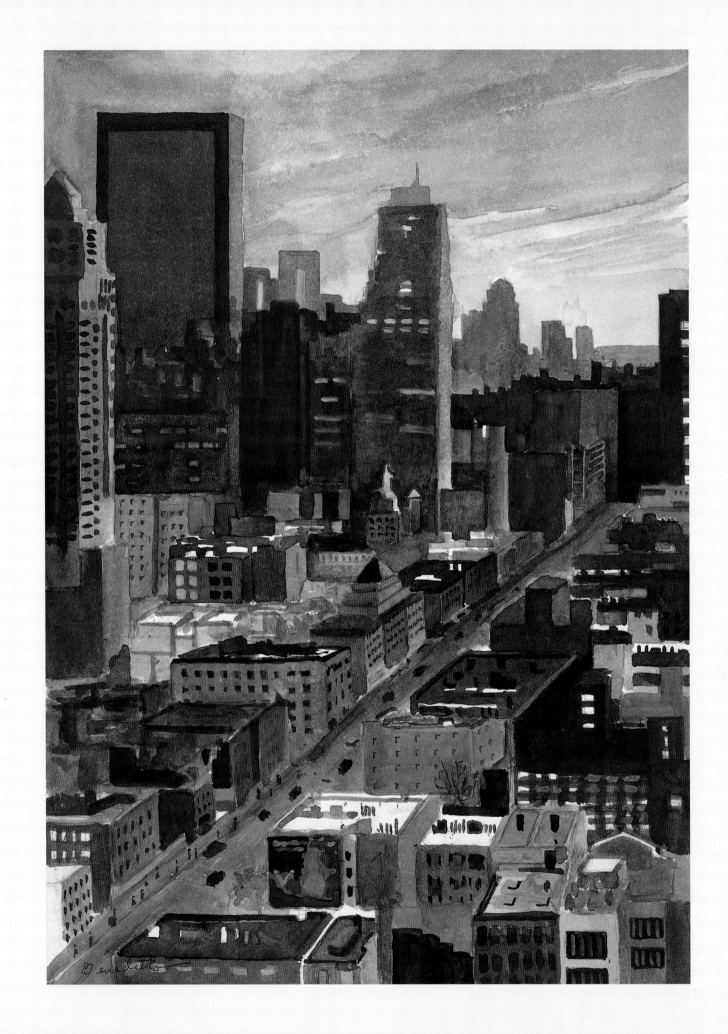

# INTRODUCTION
## MAKING THE CONNECTION

AS DO MANY AMERICANS—indeed, as do many citizens of the wide, wide world—I enjoy a personal relationship with Tony Bennett. This is as Tony wishes and wills it. In every song he sings, every hand he warmly shakes, every painting he renders, he tries to convey something of himself. He studies a lyric endlessly to find his way inside, so that "I can make it mine." Only if it is his—truly and honestly and earnestly his—will he be able to reach out to his listeners. Not only is he dedicated to giving them a song; he wants to give them a piece of Bennett. Tony moves us. We can hear the words. He doesn't only sing to us; he tells us. He tells us what it all means.

**Left:** *New York,* watercolor on paper, 20 x 14 inches

Similarly, whenever he ponders a landscape or stares at a canvas, he considers how he can best and most accurately convey to . . . well, to whomever is out there—to that unseen face in the great anonymous audience—precisely what he is feeling. He's dedicated to giving that person a piece of Benedetto. He wants his art to be highly personal. The relationship matters deeply to him, and he wants it to matter to those who appreciate him.

"I'm on a journey," he says. "It's a search for truth and beauty that I'm trying to share. What I try to do is sometimes very abstract and sometimes hits you right on the chin. Either way, I want to get through. I'm on a journey to try and communicate how beautiful life is."

In other words, as E. M. Forster had it: Connect. Only connect.

TONY WOULD GET A KICK OUT of the Forster bit; he's always quoting someone. I've heard him quote Irving Berlin and Benvenuto Cellini; Pablo Casals and Pablo Picasso; his old friend Frank and his elder brother, John; the Duke and the Count. . . .

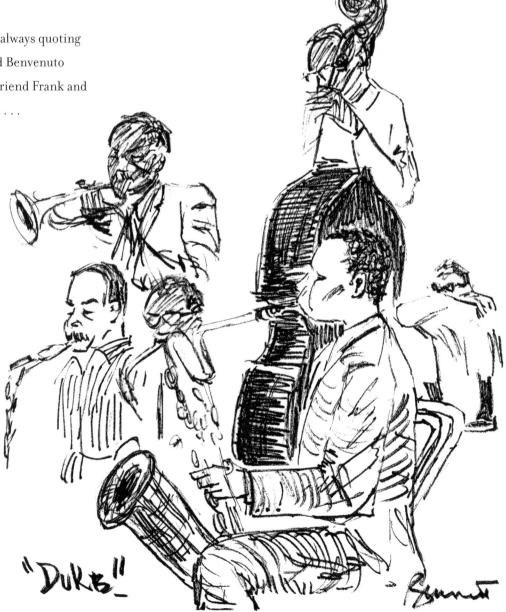

*Duke,* pen on paper, 13½ x 11 inches

# "It's a search for **truth and beauty** that I'm trying to share."

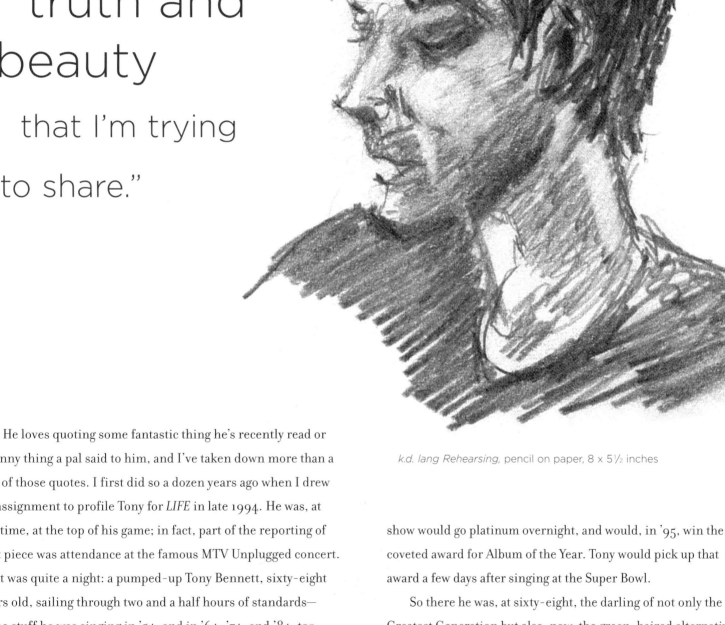

*k.d. lang Rehearsing,* pencil on paper, 8 x 5 ½ inches

He loves quoting some fantastic thing he's recently read or a funny thing a pal said to him, and I've taken down more than a few of those quotes. I first did so a dozen years ago when I drew an assignment to profile Tony for *LIFE* in late 1994. He was, at the time, at the top of his game; in fact, part of the reporting of that piece was attendance at the famous MTV Unplugged concert. That was quite a night: a pumped-up Tony Bennett, sixty-eight years old, sailing through two and a half hours of standards— same stuff he was singing in '54, and in '64, '74, and '84, too— before a packed house in Manhattan. Tony was, as he remains today, among the hottest acts in show business. His concerts were all sellouts, and his latest albums—the Sinatra and Astaire songbooks—had won Grammys as the Best Traditional Pop Albums of 1992 and '93. The soundtrack of that night's MTV

show would go platinum overnight, and would, in '95, win the coveted award for Album of the Year. Tony would pick up that award a few days after singing at the Super Bowl.

So there he was, at sixty-eight, the darling of not only the Greatest Generation but also, now, the green-haired alternative-music crowd. He was finger-snapping away, meanwhile playing gallant host to the heirs of the very rockers who'd shunted his music aside in the sixties. After a solo set, Bennett performed affecting duets with J. Mascis of Dinosaur Jr., k.d. lang, and Elvis Costello.

I remember Costello, after singing a Gershwin song with Tony, hanging out beneath the bleachers, watching intently, and offering commentary to no one in particular. "The man's amazing," he said, shaking his head. "A pro. Truly great! His rhythm, his style, the way he grabs a tune . . ."

My assignment back then was to get to know Tony—what was up with him, what made him tick. Was he really what he seemed?

The first answer was easy: He was king of the world. What was up with him was that he had never been more successful, had never sung better, had never painted better—had never been more artistic—than he was at that moment (and would continue to be in the years that have intervened). Whether he had ever been happier was irrelevant. The salient point was, he was plenty happy.

As to what made him tick and what was his essence—what constituted that particular and peculiar Zen that Tony Bennett exuded—these would take deeper inquiry.

I talked to friends and family, of course, and they were helpful. I talked to Tony at length. And I decided to concentrate on three things: the music that you know so well, the art that you see in this book, and then, the small moments. Tony is a man of many graceful gestures, and I think that in some of the fleeting ones, the ones that could easily whiz by and be discounted or missed altogether, there are clues.

I ATTENDED, AT ONE POINT, a gallery show on the Upper East Side of Manhattan; Tony's drawings were being exhibited. From his sketch pad, which he carries with him constantly, and also from a collection of drawings made on any available scrap— saloon napkins, hotel stationery—came these black-and-white portraits and still lifes that struck me as amazing in a couple of ways. First, obviously, they chronicled an extraordinary life. Tony had been here, there, everywhere. He had been in that jazz club, this far from Ella, on that particular night. But of course he had. Why wouldn't he have been? That was his scene, for all these many decades.

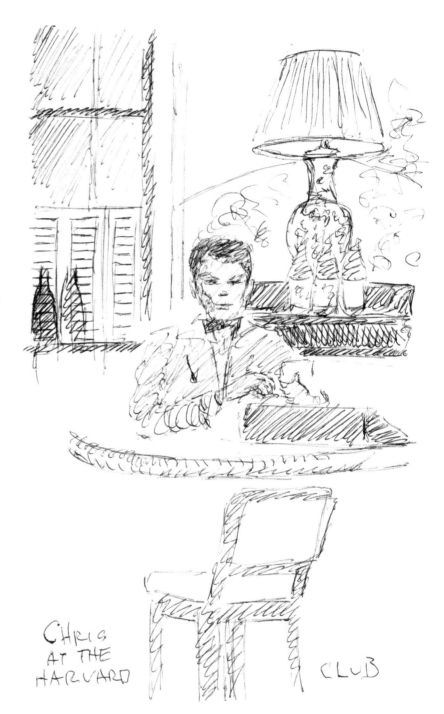

*Chris at the Harvard Club,* ink on paper, 8 x 4 inches

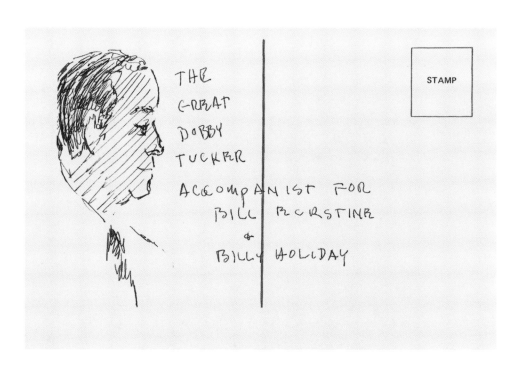

Left: *The Great Bobby Tucker,*
ink on paper, 3½ x 5½ inches

Below Left: *Ronnie White,*
ink on paper, 6¼ x 3½ inches

Below Right: *Woody,*
ink on paper, 6½ x 4¼ inches

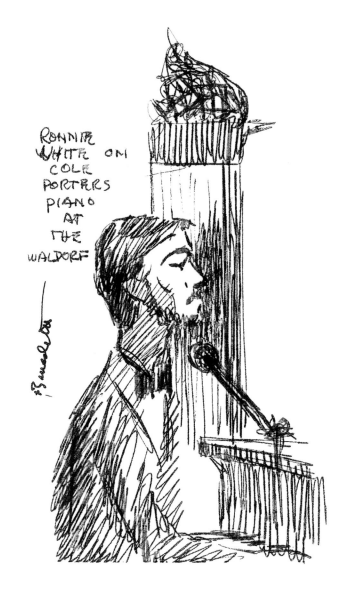

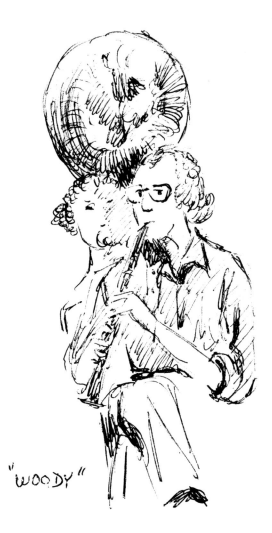

The second thought, and this took a moment to sink in, was that the work was complicated and expert in an artistic sense, and was the product of a man compelled, constantly, to express himself. He could have been enjoying his wine or chatting between songs, but instead he was drawing: transforming the feeling of the moment into art. There was not only Ella in that sketch, but the song she was singing, as the artist was hearing it and interpreting it for us. I imagined it to be "Mood Indigo," but I'll never know.

Years later, off the clock this time, I attended another exhibit of Tony's artwork, this one the 1997 opening of a show of his paintings at the National Arts Club off Union Square. Tony was the honoree and also the de facto host that evening, and he and his longtime companion, Susan Crow, greeted us all with characteristic grace and enthusiasm.

I wandered the galleries, traveling to Japan, Venice, Cape Cod, San Francisco, and Monet's gardens with Tony—at least, through his art. Here was another side: his use of color; his quest for beauty; sometimes, as with the Central Park paintings, his desire to sing a love song. As is Tony's constant wont, there was homage paid. It was blatant in the Monet garden paintings and in the David Hockney tribute, and only somewhat more subtle in paintings that hearkened back to Manet or Renoir or his teacher, Everett Raymond Kinstler, the eminent portraitist from New York City whom Tony regards as "the Sargent of today. He's really a tremendous portrait painter. I've learned from the old Masters and been inspired by the Impressionists, but I think I'm really a New York painter, and no one's done more for me in painting than Kinstler."

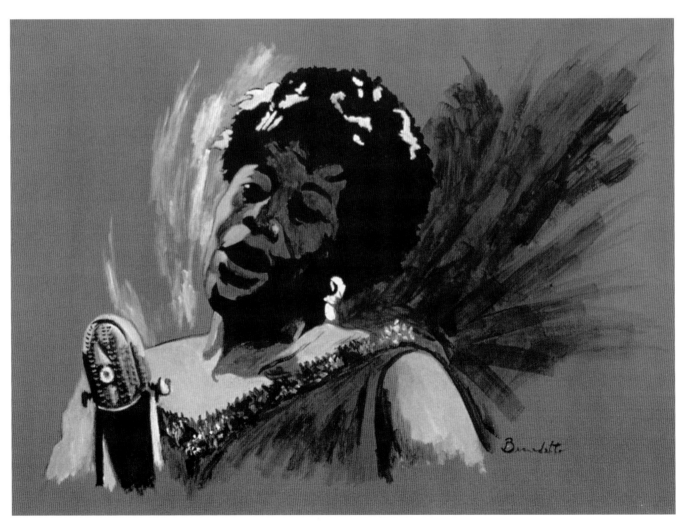

*Ella Fitzgerald,* watercolor on paper

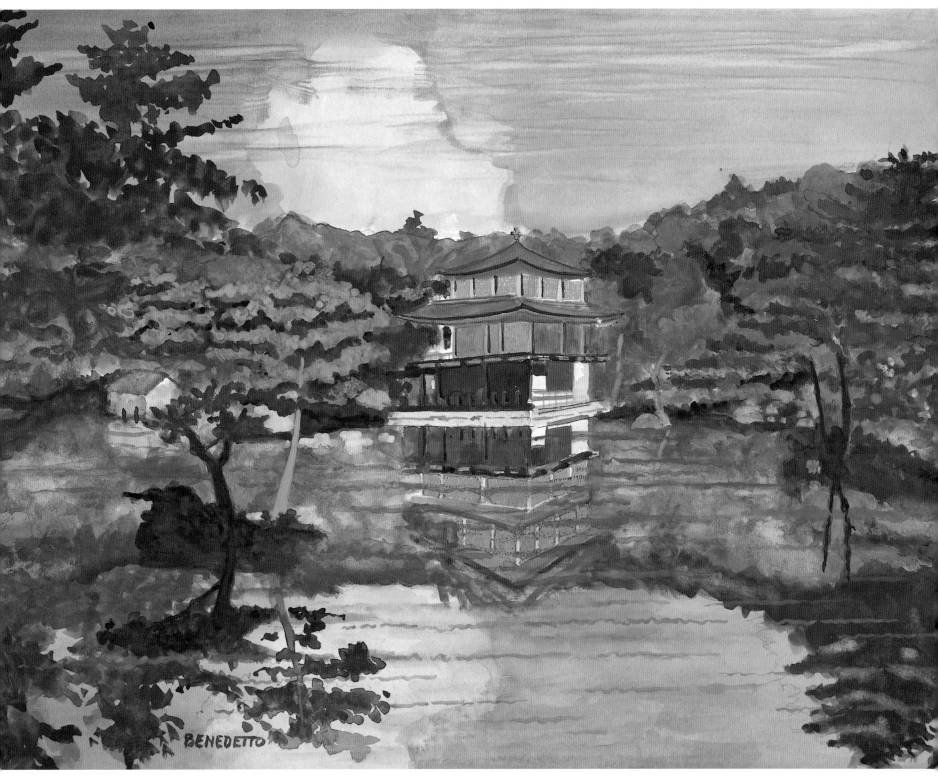

*Golden Pavilion, Kyoto,* watercolor and gouache on paper, 15 x 19 ½ inches

"I paint what I see and feel. Even when I did the paintings in Monet's gardens, I wasn't thinking about what Monet saw but what I was seeing. I should make some copies of the Masters—that would be interesting; I could learn from that—but I haven't tried that yet. There's a beautiful new book on Sargent that shows his painting from early on till the time he was twenty-six. It's amazing. He'd studied all the Masters, kind of copied Frans Hals, and all the great masterpieces. And that is how you learn; I realize that. And I realize that with everything in life, it's all a matter of learning."

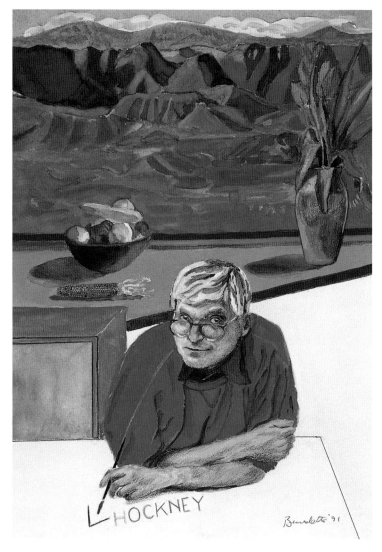

*Hockney*, watercolor on paper, 16 x 11 inches

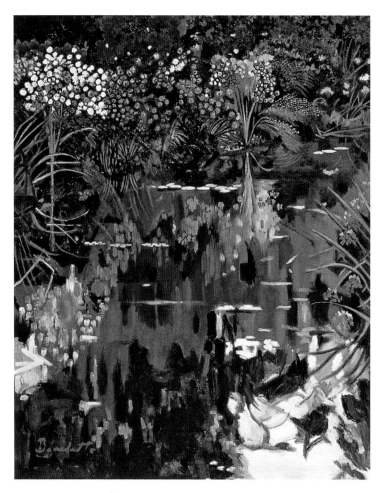

*Monet's Gardens No. 1*, oil on canvas, 40 x 30 inches

THE PAINTINGS, THE MUSIC, and the small moments helped me to get a little closer to answers back in 1994, and of course there has been much more art and many more moments since. Recently, Tony wanted to talk again, for this book. He had turned eighty, was still riding high, perhaps even higher, and he still had the Zen very much intact.

So here we go, looking at the life so far, and looking at the art not only for beauty but for those clues. Tony Bennett is in these pages just as surely as he is in that version of "Dancing in the Dark" that you're spinning on the stereo just now.

He has wished and willed it so.

—Robert Sullivan

*Mickey Rooney,* watercolor on paper, 13 x 9½ inches

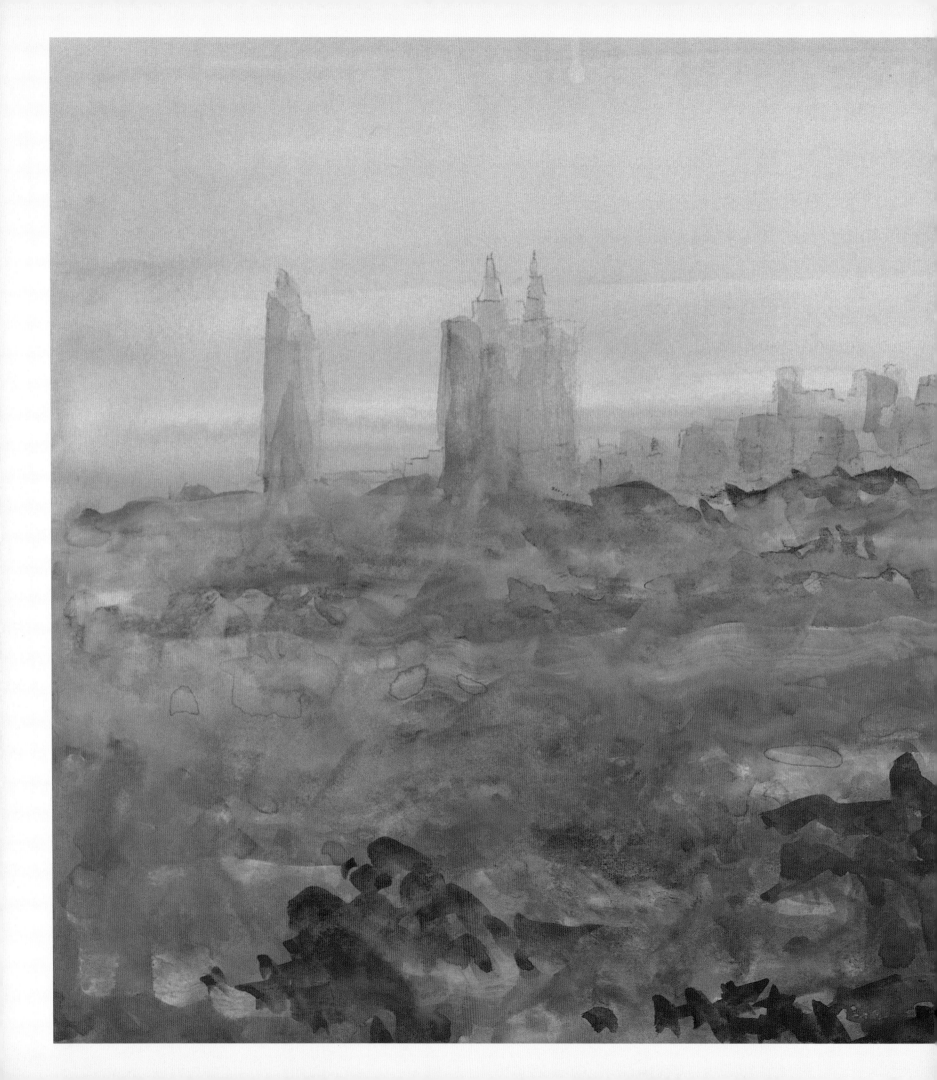

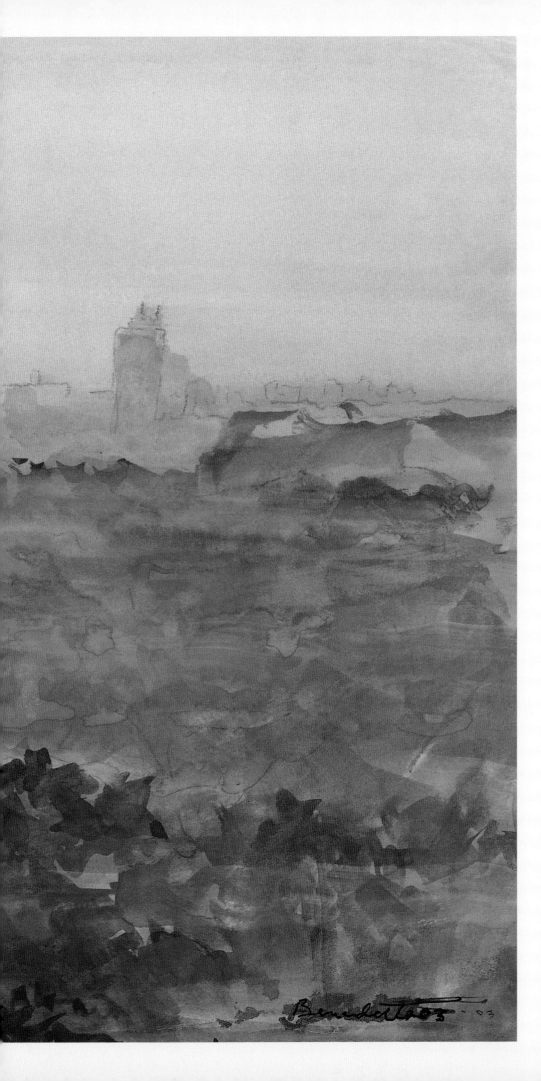

# IMPRESSIONISM

Impressionism

# "I always dreamed of having a place that would catch the afternoon light."

*T*ony Bennett listens hard and watches closely. He takes advice seriously and feels strongly that influence and inspiration can shape a life.

This was the chief message I took away from our principal interview in 1994, which was conducted over a meal at the Metropolitan Museum of Art on Manhattan's Upper East Side—one of Tony's favorite buildings. A very proud New Yorker, he considers the Metropolitan to be the greatest art museum in the world (and he's seen all of the contenders). On the Met's endless series of steps, he was greeted by several fans. He handled each with an instinctive grace that created a lasting memory. At the museum's entrance he was met by an escort who ushered our small party through the grand foyer and up to the Trustees Dining Room. Tony was given the star's table by the window, a huge window that afforded what might have been the most sublime image in that vast stone warehouse of sublime images. Central Park cyclists and strollers could just be seen through bare trees; on this early-winter afternoon, the sky was already gray. A sudden, four o'clock slant of light flared, then faded, and streetlights in the park came up like footlights. "I love that park," Tony said in a soft voice. "I always dreamed of having a

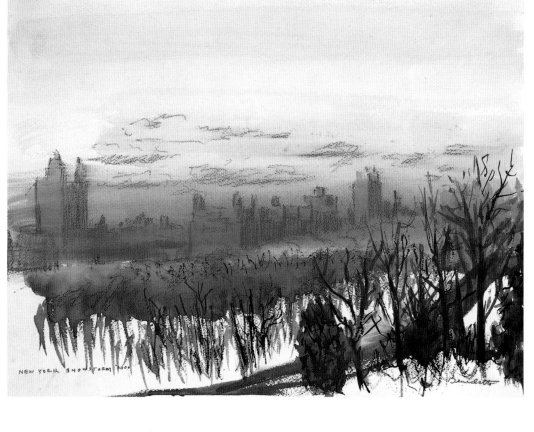

New York Snowstorm 2000

Previous Pages: *Foggy Day in Central Park,* watercolor on paper, 11 x 15 inches

Opposite Page: *Central Park,* watercolor on paper, 14 ½ x 11 ½ inches

Left: *New York Snowstorm 2000,* watercolor on paper, 12 ¼ x 16 ¼ inches

Below: *The Metropolitan Museum,* watercolor on paper, 4 x 5 ¾ inches

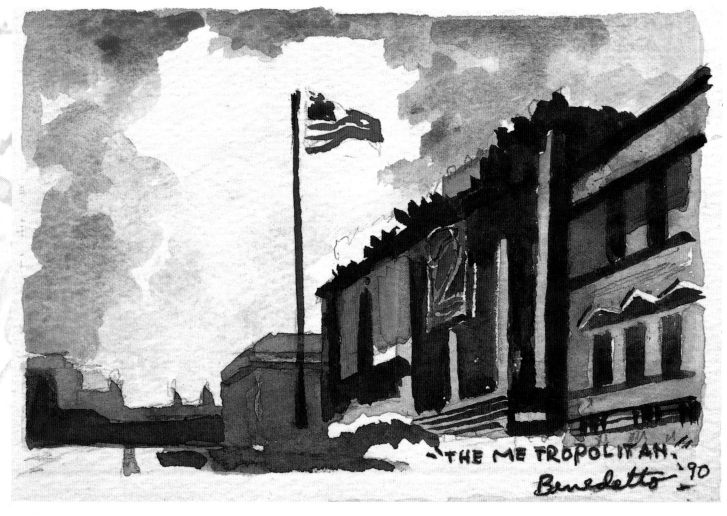

"THE METROPOLITAN" Benedetto '90

place that would catch the afternoon light, so I could paint the park over and over." Tony was well aware that the dream had come true: He was to move into the new place on Central Park South in January, a splendid apartment where he has lived ever since. "My life has been like a cheap novel," Tony said, starting off. "Interesting people, adventures, strange twists."

The "people" thing kept coming up all evening, far more often than the considerable adventures and many twists. *Bob Hope told me to do this; Sinatra said that; I learned this from Bing; I learned everything from my mother; writer, director, and childhood friend Abby Mann was so important to me; Cary Grant gave me the best advice; Ralph Sharon, my longtime musical director, insisted that I should do this; my first art teacher, James MacWhinney, meant everything to me . . .*

"I've gone back to an old piece of advice," Tony said characteristically, late in the conversation, when we were talking about the art of singing. "Fred Astaire told me, 'Look at the song through the composer's eyes. Then look at it again with a new idea, but one that's true to what was intended.' See, it's like this." He leaned in and sang lightly as he snapped his fingers. "The way you wear your hat!" It was amazing: His speaking and singing voices were so similar, yet this one floated and flew.

The very moment he started to sing he became the guy on the stage, even as he sat there beside me in a now all-but-empty dining room. "Or you can think it through again, and do this." He paused, downshifted. "The way you wear your *hat* . . ." This was a slower rendering with a backbeat and the last word emphasized—it was the version from his recording. "See?" he said. He was happy, almost excited—maybe he was, in fact, excited. He had displayed something nifty, a master's trick of the trade. "It breathes differently," he said. "That was Astaire."

No, it wasn't.

This leitmotif running through Tony's personal narrative—"Somebody told me"; "Somebody did this for me"; never "I say this"; "I say that"—might be something that Tony believes, but it's flawed, if not positively false. He seems to be saying that Tony Bennett is a synthesis, or even a product of others. Not a cipher, certainly, but something he's less than entirely responsible for.

That's wrong. What Tony is, is a generous guy with sand in his voice and an ability to communicate his passion—the word that comes up all the time: *passion*—and who has, by paying attention, learning, improving himself, and going the extra airplane mile, become an American original. A classic. A treasure.

How'd that happen?

"Fred Astaire told me, 'Look at the song through the composer's eyes. Then look at it again with a new idea.'"

*Self-Portrait,*
watercolor on paper,
14½ x 10¼ inches

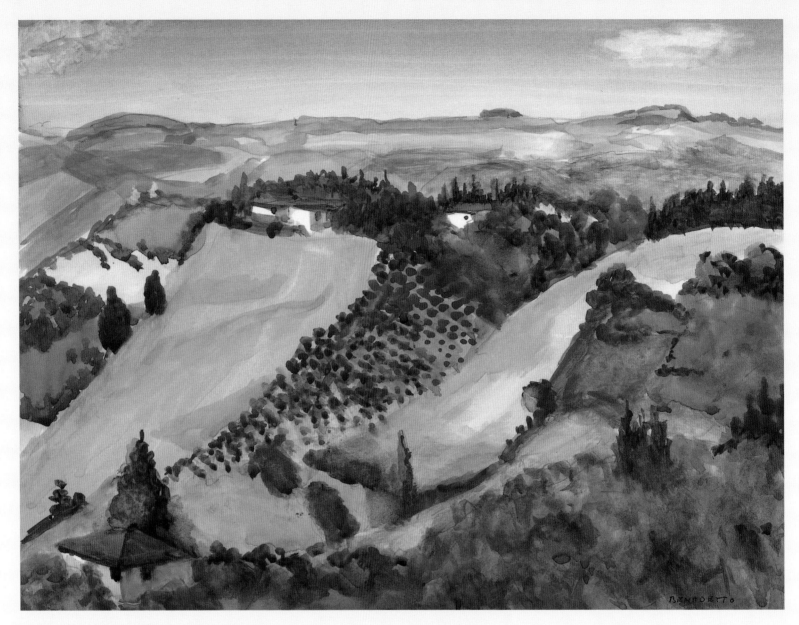

*Tuscany,* watercolor on paper, 11½ x 14½ inches

ANTHONY DOMINICK BENEDETTO was born at St. John's Hospital in Long Island City, New York, on August 3, 1926, to parents of less-than-modest means. He was the first person in his family, American or Italian (his widowed grandmother was the immigrant), to be born in a hospital. Tony's parents, who were first cousins before they wed, and his older brother and sister had lived in an apartment above a grocery store where Tony's father was employed. But the father, John Benedetto, was already seriously ill at the time of his third child's birth, and within a year he was unable to work. The store was sold, and the Benedettos were forced to look for a cheaper place to live in the same neighborhood, which was in Astoria, Queens.

In his 1998 autobiography, *The Good Life,* written with Will Friedwald, Tony remembered, "They found an apartment in a four-story apartment house on Van Alst Avenue and Clark Street. It was a typical four-room railroad flat: the rooms were lined up in a straight row, like train cars, and you had to go through one room to get to the next. We were on the second floor of the building, above a candy store."

Today, Tony says wonderingly, "I grew up in poverty, another thing that makes where I landed so unbelievable."

It was poverty indeed after Tony's father, who Tony remembers as "a very poetic, sensitive man, full of love and warmth," died when the boy was but ten, and he himself was only forty-one.

"I couldn't believe that this wonderful, beautiful man was really out of my life and that I would never see him again," Tony once wrote. "I was heartbroken. My eyes welled up with tears and I wept."

His mother, who has always been Tony's life hero (when asked if the term applies, he whistles, drops his eyes, and says, "Absolutely"), had already begun to work to make ends meet. Again, from the memoir, which is dedicated to her: "My most vivid memory from my childhood is of myself as a ten-year-old boy during the Depression, sitting at my mother's side in our modest home as she worked as a seamstress. Her salary depended on how many dresses she could make and I remember the constant hum of the sewing machine that stopped only long enough for her to cook our dinner."

Today, he remembers further, "One of the early gifts I got was from my mother. She always insisted on top quality. She would make those penny dresses, and the more she made, the more money she would earn. But even still, she'd throw away a bad dress. Always quality. Ever since, I never wanted to do a song that would insult the audience. That's the way to make music that lasts. Like a dress that lasts."

All the Benedettos made music, particularly the men. Tony believes this was predestined. "It's funny," he reflects during a conversation in the earliest days of 2007, "I really work hard not to retrogress. And yet, you know, with my brother and sister dying last year, you just . . . Well, they're gone, you know, my whole family's gone. And so—*voooom*—you go right back to the beginning, right back. My father." Tony pauses and gathers himself. "Sorry. Lately, because my brother and sister died, I get so emotional sometimes . . .

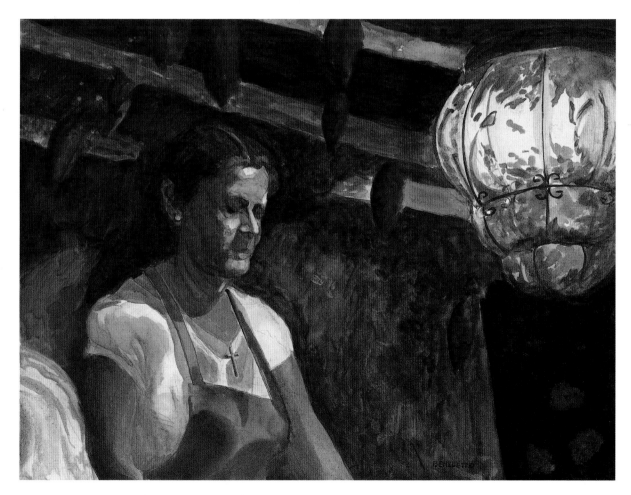

*Antoinetta Serving Lunch, Tuscany,* watercolor on paper, 18 x 24 inches

"So, then: My father died when I was ten years old. Now, in Podargoni, Calabria, Italy, the legend in my family was that he used to stand at the top of a mountain and the whole valley would hear him sing. That did it. When I heard that, it became as clear to me as I'm speaking to you right now—that is the reason I'm singing. I realized, wow, this was my father, the father I never really had. He was very well loved by the family, and he used to sing and the whole valley would hear him. That did it for me, you understand? We're put here to sing; this family was put here to sing. I've always felt that right through my life, right up to today as I speak to you. I just feel that I have to do it, not that I want to do it. I feel I'm blessed with a passion to sing and paint. The Benedettos had to sing."

The family sang often, with the kids taking the stage during Sunday evening gatherings. Tony's older, opera-loving brother, John, was a sensational singer of arias; he performed solos at the Metropolitan Opera as a young teen and was dubbed by the New York press "Little Caruso." Tony, for his part, deferred to his brother on the Verdi material and chose to entertain his parents, aunts, and uncles (one of whom was a tap dancer in vaudeville) with popular tunes of the day. He'd give them Eddie Cantor songs and Al Jolson numbers. "I had a beautiful family," he recalls warmly. "We'd make a circle, and the entertainment was my brother, my sister, and myself. We'd stand inside the circle and they're all sitting in a circle around us with guitars and mandolins, and they'd have us perform for them. It was all very positive; they used to have so much fun with us. Every week we couldn't wait for the next Sunday, then the next Sunday to come."

If all the Benedettos sang, the drawing was, for Tony, more personal. "I found, even as a kid, I'd draw or paint away and all of a sudden it was my own little creation," he recalls. "I was shocked by it, in a way. I'd say, 'Look at that. Look at that thing I made.'"

*Taormina, Sicily,* watercolor on paper, 8 ¾ x 13

# "I knew very early that somehow I would sing and draw and paint my whole life."

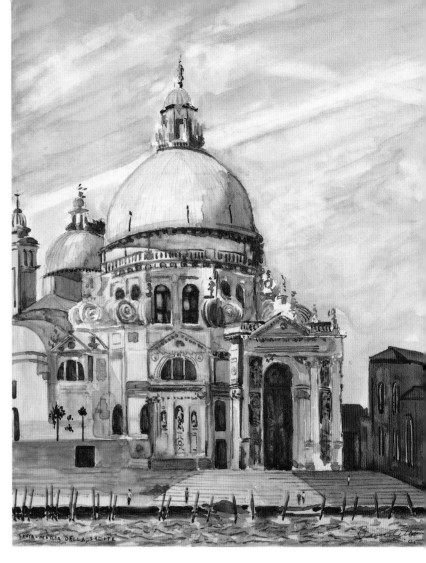

*Santa Maria della Salute, Venice,* watercolor on paper, 14½ x 11½ inches

Ralph Sharon, Tony's dear friend, accompanist, and musical director from 1957 right on through the end of the millennium (with one fifteen-year hiatus), wrote about the years immediately after Tony's father's death in an introduction to a previous book of Benedetto paintings: "With his mother going to work and his siblings busy with their own lives, Tony found himself alone for many quiet hours. Drawing, sketching, and even cartooning became important afternoon activities for him. While other children would doodle, Tony would try to 'get the picture right.'"

*Ralph Sharon,*
ink on paper,
8¾ x 6 inches

Perhaps nobody has seen more often Tony's compulsion to get an artistic effort right than has Ralph Sharon.

By the time he was twelve years old, Tony was an accomplished—and notorious—caricaturist of classmates and teachers at P.S. 141, and drawing had become his cofavorite pastime with singing. "I knew very early that somehow I would sing and draw and paint my whole life." And now came a crucial meeting—right out of the blue, a bit of kismet. Just before Thanksgiving in 1938, Tony was making a massive holiday mural on the sidewalk outside the family's housing-project building—"I was having fun, doing this thing with the Pilgrims and the Indians. I was using chalks my mother had bought me." He was concentrating on his work, when a large shadow suddenly covered part of the picture, and a man said, "That's pretty good." Sixty-eight years later, Tony remembers the details vividly: "James MacWhinney, a great schoolteacher.

A handsome guy back then, handsomer than Kennedy, John Kennedy. He was a junior high art teacher. 'I like what you're doing, son.' He and his wife were living in the same building as us, and he offered to help me with my art. 'I go over to Rainey Park on Saturdays, son, and paint. Would you like to come with me?' I was barely a teenager. I said, 'Terrific. I'd love to!' He took me under his wing. A wonderful man. He and his wife introduced me to culture. They took me to my first musical, *Carmen Jones.*

They took me to the Museum of Modern Art. They encouraged the things I had a passion for. We stayed friends his whole life.

"To this day, whenever I do a watercolor, I see him painting."

At one point a few years ago, MacWhinney told Tony the story of the Renaissance painter Cimabue, who mentored young Giotto after finding the boy drawing, brilliantly, on a sidewalk in Italy. MacWhinney likened their own relationship to Cimabue and Giotto's, and Tony got a huge kick out of the comparison.

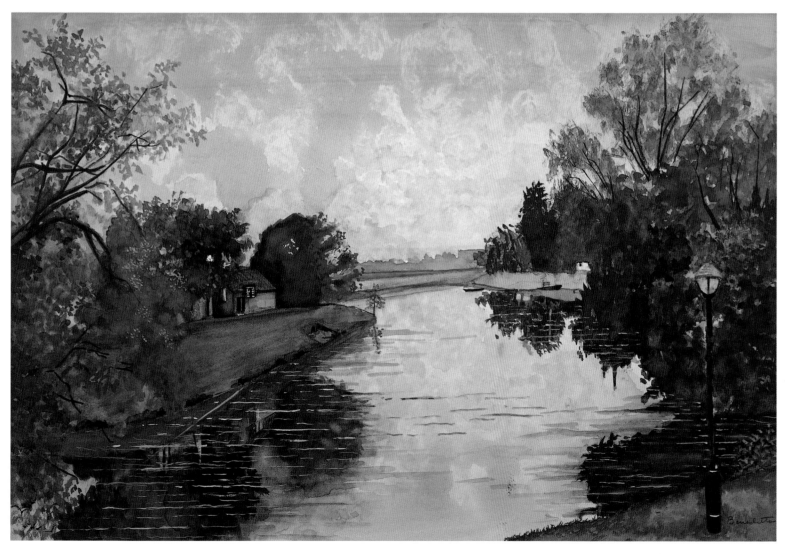

*Den Bosch, Holland,* watercolor on paper, 15 x 22 inches

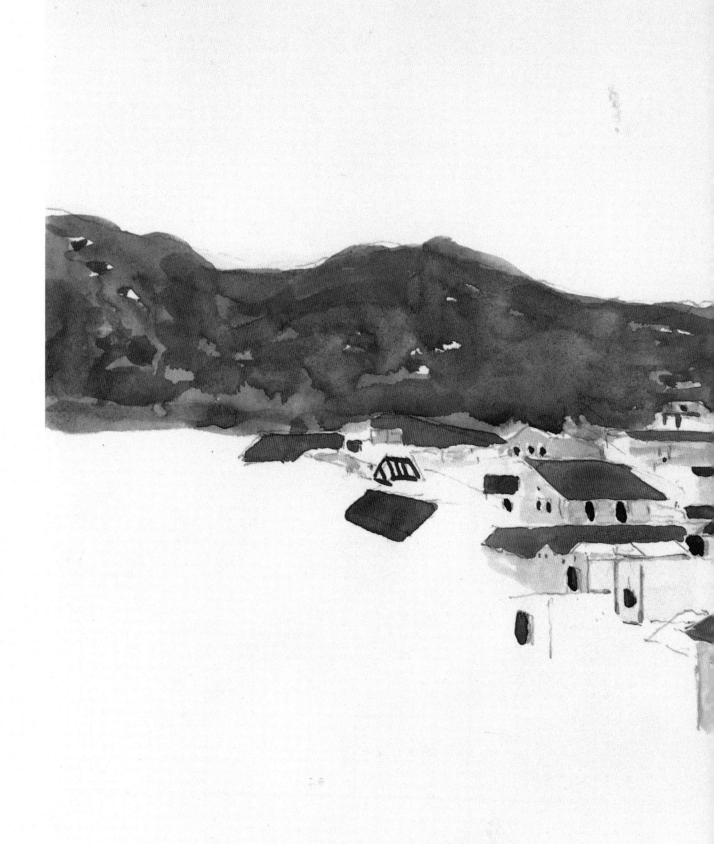

*Duomo, Florence,*
watercolor on paper,
10 x 14 inches

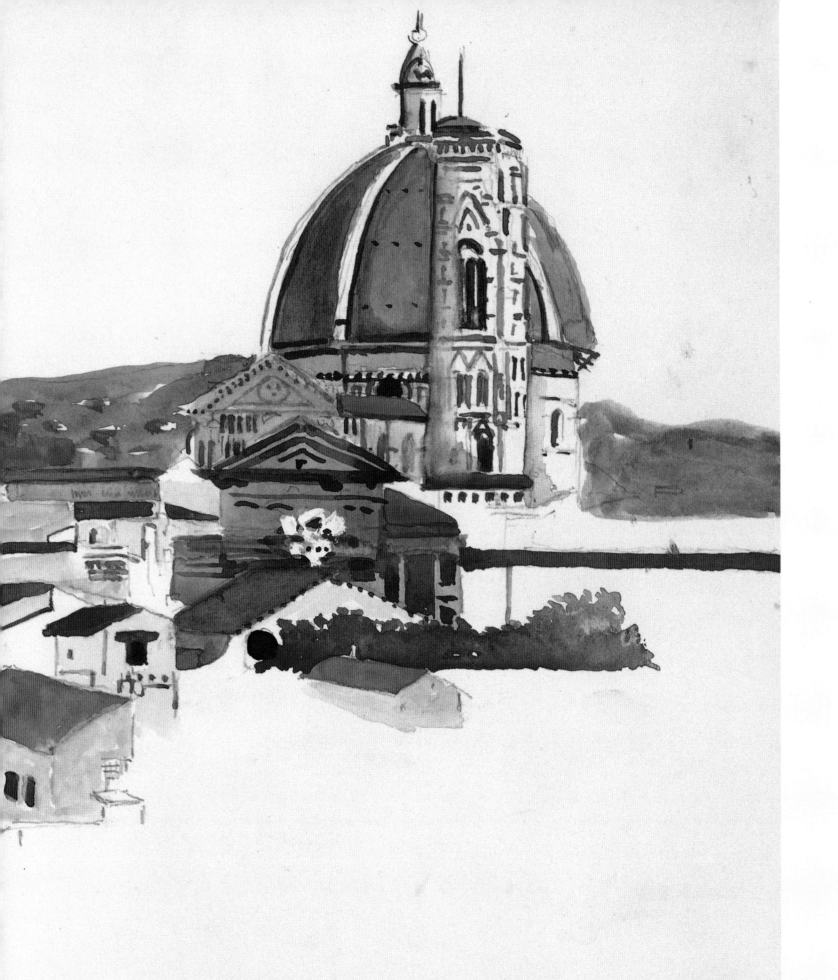

BENEDETTO '03

# "You see, they taught you how to express yourself, the rules of expression."

In his teens, Tony received formal training not only from MacWhinney but from the teachers at New York's distinguished School of Industrial Art, to which he'd been admitted. "I got turned down at the High School of Music and Art, and it kind of crushed me," he says. "A friend from my neighborhood said, 'Go to the Industrial Art School,' and I did. Turned out to be a blessing. I found that out many years later when I met Kinstler at the National Arts Club on Gramercy Park. He said, 'You're Benedetto; I went to the same classes as you at Industrial Art.' He's the same age as me, and he told me he had had a scholarship to Music and Art. He was so bright, sixteen years old, and the teacher at Music and Art told him, don't worry about technique; just paint what you feel. And because of that, he just closed up the book and said, 'I'm sixteen, I don't feel anything; I want to learn how to do it.' He transferred to the Industrial School, which shows you technique. Many years later, he's telling me, 'You went to the better school. They taught you the rules for painting, sculpting, everything.'

"You see, they taught you how to express yourself, the rules of expression. You can't break the rules until you know the rules, and that's the same in singing or art. Look at Picasso. Picasso's early paintings aren't to be believed. They're classical painting—complete technique. If you don't know how to do it, you won't know what to do next."

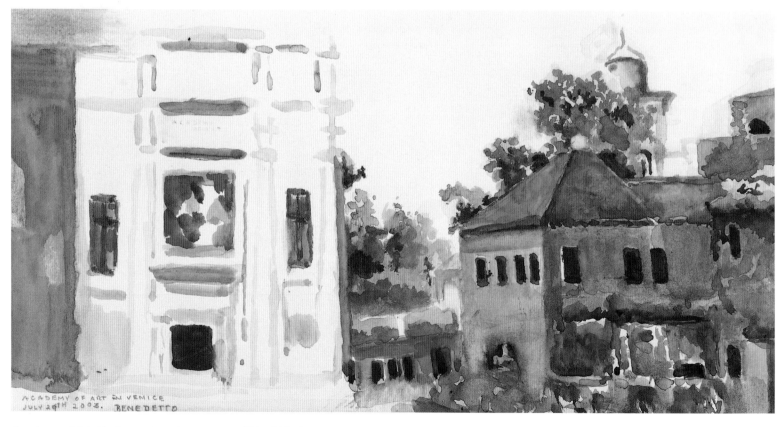

*Academy of Art, Venice,* watercolor on paper, 7 1/4 x 14 inches

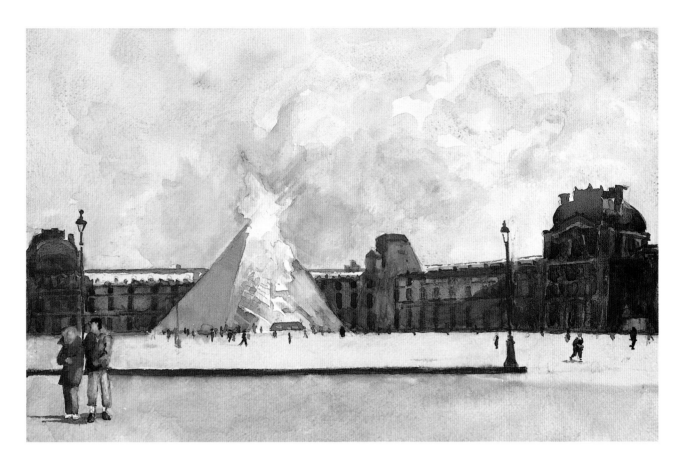

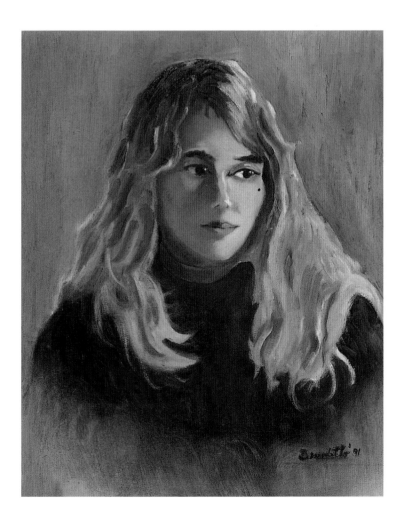

A note in passing: The various philosophies about artistic development that Tony formed at the School of Industrial Art and, later, in discussion with friends such as Kinstler are today employed at a school Tony recently founded, with his longtime companion Susan Crow, in his hometown of Queens. The school, in just its fifth year, has one of the highest graduation rates in the city—in the country, in fact—and is sending its grads off to college. Frank Sinatra School of the Arts—or more familiarly "Tony's school"—is open to all of New York's high-school-age children; despite advice from many that it would be much easier to establish a private arts school, Tony insisted it be public.

Tony studied music and painting at the School of Industrial Art until dropping out at age sixteen. The family needed his help, and of course he would pitch in. But "I just didn't want to work unless I was singing. I'm proud of my intuition, that I stuck with it. With my dad having died, everyone was pleading with me to take this job or that to help out. I wanted to sing."

And so he found work as a singing waiter, a gig he absolutely loved. He felt at the time that if he was singing for his supper in a restaurant for the next twenty years, fine—he'd get to sing.

As happened just then to so many Americans, Tony's dreams were interrupted. Drafted into the army in 1944, he wound up with the Sixty-third Infantry as it moved through France and Germany near World War II's end. Tony downplays his military career when asked about it, but the facts remain: He saw some things. He was nearly killed more than once and was in on the liberation of the Landsberg labor concentration camp in Germany. To distract himself at arduous times, he drew. "There was a guy who was on the line with me in Germany," Tony recalls, "and he said to me later, after the war, 'Do you remember when we were in those trenches, with the bombs coming at us and everything? Remember what you were doing?' I said no. He said, 'You were sketching all the time.' Crazy."

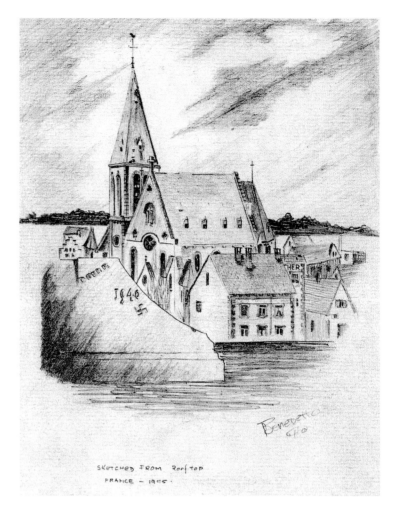

*France, 1945,* pencil on paper

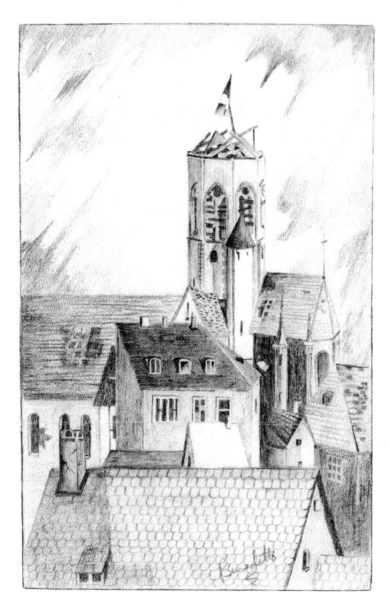

*France Rooftops,* pencil on paper, 10 x 6½ inches

Certainly his experience on the front lines, as well as another incident that happened during the war—one discussed in a later chapter of this book—served to foment a lifelong antipathy for the military. Tony is a patriot and he's proud, but he is also a pacifist. He wrote in his memoir, "The main thing I got out of my military experience was the realization that I am completely opposed to war. Every war is insane, no matter where it is or what it's about. Fighting is the lowest form of human behavior. It's amazing to me that with all the great teachers of literature and art, and all the contributions that have been made on this very precious planet, we still haven't evolved a more humane approach to the way we work out our conflicts."

After Germany surrendered, Tony stayed in Europe as part of the occupying force, singing regularly with a Special Services band that entertained the troops on army bases. When he returned to New York after his discharge, he took up where he had left off in the restaurants, singing into the wee hours every night of the week.

*Venice in '03,* watercolor on paper, 11 x 15 inches

He studied bel canto singing at the American Theatre Wing on the GI Bill; he was getting serious about his craft and no longer felt that Singing Waiter would be the big posting on the resume. He also took an acting class with a Russian professor named Zhilinski, who propounded theories that would later be put together as Method acting. Tony took what he learned from Zhilinski and applied it to song: He began to think auto-biographically as he got inside a lyric. He would apply the technique in his painting as well. "You look at the Masters," he says. "Take a look at Rembrandt, for instance, and you realize that nobody ever felt more about putting pen to paper or brush to canvas than he did. And he was the pen; he was the brush. Everything was all about how beautiful he felt about life. Everything was all about feeling. Every painting has a feeling,

whether it's a landscape or a portrait. You see what he was feeling and you can feel what he was feeling."

Are you in every painting? he is asked. "Oh, yeah," he replies instantly, then pauses. "It's not about sticking my ego into it. It's not that. I just paint what I feel and what I sense."

Tony certainly would have liked to make his living doing nothing but expressing himself artistically, but there were still real-world concerns, so he decided to take a mundane day job to help with the bills and to support his life as "Joe Bari" (that was the stage name) in New York's nocturnal saloons. Pearl Bailey caught his nightclub act, and Tony caught her attention. She insisted he open for her at the Greenwich Village Inn. Bob Hope, who was performing in town, was invited to the show. Hope, too, liked what he saw.

JIMMY HEATH... Benedetto

BILL CHARLOP AT JAZZ STANDARD—
WITH THE WASHINGTONS

BENEDETTO

# "Now, my break came in 1950. I got a job on Bob Hope's bill at the Paramount."

## Hope's 'Find' Making Mark

### Bennett Justifying Discovery by Film Star

**by Rube Dorin**

(Staff Correspondent.)

Into the swim of male vocalists jumps Tony Bennett, a neat, serious looking young man who carries with him the distinction of having been discovered and yanked from comparative obscurity by none other than Bob Hope. And from the looks of things the young gentleman from Astoria will make decidedly more than a pebble-splash.

Hope caught Bennett one night when he was singing at the Greenwich Village Inn during the fairly recent show which starred Pearl Bailey. The star took a shine to him and the next thing Tony knew Hope had him up on one of his Paramount stage shows, then dragged him off on a tour. Clicked, too, especially at the Princess' Ball, crowning event of the Apple Blossom Festival at Winchester, Virginia, where he sang with Tony Pastor.

A "cross between a tenor and a baritone," Bennett has already recorded for Columbia and his platters of "I Wanna Be Loved" and "A Boulevard of Broken Dreams" are in the best-seller class. He's appeared at the Club Charles in Baltimore, the Pittsburgh Copa and on a number of television shows, including Robert Q. Lewis'. Mitch Miller at Columbia Records sees Bennett skyrocketing before the year is up. A personal appearance at one of

**TONY BENNETT**

Broadway's presentation houses is in the offing.

Bennett's background is not unusual, with a single twist. Parents (especially fathers) have never been known to encourage singing careers. Tony's father explicitly wanted him to become a singer and hoped for it all his life. That was OK for Tony, too, who would sing at any opportunity—church socials, community sings and the like. Went to the School of Industrial Art, graduated, got a routine job, then decided the only way to get to sing is to do just that. Got a job in a local night club and was coming along nicely. Then, as it must (and did) to all men, the war came to Tony Bennett, nee Anthony Benedetta. It was the infantry and he eventually landed in Germany with the 63rd, but at the tail end of the conflict was transferred to Special Service, where he sang with various bands.

Out of the Army, he was doing a number at the studio of a friend, Ray Mascarella, who is Vic Damone's sponsor and manager. Mascarella immediately signed him to an exclusive contract and his first big stop was the Village Inn engagement.

Tony lives in Astoria with his mother, a brother and a sister. His father died when he was 9. His uncle, Dick Gordon, was a dancer who played the Palace and other local spots and who furnished the major inspiration and drive for Bennett.

Personal preferences in singers? We get an answer from Tony that's refreshing and unhackneyed. Not Vic Damone, or Perry Como, or Frankie Laine or any of the other boys.

'I get a kick out of the way Fred Astaire sings," he claims.

---

NOW, TONY HAS TOLD ME THIS NEXT STORY a few different ways through the years, and in fact he tells it a bit differently in the autobiography, but this is the way he told it to me, and I love the flash and fizz of this version. I suggest that this might be, if not apocryphal, at least an elaboration. Hope might have suggested the name change over lunch. Memory is, as we know, a tricky thing.

But Tony is allowing me to stick with this altogether more colorful telling. So here it is:

"See, I'm the elevator operator during the day, but Joe Bari in the clubs. Now, my break came in 1950. I got a job on Bob Hope's bill at the Paramount, and just before I'm going on, Hope tells me the name's no good. Joe Bari's no good. He asks what my real name is. I say Anthony Benedetto. That doesn't do it for him either. So he goes out and says to the audience, 'And here's a new singer, Tony Bennett!' He had to introduce me twice 'cause I didn't know who he was talking about."

The name, like the man, would stick around.

---

OPPOSITE PAGE:

**Top Left:** *Folk Singer,* pencil on paper, 5 x 3 3/4 inches

**Top Right:** *Jimmy Heath,* ink on paper, 5 1/2 x 4 inches

**Bottom Right:** *Bill Charlap with the Washingtons at Jazz Standard,* pencil on paper, 5 1/2 x 8 inches

**Above:** This article, which appeared in the *New York Morning Telegraph* on May 25, 1950, recounts the story of Tony Bennett being discovered by Bob Hope at the Greenwich Village Inn—Hope then brought Bennett to the Paramount and "dragged him off on a tour."

"You can't **break the rules** until you know the rules, and that's the **same in singing or art**.... If you don't know how to do it, you won't know what to do next."

*Night Scene, Manila,* watercolor on paper, 9 x 11¾ inches

*Manila*

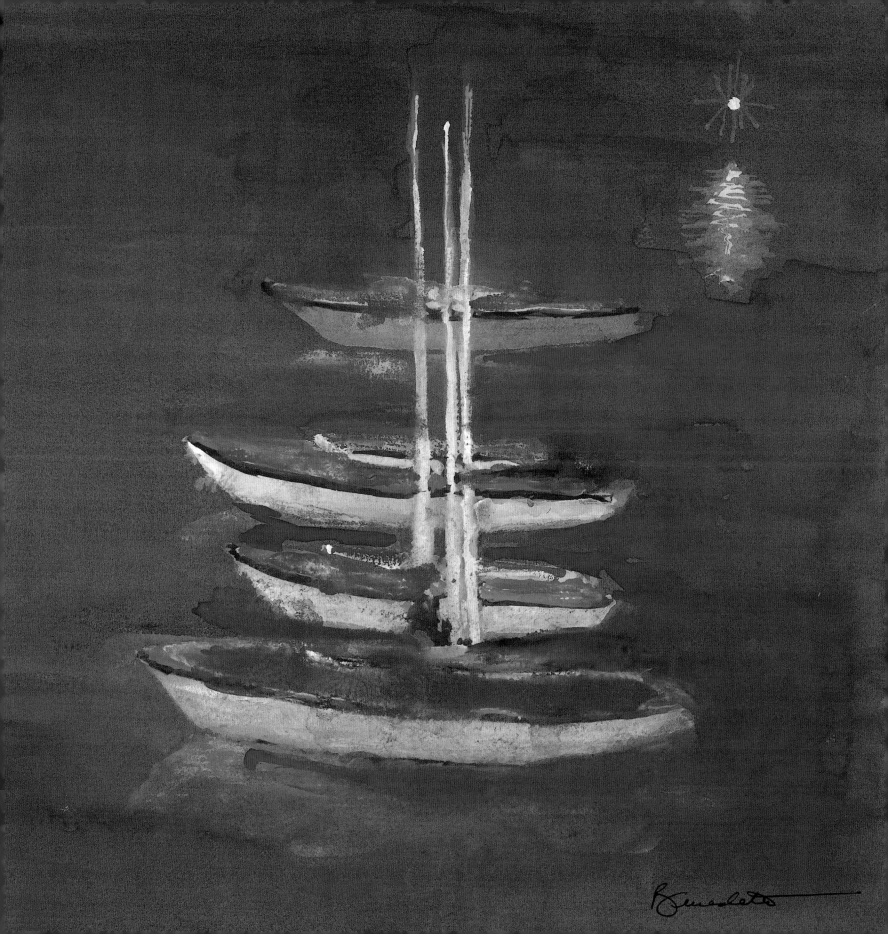

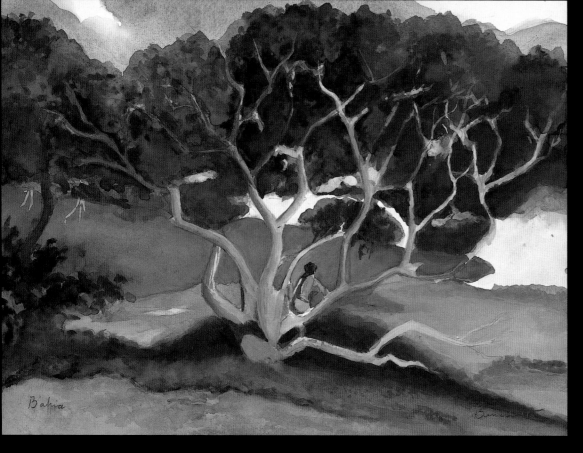

*Bahia, Brazil,*
watercolor on paper,
12 x 16 inches

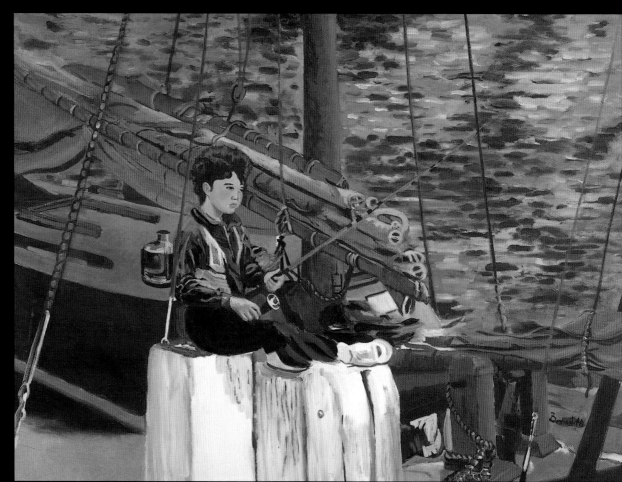

*Boy on Sailboat,*
*Sydney Bay,*
oil on canvas,
30 x 40 inches

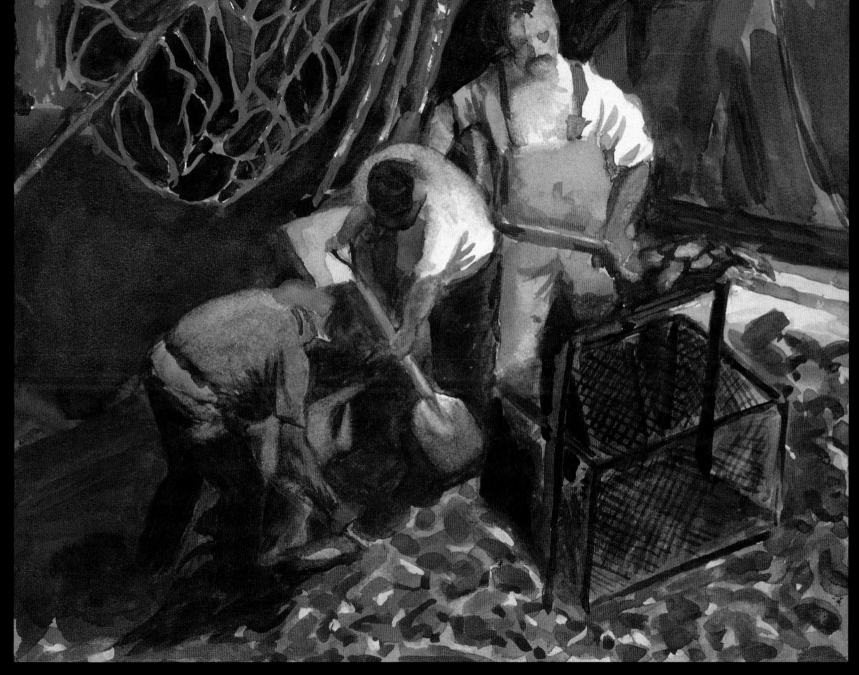

*Fishermen, San Francisco,*
watercolor on paper,

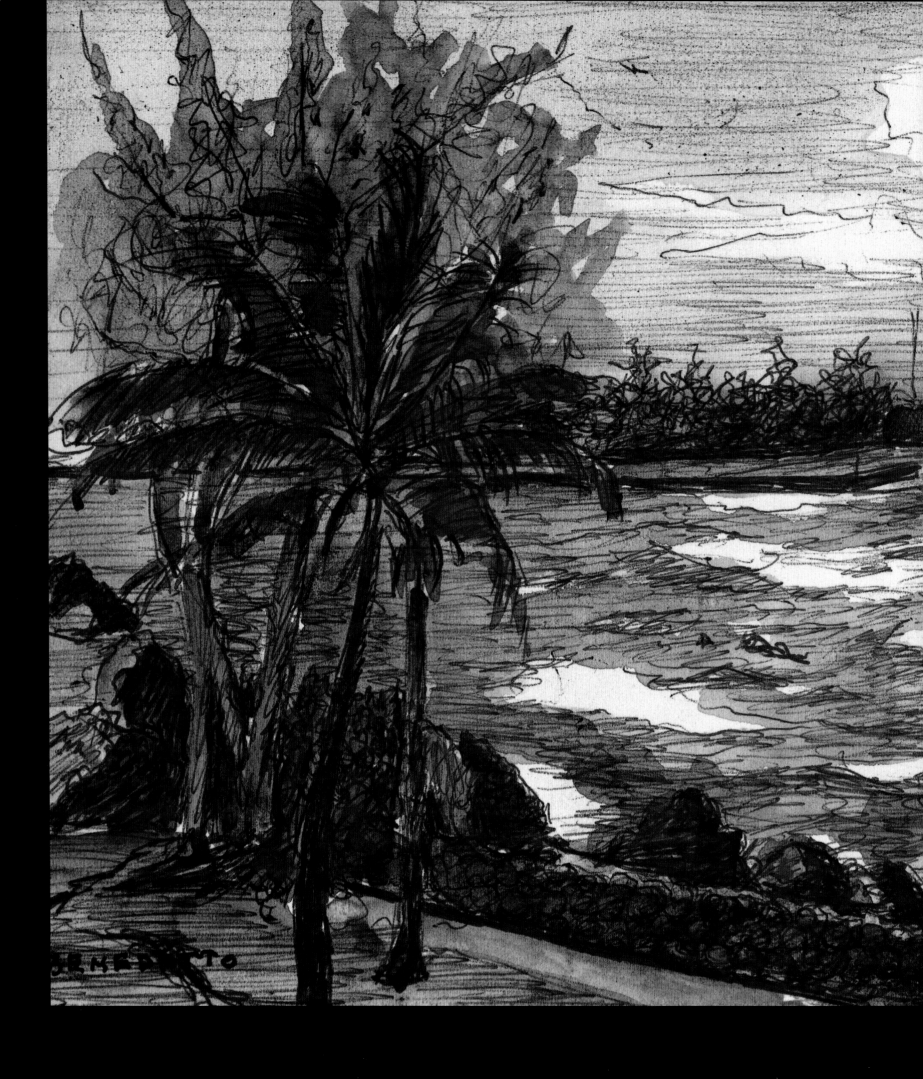

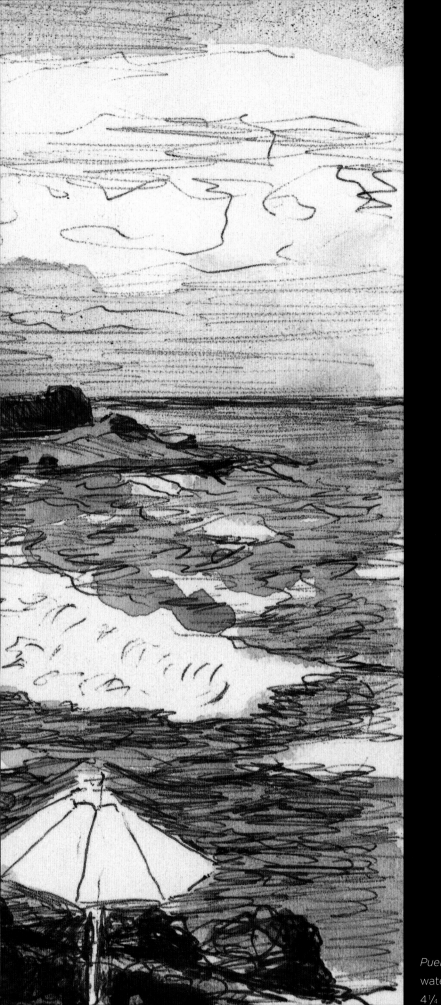

*Puerto Rico,*
watercolor on pape
4¼ x 5½ inches

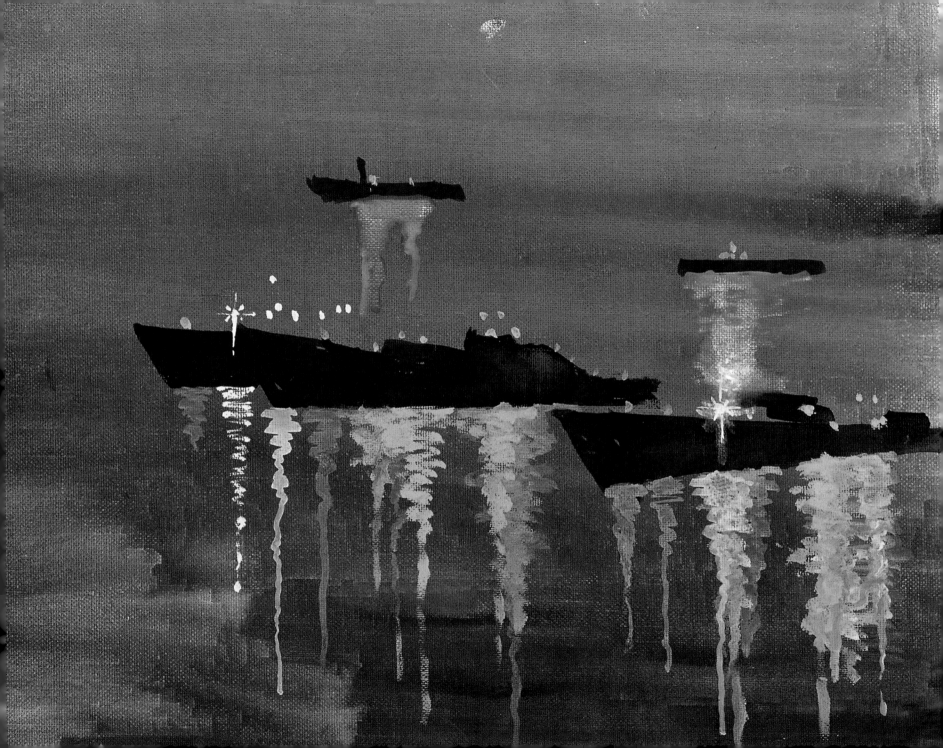

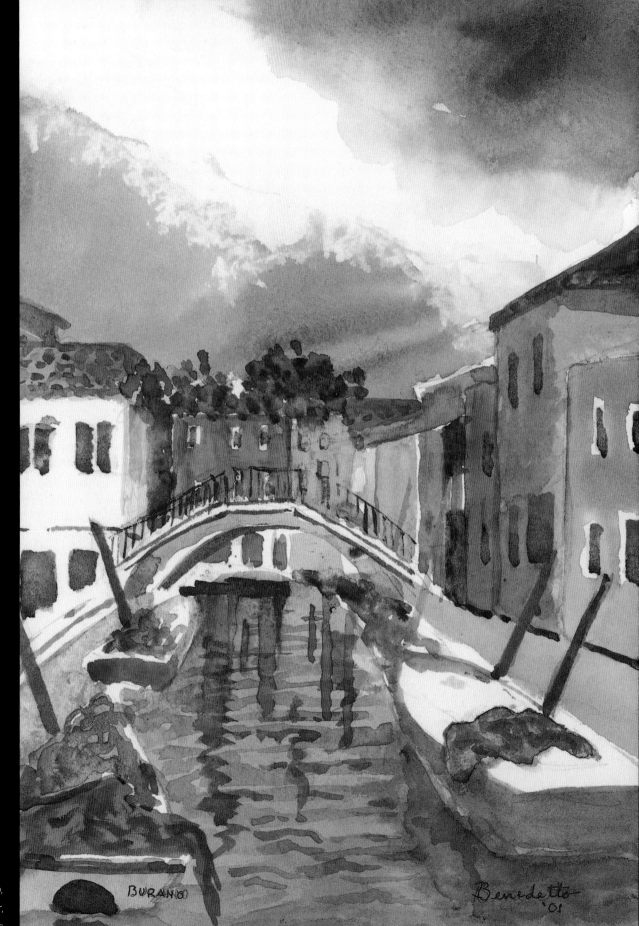

BURANO

Benedetto
'01

Right: *Burano,*
watercolor on paper,
10¾ x 7 inches

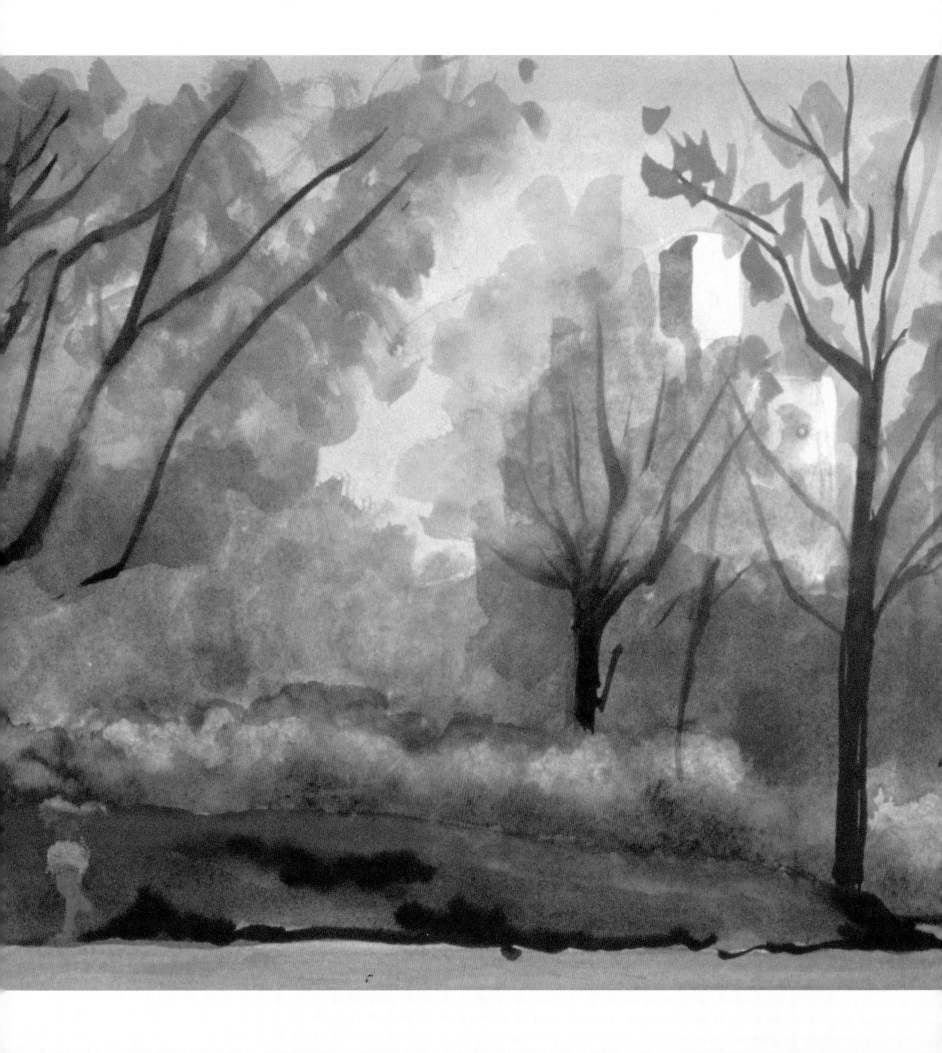

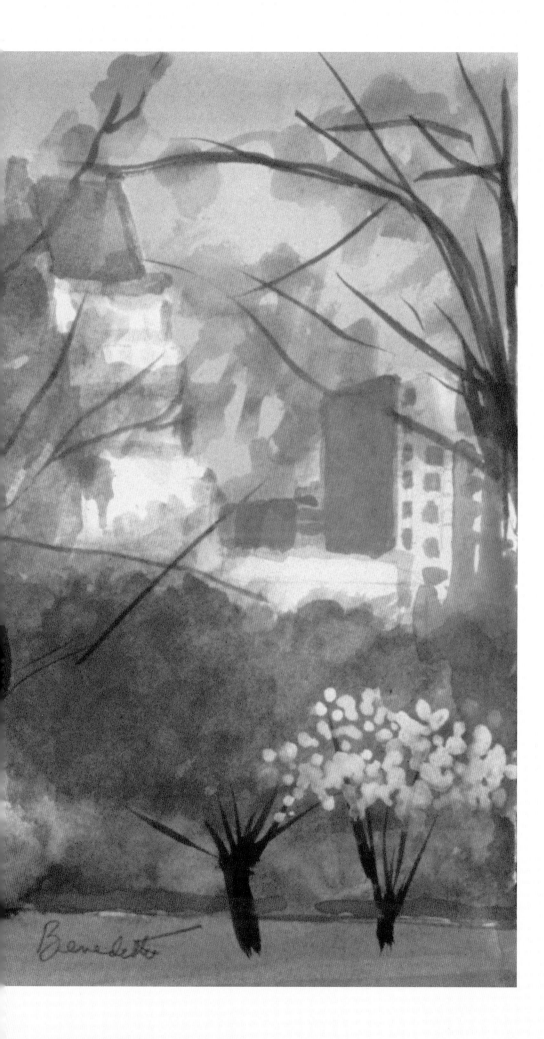

# BRIGHTNESS

Brightness

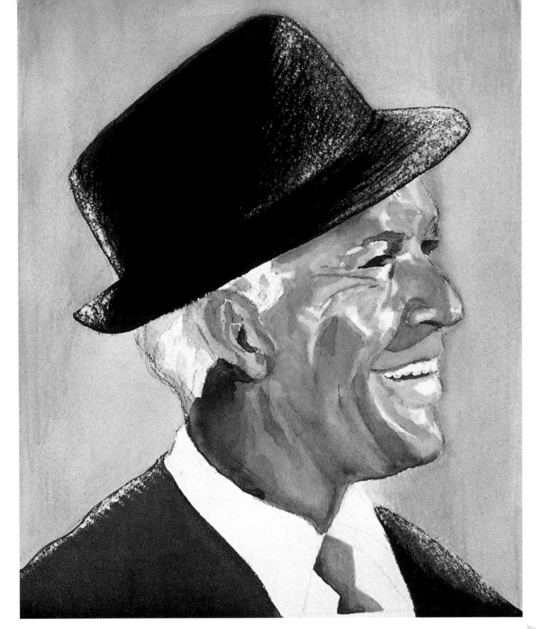

Previous Pages: *Central Park,*
watercolor on paper,
9½ x 16 inches

Left: *Perfectly Frank,* watercolor
on paper, 22 x 18 inches

*I*n 1997, I was sitting with Tony in one of his favorite East Side Italian eateries—again, at the best table in the house. He was, as always, bespoke in manner and attire. (I have to remember to ask him where he gets those neckties.) This time, we were talking nearly exclusively about Frank Sinatra. Tony had agreed to provide the foreword for an illustrated book on Sinatra's life that *LIFE* was producing, and our preplanned methodology was that I would let the tape recorder run, then cobble something together from the transcript for Tony's approval.

I recall it, now, as an altogether delightful afternoon. Talking about somebody else rather than himself, and a somebody for whom he had clear and abundant affection, Tony never stopped smiling. And when he reminisced about the early days of stardom

and glory, when Frank and Tony and Ella and Sarah were the kings and queens of pop-singing royalty, there was not only a pep to his speech, but a kind of awe. *That really happened to us. Imagine that.*

"The competition was intense back then," he said. "It was a great era—you had Jo Stafford, Dick Haymes, Nat King Cole, Sarah Vaughan, Rosemary Clooney, Louis Armstrong, Billy Eckstine, Lena Horne, Judy Garland, Dinah Washington, Peggy Lee, Margaret Whiting. All these great singers. Fierce competition, but there was a camaraderie. Sinatra was the one who set the tone."

He continued, "The first time I met him was after I was established as a successful recording artist in my own right. I was given the summer replacement spot for Perry Como on his *Kraft Music Hall* television show. Since I was still new at show

# "Sinatra was wonderful to me. I asked him, 'How do you handle being nervous onstage?'"

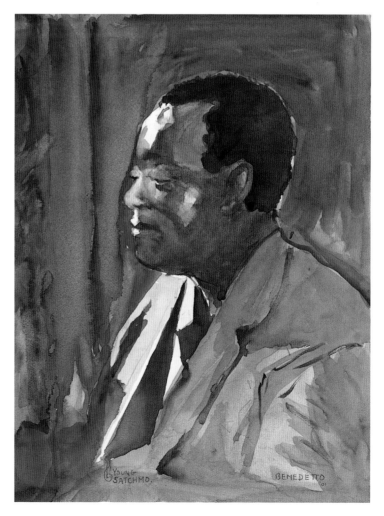

*Young Satchmo*,
watercolor on paper,
13 ¾ x 11 ¾ inches

business, I was nervous as all heck. I thought I'd take a big chance and seek Sinatra's advice. Sinatra was over at the Paramount, and I decided to visit him backstage. A friend of mine warned me not to go because Sinatra had a reputation for being tough. But I took a deep breath and showed up at his dressing room. The Sinatra I met was quite different from the one I had expected. Sinatra was wonderful to me. I asked him, 'How do you handle being nervous onstage?' He said, 'It's good to be nervous. People like it when you're nervous. It shows you care. If *you* don't care, why should *they*?' And then he told me to stay away from the cheap songs. It was great advice. I've followed it since."

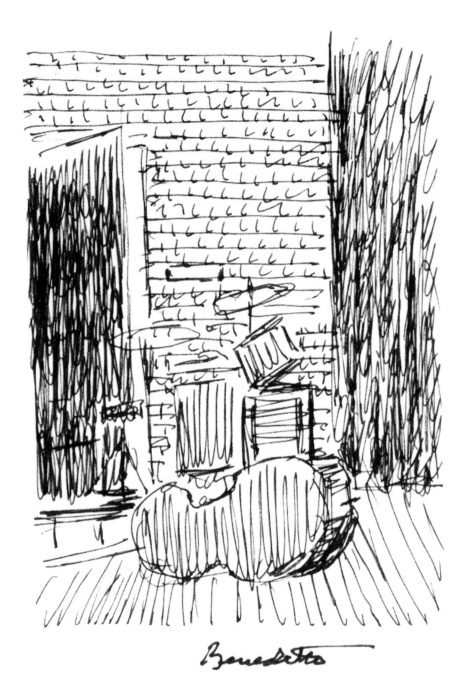

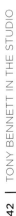

There it was with the advice again, and the listening. Tony's personal taste in music is indisputably one of the most refined in the history of popular song, but to hear him tell it, everyone this side of Mitch Miller (and we'll get to him) is responsible for the wondrous discography that constitutes the Tony Bennett songbook. His brother, John, Ralph Sharon, Bing Crosby, Sinatra: All these other guys knew what was right.

Fact is, when things started to take off for Tony in 1950, when he was launched into the surreal world of superstardom already inhabited by Sinatra and the others, he was well poised for whatever wild ride was ahead. He had an innate aesthetic sense for good material. He had worked at honing his artistic talent. He knew how to work hard and long (seven shows a day at the Paramount would seem light lifting after all those four A.M. saloon sessions). He had seen war and therefore had developed opinions about life's trivialities. He had, by then, notions about what mattered and what didn't.

As Tony negotiated the early minefields of show business, one thing that was reinforced for him by Sinatra was the importance of loyalty. "That word overrides anything else you need to know about Sinatra," Tony said that day. "And of course it worked

Left: *Bass and Drums,* ink on paper, 5 x 3 inches

Opposite Page: *Rehearsal Room,* pencil on paper, 4 x 4 inches

Tony's personal taste in music is indisputably one of the most refined in the history of popular song.

both ways with him. If he loved someone, he loved them for life. It didn't matter if you were the queen of England or a waiter." He came to consider Sinatra his best friend, and I think Sinatra's instinct for grace notes (if, of course, you were on his side) rubbed off. "One night my mother and I were watching Sinatra on TV doing *The Main Event* at Madison Square Garden. He knew my mother was dying, and he turned to the audience and said that Tony Bennett was his favorite guy in the whole world. My mother's face lit up like a Christmas tree—this image will stay with me as long as I live. This was the kind of small thing he would do that would make such a big difference."

It's precisely the kind of small thing I've seen Tony do a hundred times, at postconcert meet and greets, at CD-signing appearances, at the museum that first time, and at the East Side restaurant, where the other diners who approached our table all afternoon fazed Tony not a bit.

I saw this trait evinced well before I got to meet the man. One afternoon, in 1980, I was walking up Sixth Avenue toward Central Park. I noticed this well-dressed suntanned fellow walking breezily in the other direction, and I said to myself, "That's Tony Bennett." Consider the year in question: Tony was largely off the radar screen in 1980. It wouldn't be clear that he had any reason to be happy. But here he came, looking positively chipper. On top of the world.

A deli worker, obviously Italian, must have spotted the singer passing by and rushed out to the sidewalk. "Mr. Bennett!" he shouted. "Me and the wife, we love your music!"

Tony stopped, turned on his heel, shook the man's hand, and put his other hand on the man's shoulder. I swear he said, "Thanks, pal-o! And tell her I said hi!"

I told my friends that evening in a bar, "Saw Tony Bennett on the street today. Boy, does that guy know how to be a star."

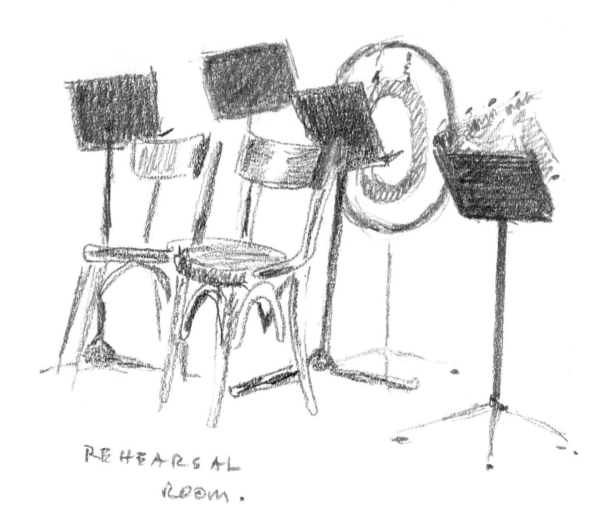

REHEARSAL
ROOM.

Stardom, when it came, came suddenly. In 1950, under the name Bennett, Tony cut a demo and was signed to Columbia Records by the label's A&R man, Mitch Miller. Within a year, by virtue of the lush ballad "Because of You" and a similarly voluptuous rendering of Hank Williams's "Cold, Cold Heart," both chart-toppers, everyone in the country knew about Tony Bennett. At twenty-five, he was, it can safely be said, the hottest singer in the country. And as a handsome man, he was a heartthrob on the order of Sinatra circa 1940. This was the first flowering of Bennettmania, something that would bloom across the country in different seasons and in different hues over the next five decades.

You have to listen intently to catch what Tony says in conversation; his voice is mellifluous but exceedingly mild. It's odd to be straining to hear a man say "I was always loud, and always very

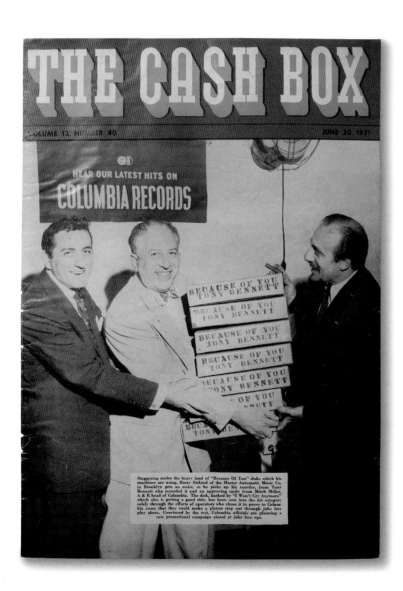

## THE BILLBOARD Music Popularity Charts

### ● Best Selling Pops by Territories

. . . Based on reports from key dealers in each of these cities, secured via Western Union messenger service.

Each week, The Billboard in co-operation with Western Union, secures last minute sales reports from top dealers in the nation's largest record markets. Altho the number of stores queried in each market does not necessarily constitute a scientific survey sample, there are enough reports to avoid any possibility of the over-all local picture being unduly influenced by the report of a single store.

**NEW YORK**
1. BECAUSE OF YOU
   T. Bennett—Columbia
2. COME ON-A MY HOUSE
   R. Clooney—Columbia
3. TOO YOUNG
   Nat (King) Cole—Capitol
4. I GET IDEAS
   T. Martin—Victor
5. WORLD IS WAITING FOR THE SUNRISE
   L. Paul-M. Ford—Capitol
6. JEZEBEL
   F. Laine—Columbia
7. LOVELIEST NIGHT OF THE YEAR
   M. Lanza—Victor
8. SWEET VIOLETS
   D. Shore—Victor
9. BELLE, BELLE, MY LIBERTY BELLE
   G. Mitchell-M. Miller—Columbia
10. COLD, COLD HEART
    T. Bennett—Columbia

**BOSTON**
1. BECAUSE OF YOU
   T. Bennett—Columbia
2. COME ON-A MY HOUSE
   R. Clooney—Columbia
3. COLD, COLD HEART
   T. Bennett—Columbia
4. I GET IDEAS
   T. Martin—Victor
5. LOVELIEST NIGHT OF THE YEAR
   M. Lanza—Victor
6. I WON'T CRY ANYMORE
   T. Bennett—Columbia
7. SWEET VIOLETS
   D. Shore—Victor

**PITTSBURGH**
1. BECAUSE OF YOU
   T. Bennett—Columbia
2. COME ON-A MY HOUSE
   R. Clooney——Columbia
3. COLD, COLD HEART
   T. Bennett—Columbia
4. DETOUR
   P. Page—Mercury
5. WORLD IS WAITING FOR THE SUNRISE
   L. Paul-M. Ford—Capitol
6. WHISPERING
   L. Paul—Capitol
7. CASTLE ROCK
   H. James-F. Sinatra—Columbia

**DETROIT**
1. BECAUSE OF YOU
   T. Bennett—Columbia
2. WORLD IS WAITING FOR THE SUNRISE
   L. Paul-M. Ford—Capitol
3. LOVELIEST NIGHT OF THE YEAR
   M. Lanza—Victor
4. SMOOTH SAILING
   E. Fitzgerald—Decca
5. COME ON-A MY HOUSE
   R. Clooney—Columbia
6. BECAUSE
   M. Lanza—Victor
7. WHAT IS A BOY?
   A. Godfrey—Columbia
8. I GET IDEAS
   L. Armstrong—Decca
9. I GET IDEAS
   T. Martin—Victor
10. SWEET VIOLETS
    D. Shore—Victor

**CHICAGO**
1. BECAUSE OF YOU
   T. Bennett—Columbia
2. COME ON-A MY HOUSE
   R. Clooney—Columbia
3. I GET IDEAS
   T. Martin—Victor
4. LOVELIEST NIGHT OF THE YEAR
   M. Lanza—Victor
5. COLD, COLD HEART
   T. Bennett—Columbia
6. JEZEBEL
   F. Laine—Columbia
7. WHISPERING
   L. Paul—Capitol
8. WORLD IS WAITING FOR THE SUNRISE
   L. Paul-M. Ford—Capitol
9. SHANGHAI
   Billy Williams—MGM
10. TOO YOUNG
    Nat (King) Cole—Capitol

**NEW ORLEANS**
1. BECAUSE OF YOU
   T. Bennett—Columbia
2. COME ON-A MY HOUSE
   R. Clooney—Columbia
3. TOO YOUNG
   Nat (King) Cole—Capitol
4. JEZEBEL
   F. Laine—Columbia
5. LOVELIEST NIGHT OF THE YEAR
   M. Lanza—Victor
6. SWEET VIOLETS
   D. Shore—Victor
7. ALEUNA MEZZUMARE
   E. Dewan—Mercury
8. MY TRULY, TRULY FAIR
   G. Mitchell-M. Miller—Columbia
9. I GET IDEAS
   T. Martin—Victor
10. SHANGHAI
    Doris Day-P. Weston—Columbia.

(Continued on page 37)

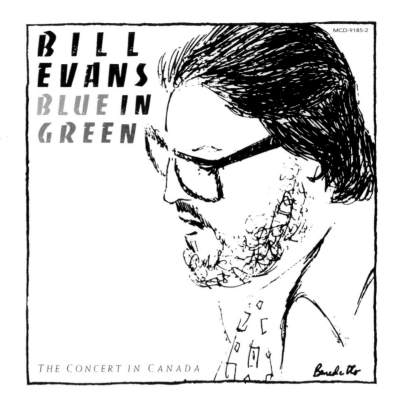

MCD-9185-2

**BILL EVANS BLUE IN GREEN**

THE CONCERT IN CANADA

Benedetto

Opposite Page, Left: Tony poses with Harry Siskind of the Master Automatic Music Company on the June 30, 1951, cover of *Cash Box* magazine—a former music/jukebox industry publication. Siskind holds boxes containing disks of Tony's best-selling hit "Because of You"; on the right, Mitch Miller of Columbia helps carry the load.

Opposite Page, Right: This page from a 1951 issue of *Billboard* magazine shows "Because of You" reigning at number one on the music popularity chart for "Best Selling Pops by Territories."

Right: Tony Bennett drew this insightful portrait of his friend the acclaimed jazz pianist Bill Evans for the cover of this 1974 album entitled *Bill Evans: Blue in Green.*

dramatic. Back then, I was too much. The guys in the band would say to me, 'Hey, kid—what're you trying to do? Calm down.' But see, Ella had told me to sing to the balconies. And also, I was nervous and I couldn't control myself." The odd combination of vulnerability and volume, which can be seen as well in some of his vibrantly colored paintings, blended perfectly in Tony; his frailty let the listener in, and his fierce emotion—today he still belts out his top notes—absolutely thrilled them.

Finding himself in a new realm—world-class entertainment— he quickly developed some philosophies. To put it kindly, neither Sinatra, who was just then leaving Columbia, nor Tony cared much for Mitch Miller's taste, which ranged on regular occasion from saccharine ballads to novelty songs. Sinatra, characteristically, never forgave Miller for asking him to sing some pretty awful kitsch, including a song that became a big hit but featured barking dogs in the background. One night, when the Chairman of the Board was in full flight with his late 1950s'

comeback on Capitol Records, Miller approached him with pleasantries in a Vegas casino. Sinatra refused to shake his hand, uttered an epithet, and told Miller to keep walking. Tony, also characteristically, is far more polite and measured in remembering the early days at Columbia. "Miller wanted me to do one ballad after another," he says. "Ralph Sharon said, 'Make sure you do some jazz.' Ralph knew how much I loved jazz. He knew that, really, I'm a jazz singer. In this commercial world, they put me in the traditional pop category, because, well, I'm white and Italian, which makes it tough to be seen as a jazz singer. But if you asked me what I was, once I'd learned how to sing, I'd say 'a jazz singer.'

"But anyway, Ralph Sharon never played a wrong note for me through all those years. And his advice! The music I made with Stan Getz, Bill Evans—the jazz giants—those are the best records I ever made in my life.

"I think what I was saying about music in 1950 is what I'm saying now," he continues. "I've never tried to follow a fashion."

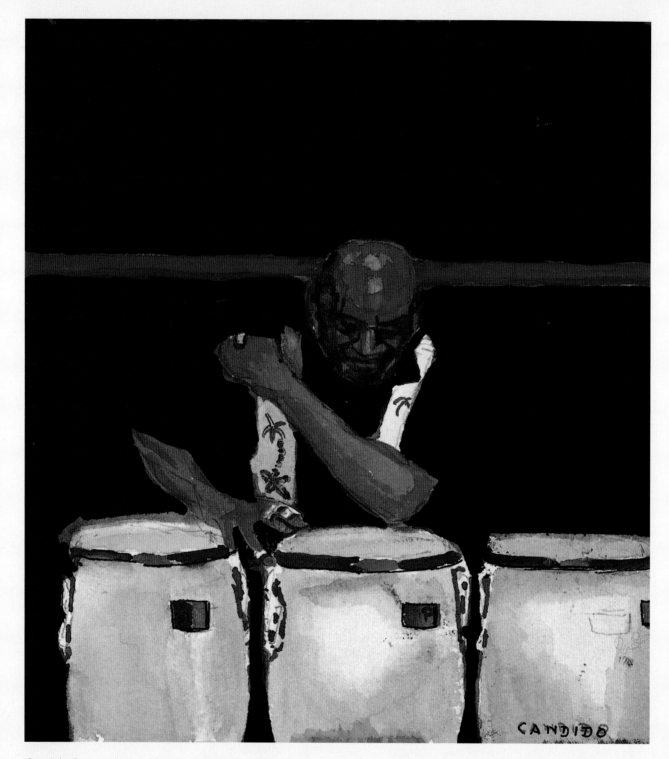

*Candido Camero,* watercolor on paper, 8½ x 7½ inches

In 1957, the same year Sharon joined him, Tony released an early and rather fantastic example of just how right Ralph was. Tony gathered together a band of all-star jazz musicians, anchored by the finest percussionists on the scene—Art Blakey, Candido, Jo Jones, Chico Hamilton—and recorded *The Beat of My Heart*, an album that endures today as a classic. The rhythmic colorations on that disc are, well, painterly. In evidence on almost every track is a technique Tony had started working on at the American Theatre Wing, one that now distinguished him from the pack. He would seek to imitate the sound of the instruments. His drill in the 1940s was to try to sing like Art Tatum's piano, or Getz's tenor sax. The effort loaned his singing a dynamic musicality that he shared with no one.

As Tony said, he could sing loud—it is still his habit to do one song in concert, often "Fly Me to the Moon" a cappella and without amplification, as an awesome demonstration of how a singer can project—but, loud as he was, he wasn't as loud as rock and roll. Elvis and Co. sent Bennett into modest eclipse, and as the 1960s dawned he was playing smaller venues—for instance, the Fairmont Hotel in San Francisco. In anticipation of a stint there in 1961, Ralph Sharon asked George Cory and Douglas Cross, two songwriting partners who had spent time in San Francisco in the fifties, whether they had anything that might

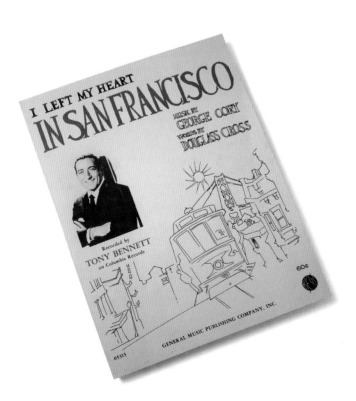

**Above:** *Pori Jazz Festival '98,* chalk on paper, 11¾ x 8¼ inches

**Left:** The General Music Publishing Company, Inc., published this sheet music for "I Left My Heart in San Francisco" in 1954; it sold for 60 cents at the time.

strike a Bay Area chord. "Well, we've got this seven-year-old tune called 'I Left My Heart . . .'"

Tony, who wears a constant half smile when it's not a full-blown grin, beams as he talks about that song. "Thank God I like it," he says, and laughs. "I don't think I've ever left it out of a show. I sing it every night." On the charts for a year, "San Francisco" sold more than two million copies and earned Bennett his first two Grammy Awards. He was back in the driver's seat for a ride that would last until the mid-1960s, as he and Sinatra and Cole and Como represented a sophisticated, still lucrative shadow presence behind rock.

EDDIE DAVIS
LOCKJAW

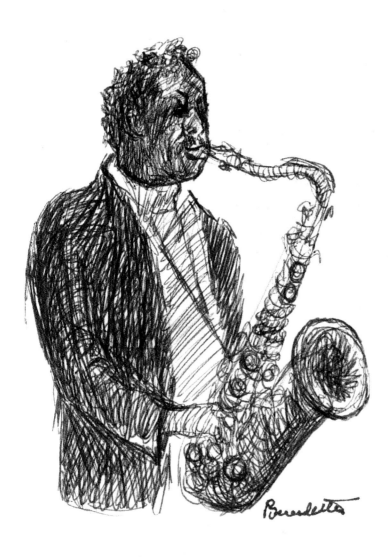

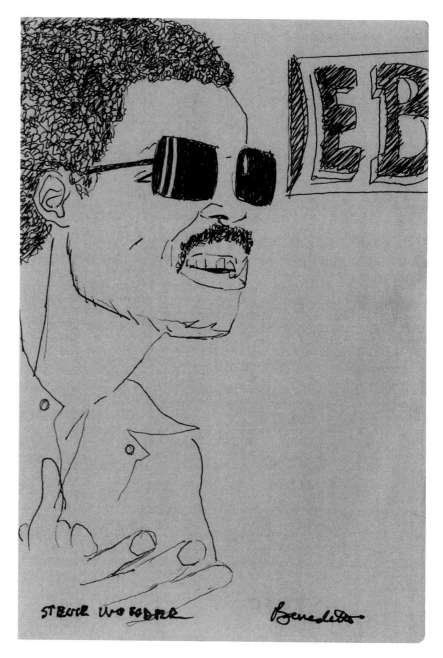

Above: *Eddie Davis,*
pencil on paper,
6 x 4 inches

Right: *Stevie Wonder,*
ink on paper,
7 x 4½ inches

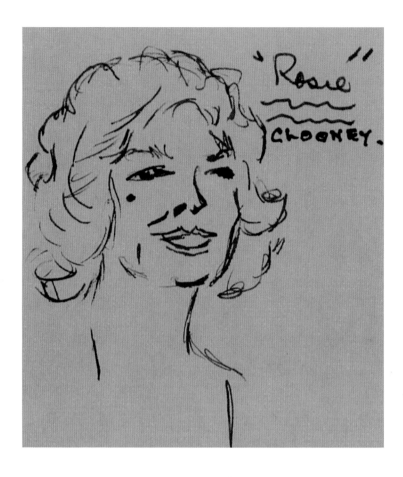

know, there were a lot of great ones. I happen to like Pollock. I understand him, I think. I see the universe in his paintings. There's a depth to it, in those circles and spillings. And when you look at the universe, it has that feeling. At night, without any lights, you look at the sky and you say, 'Wow.' The depth of it, and it's all very abstract.

"So I appreciate that kind of painting, but it's never been what I do."

His other principal recreation at home and on the road was always reading. "I love books," he says. "In my apartment I have books and books. I haven't read them all yet, but I'm working on it. I love the classics. Sometimes I'll read something, and it will move me to sing, or to paint—to express myself. As much as I love to read and admire great writing, I've never been able to write myself. A guy like Louis Armstrong wrote his own life story and it was magnificent. He was able to be himself. He had a gift with words. I don't have that gift, which in one way I regret.

TONY HAD, AFTER THE WAR YEARS and the scrambling years before stardom, gotten seriously back into the visual arts. Just as he used to draw his teachers and classmates, he took to doing portraits of other musicians in black-and-white. As he began to travel widely, he found it was a way to record what he was seeing and feeling. And it was calming in the way painting always had been for him. "I wasn't really studying painting in those days as much as just doing it," he says. "At one point I just got into sketching people on airplanes, in airports, in restaurants—people, people, people. I tried all kinds of different things, but it was always pretty much in the same style, the style I had developed.

"Sinatra was a painter, too, in those days. He was into that. He was abstract. His paintings were very good—academically correct, that kind of thing.

"It's funny, some of the teachers I've studied with, I asked them, What do you think of that kind of painting? The abstracts? One of them said to me, 'It's trickery.'" Tony laughs. "But, you

*Paris*, watercolor on paper, 12 x 9 inches

*Chianti, Italy,* oil on canvas, 30 x 24 inches

*Peninsula Hotel, Beverly Hills,*
watercolor on paper,
9¼ x 13 inches

*New York Still Life,*
watercolor on paper,
14 x 20 inches

*San Francisco*, ink on paper, 4 x 6 inches

*San Francisco*, ink on paper, 4 x 6 inches

"And on the other hand, I don't, because the urge to express myself goes into my paintings and my singing. I search for songs that will explain what I've learned about life and what I feel about life. And the paintings and drawings are kind of a visual diary. I've never kept a diary, although sometimes I wish I had. But then I think: I've sketched the diary."

Clearly an intelligent man, Tony has never been daunted by subject matter or style, and his taste in literature, as in art, is eclectic and wide-ranging. There are the Russian masters, and then, "one time," he recalls, "I was reading *The Autobiography of Benvenuto Cellini.*" Here he settles into yet another, very funny anecdote involving Sinatra. "Benvenuto was a sculptor in Renaissance Italy whose works were pure magic. Kings and popes from Italy and France demanded his works. Now, Benvenuto's father demanded true justice from everyone he encountered, and he passed this philosophy down to his son. Benvenuto would draw his sword and battle every hypocrite and phony who stood in the way of truth. It reminded me so much of Sinatra's plight that I once sent a copy of the book to him for his birthday. I inscribed it, 'If Shirley MacLaine's philosophy is right, you *must* have been this cat in another life.'"

*New York Still Life,*
watercolor on paper,
15 x 22 ½ inches

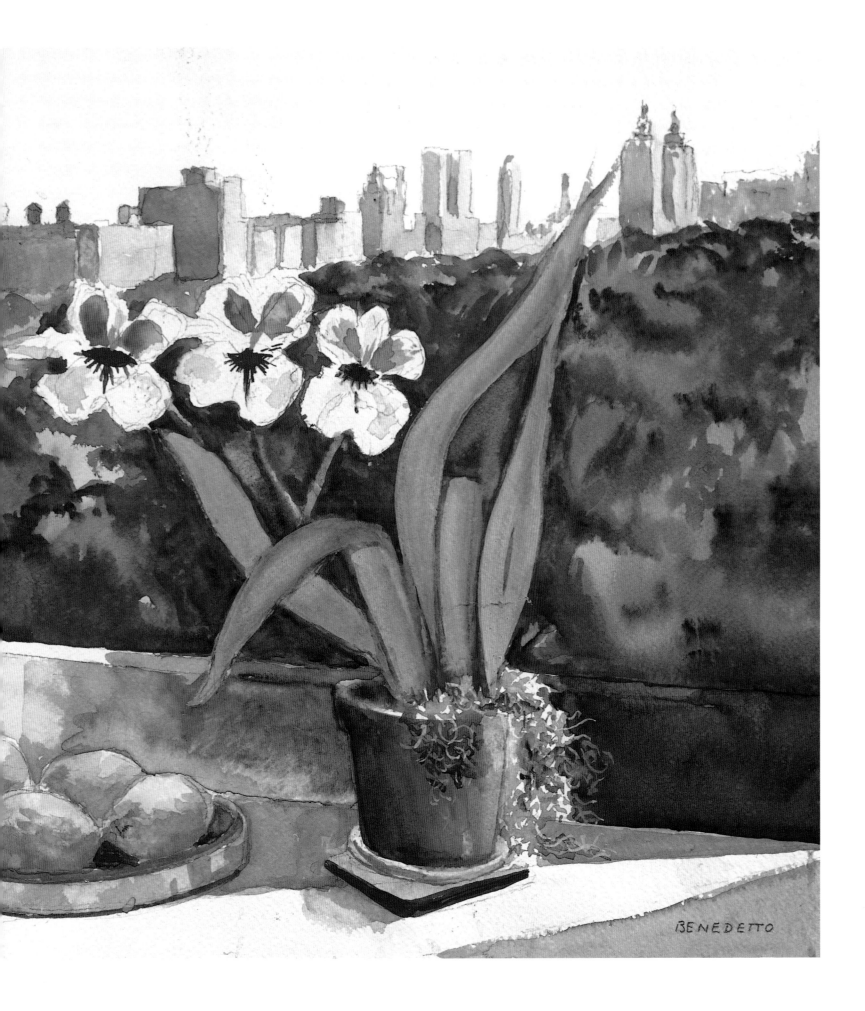

At one point during the lunch on the East Side, Tony paused, then made it clear that, as much as he loved the man, he wasn't part of Sinatra's gang. "I wasn't in the Rat Pack," he said. "I was in New York; they were out there. I had my singing and painting, and with the hours they kept—whoa!—it's just as well I wasn't in that scene."

He wasn't dissing Frank's friends when he offered the remark. I think the point he was trying to make was that he always went his own way. He's proud of that: following his intuition, making his own decisions, standing up to be counted in matters of consequence (as we will see in the next chapter). Tony leaned on others for advice, always, but whenever he took a step forward—or, sometimes, backward—he was rigorously his own man.

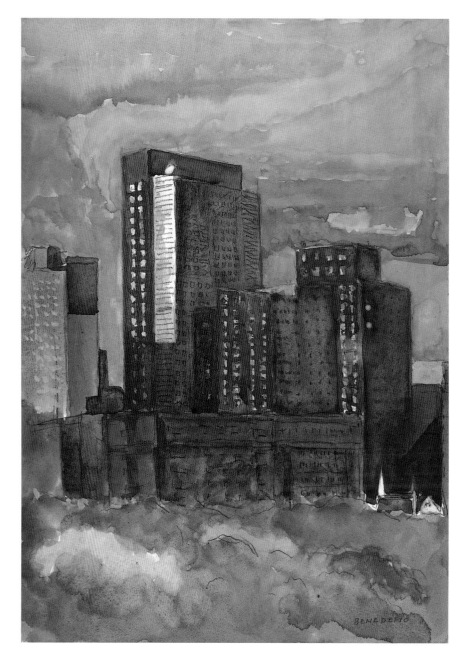

Above: *West Side Blues,* watercolor on paper, 20 x 14 inches

Opposite Page: *New York City Snowstorm,* oil on canvas, 28 x 22 inches

"I wasn't in the Rat Pack. I was in New York; they were out there. I had my singing and painting."

# BRIGHT LIGHTS

"I search for songs that will explain **what I've learned** about life and **what I feel** about life. And the paintings and drawings are kind of a **visual diary.**"

*Provence,*
watercolor on paper,
15 x 22 ½ inches

*Castle de Ruffo,*
*Reggio di Calabria,*
watercolor on paper,
11½ x 14½ inches

*Cipriani, Venice,*
watercolor on paper,
11¾ x 15 inches

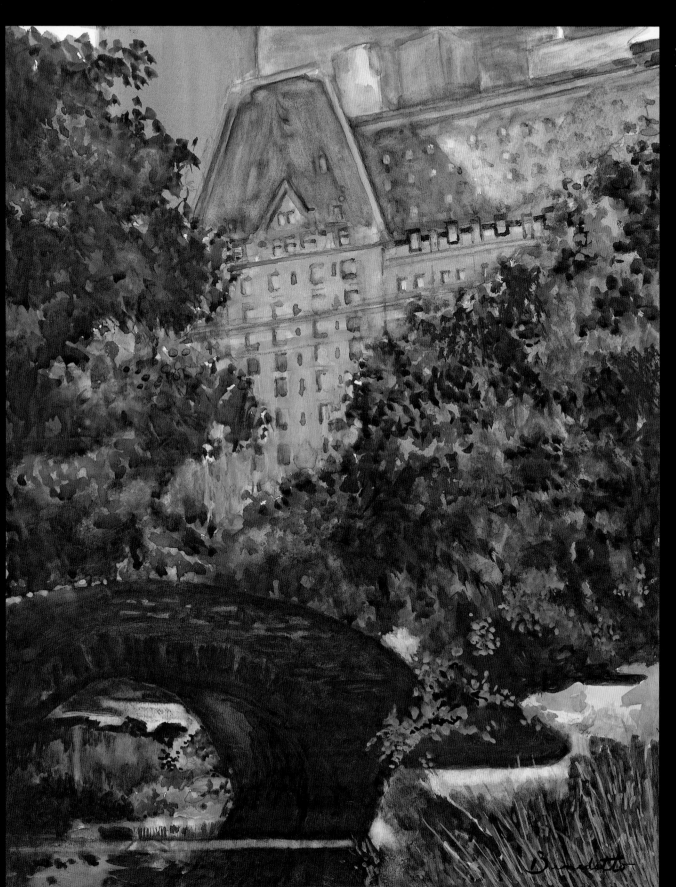

*The Plaza,*
watercolor on paper,
14 1/2 x 11 1/2 inches

*Palmilla, Los Cabos,*
watercolor on paper,
15 x 11 inches

PALMILLA
LOS CABOS
MEXICO
BENEDETTO

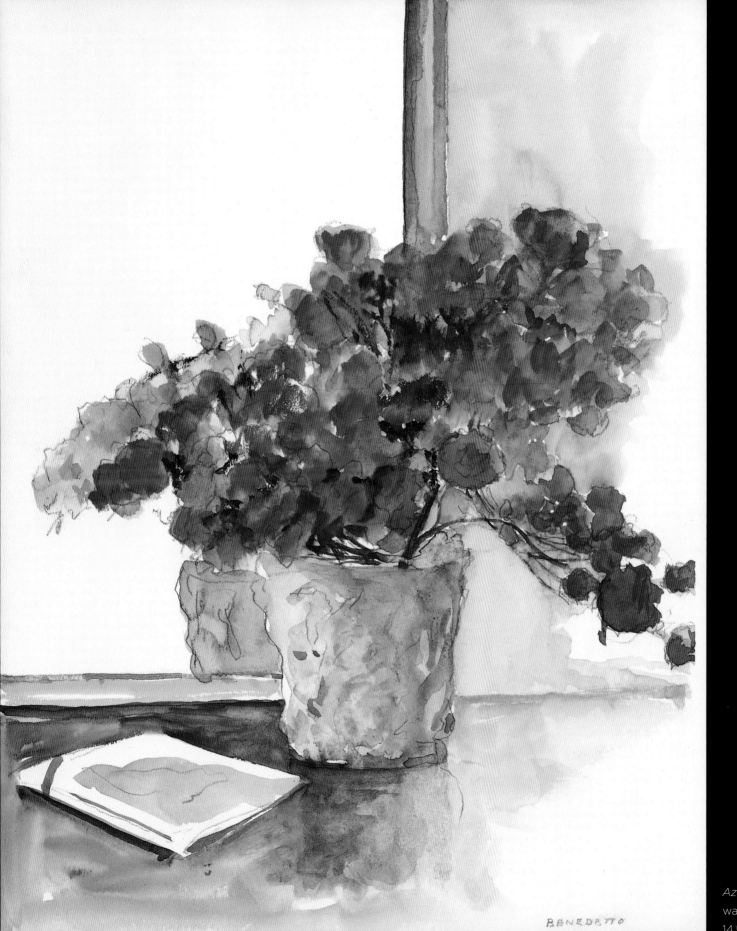

BENEDETTO

*Azaleas,*
watercolor on pape[r]
14 ½ x 11 ¼ inches

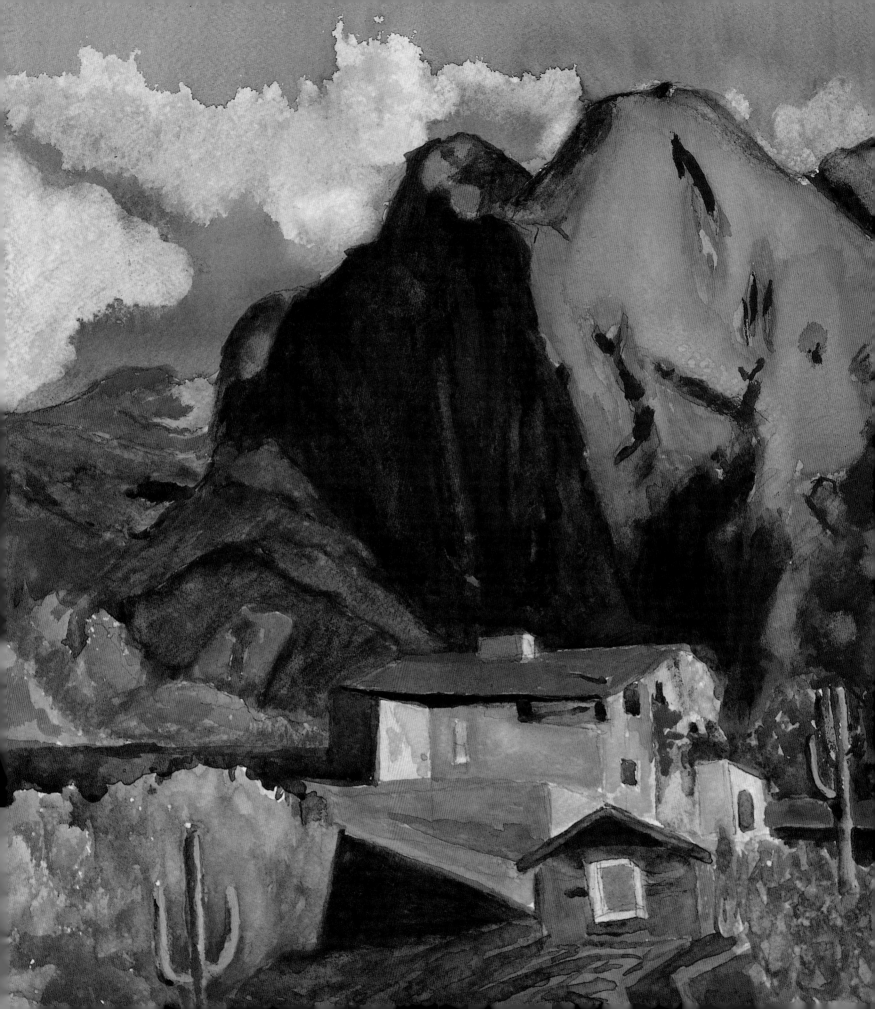

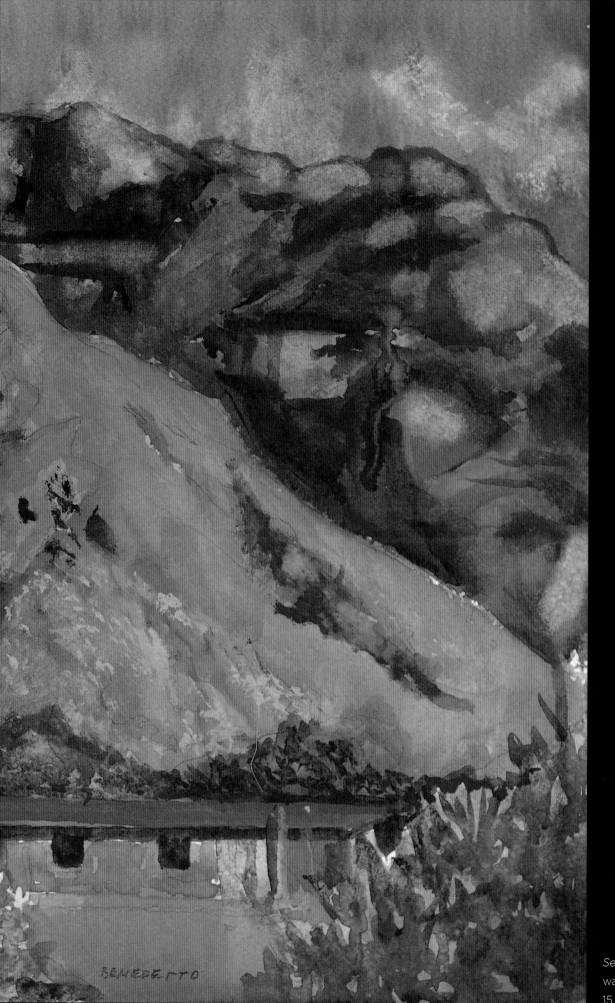

BENEDETTO

*Sedona,*
watercolor on pa[...]
15 x 22 inches

*Estoril, Portugal,*
watercolor on paper,
11½ x 15 inches

Portugal, Benedetto

Chiaroscuro

# "Allen Ginsberg was a very interesting cat. I like him very much."

At the same time that I was profiling Tony in 1994 for *LIFE*, I was also assigned to interview another Comeback Kid. Of all people: Allen Ginsberg. I happened to mention this to Tony at the time. Toward the end of our meal at the Metropolitan Museum of Art, there came a brief lull in the conversation. Searching to fill dead air, I offered irrelevantly, "Tomorrow I'm seeing the poet Allen Ginsberg."

"Allen Ginsberg," Tony said in that raspy voice, his narrow eyes all but closed, "was a very interesting cat. I like him very much. Met him long ago at a party in the Village for Franz Kline. We hit it off. I had been looking for this art book and Allen told me where to find it, a dealer named Bill ——." Tony remembered the last name, but I don't. "I called the guy up and got the book.

"Allen was into Blake. We talked about Blake. I was trying to put some Blake poems to music, and so was he.

"Tell Allen I said hi. Interesting cat, Allen."

**Previous Pages:** *Sunday in Central Park*, oil on canvas, 36 x 60 inches

**Right:** *Winter in Central Park*, watercolor on paper, 9¼ x 12¼ inches

**Opposite Page:** *New York Rainy Night*, oil on canvas, 30 x 24 inches

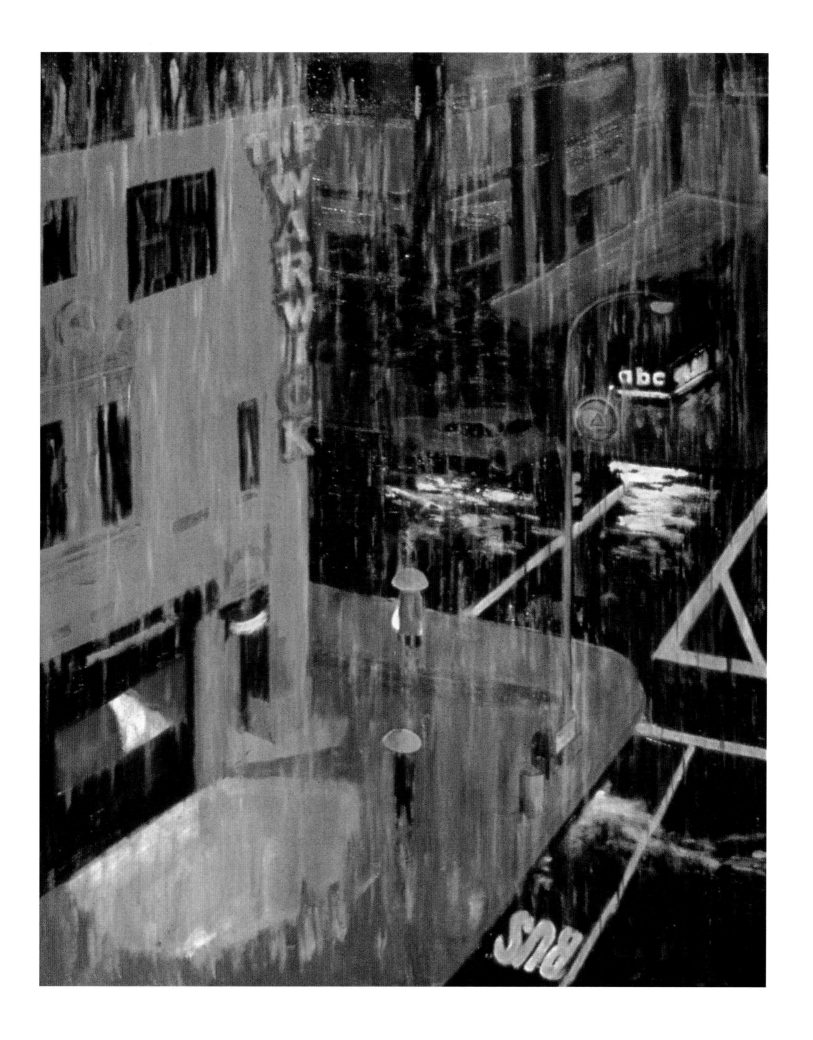

# "Well, I like Tony Bennett. Very interesting man, Tony Bennett."
## —Allen Ginsberg

As Tony's limo drove south through Central Park later that evening, past the twinkling lights of Tavern on the Green, he was humming a tune. What a lovely afternoon it had been, I reflected, as I prepared to shift mental gears to a subject quite different (or so I thought): Allen Ginsberg.

The next night it was bitterly cold as I walked against a gale to the Lower East Side brownstone where Ginsberg had lived for years. My fingers were frozen as I pushed the button and heard a voice bark something through the crackling. The front door was broken and open; I made my way in, then up several flights of stairs. Steps needed fixing and walls needed paint; the place did not feel safe. It all could not have been farther from my experience at the museum the evening previous.

Ginsberg's apartment door was open. I knocked gently and heard him mumble something. I entered and saw the poet seated at his mean kitchen table eating a bowl of soup. Dishes were piled in the sink; the place was thoroughly cluttered. Of course, it was interesting: Books were everywhere. Stuff was everywhere: junky furniture, posters, strange pictures. On one wall was a framed copy of Blake's "The Tyger" and on another was a Buddhist prayer wheel.

"Sit down," Ginsberg ordered. I knew that he considered the interview an art form, a competition, a duel, and I knew we had begun. I sat as he ate, declaiming while he did so about one outrage or another—the CIA and Nixon came up, I remember—then, finally, pausing to see whether I had been provoked. Whether I might flinch.

*Still Life,* watercolor on paper, 15 x 11 inches

I realized that of all the world's interview subjects there were few less vulnerable to being softened up by small talk than Allen Ginsberg, yet I had an assignment from Tony.

"Tony Bennett says hi."

"Tony Bennett," said Ginsberg in that acute staccato he had. "Tony Bennett. Tony Bennett. I met him at a party for Franz Kline." Remarkable, I thought. It's all true, and they both remember. "He was very much into Blake. Do you know Blake visited me in a vision in 1948? In Harlem? He did.

"Tony Bennett said he was putting Blake to music and I told him there was no need—I'd already done it myself." I suppressed a smile as I mused that Ginsberg's chanting might not fill the void for Tony's fans.

I said to Ginsberg, "Tony said thanks for the book. He found the book through your friend. . . ."

"Bill —." Ginsberg, too, remembered the name, but I don't. "Well, I like Tony Bennett. Very interesting man, Tony Bennett."

I was somewhere between amused and (to use the old phrase) freaked out by this. *Allen Ginsberg and Tony Bennett?* Where's the nexus in that? Where does the unkempt beatnik meet the tuxedoed balladeer?

But then, as I got deeper into my research for those 1994 articles, the association became simultaneously more sensible and more bizarre. They had been born in precisely the same year, and they grew up, these two boys, on the other sides of New York City rivers, gazing at bridges, dreaming Manhattan dreams. One was from Astoria, Queens, and the other from Paterson, New Jersey.

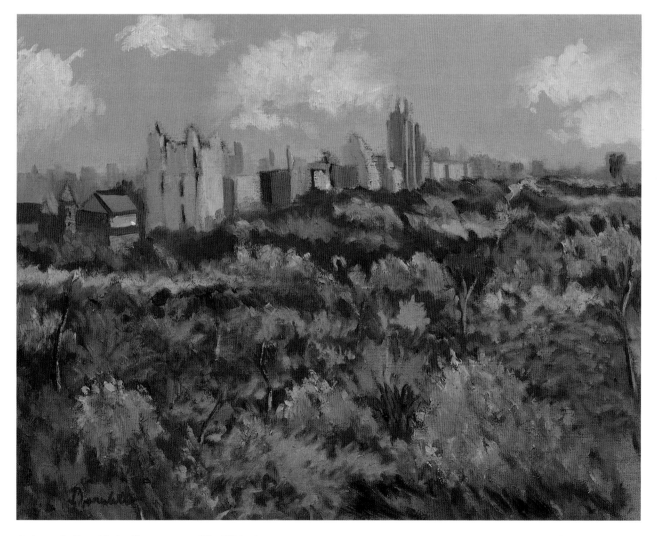

*Autumn in New York,* oil on canvas, 16 x 20 inches

**Right:**
*Autumn in Central Park,*
watercolor on paper,
10 ¼ x 14 ¼ inches

**Below:**
*Christmas Eve in Central Park, 1998,*
watercolor on paper,
10 x 14 inches

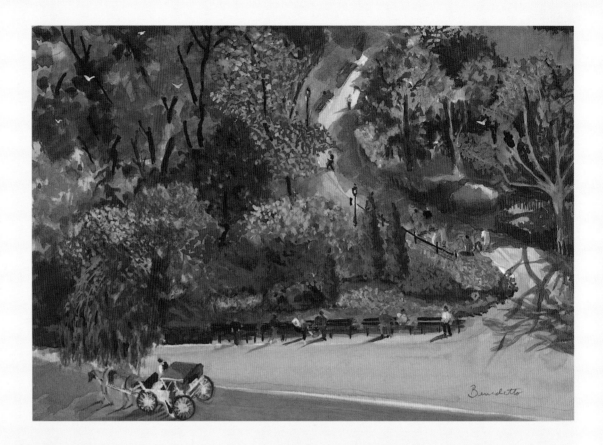

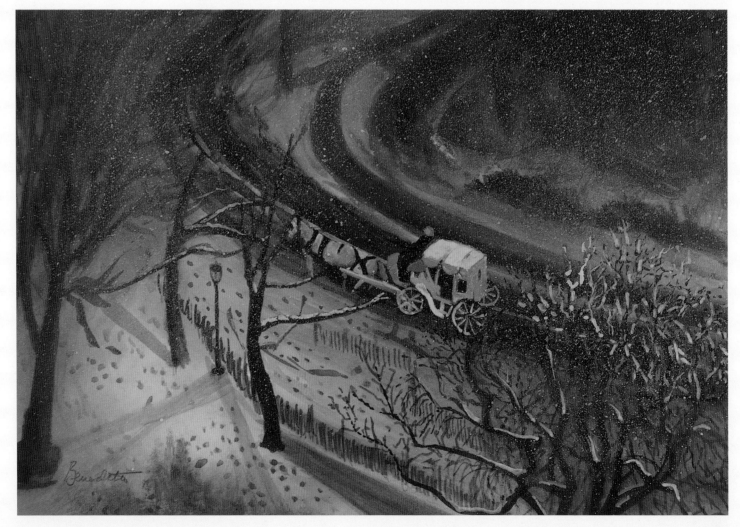

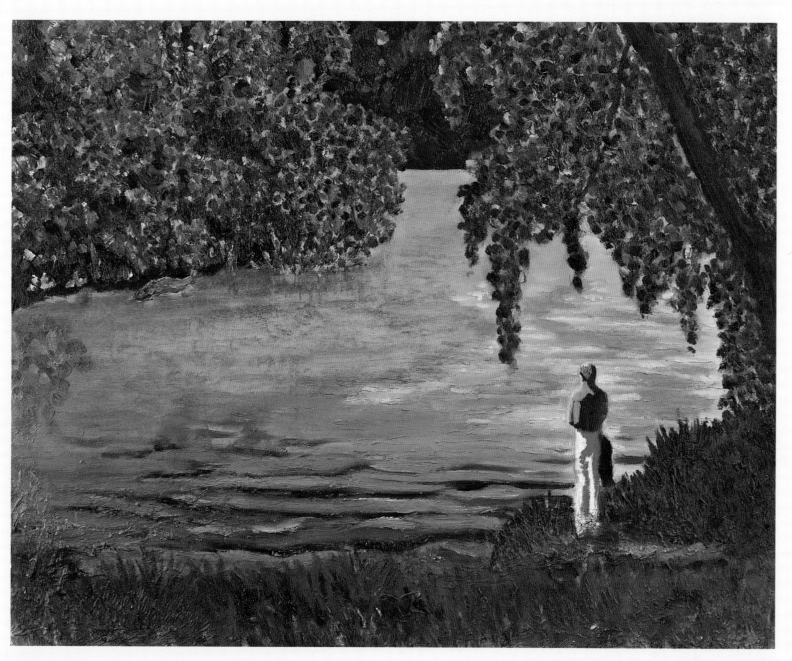

*Summer in Central Park,* oil on canvas, 24 x 30 inches

# There is and always has been a well-known Tony and an unexpected Tony.

They had made it there, in New York, going to school in town, finding a first rush of excitement and a first blush of success on the never-sleeping streets of the postwar city. Then, like so many young men, they went west. In the Bay Area, that well-watered garden of hipness, they seized greater notoriety—in fact, became branded by the town, as seminal works they created while there became, for their millions of followers, anthems. The 1950s became the 1960s, and their arts and minds expanded.

They were each very, very cool—to their own very different audiences.

The 1960s belonged to a generation younger than their own, but since they were smart, concerned, engaged men, they attached themselves. One boosted Buddhism well before it entered the Zeitgeist; the other went south and marched with Martin Luther King Jr. As the decade progressed and gave way to the next, they found themselves in and out of fashion. They were back in New York now, soldiering on, wondering at times whether the times had passed them by.

Each of them enjoyed a marvelous, century's-end renaissance, with retrospectives of their life's work bringing fresh applause and new celebrity. Books and box sets sold in quantity; gigs were sold out. A generation behind even the boomers came to appreciate these aging hipsters, these ever-cool cats.

Tony continues to thrive, of course. Allen did until his death in 1999 at age seventy-three.

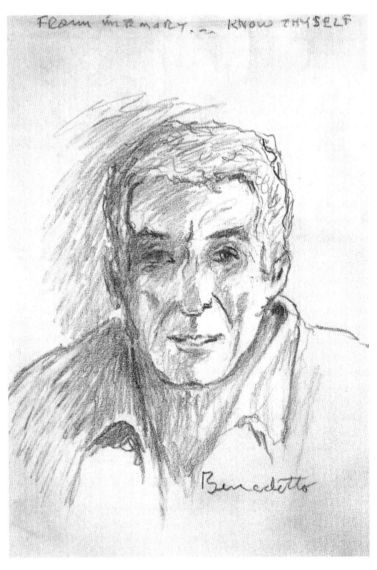

*Self-Portrait from Memory . . . Know Thyself,* pencil on paper, 5½ x 4 inches

THE TONY BENNETT SHOW
RUNDOWN

| | INDIVIDUAL TIMINGS | ACCUMULATIVE TIMINGS |
|---|---|---|
| 1. OVERTURE | 1:45 | |
| 2. "WHO CAN I TURN TO" | | |
| 3. TITLE AND BILLBOARDS | | |
| 4. COMMERCIAL NO. 1 | | |
| 5. "I CAN'T GIVE YOU ANYTHING BUT LOVE" *WHEN YOURE SMILING* | 2:20 | |
| 6. "THE SHADOW OF YOUR SMILE" (with Paul Horne) *BECAUSE OF YOU* | | |
| 7. "ONE FOR MY BABY" "IT HAD TO BE YOU" (with Bobby Hackett) "ONE FOR MY BABY" - (Reprise) | | |
| 8. "IF I RULED THE WORLD" *SHADOW OF YOUR SMILE* | | |
| 9. "SING YOU SINNERS" | | |
| 10. "BECAUSE OF YOU" *IF I RULED THE WORLD* | | |
| 11. "FASCINATING RHYTHM" (with Buddy Rich) | | |
| 12. COMMERCIAL NO. 2 | | |
| 13. SAN FRANCISCO SEGMENT "SAN FRANCISCO" "JUST IN TIME" "TASTE OF HONEY" "ONCE UPON A TIME" "SAN FRANCISCO" (Reprise) | | |

In April 1966, Tony Bennett appeared in a television special called *The Singer Show: Tony Bennett Presents;* here we see a typed song rundown for the show with notes from Tony about possible song changes.

What does this all mean? Well, for me, it has always meant that Tony, to be fully considered, should be considered in context with such as Ginsberg as well as such as Sinatra. He has never been a hanger-on. He's been a floater, and an ecumenist. In the art world, which he calls his "favorite fraternity"—a band of brothers even more welcoming than the society of singers of the fifties—he met Allen Ginsberg. And he liked him. Tony knows whom and what he likes, and he knows what he cares about, and appearance, orientation, and expectation matter to him not a whit. Sometimes this has helped forward his career—his life— and sometimes it has not.

Tony surprises you at many turns. The Ginsberg thing certainly surprised me. And consider: The early 1960s songs he is most closely associated with—"San Francisco," "The Best Is Yet to Come," "The Good Life," "I Wanna Be Around"—certainly are fine, but just as important to that period in his life, as we will now see, was "We Shall Overcome."

There is and always has been a well-known Tony and an unexpected Tony. This is, to a degree, what happens to any public personality through marketing, image enhancement, promotion. We think we know the famous person, and then we see, hear, or sense something, and we're forced to reconsider. Any single individual is too complicated to be simply a fulfillment of the image. A complex individual such as Tony (or, for that matter, Allen) is too complicated in spades.

Tony was, by the 1960s, a very famous man. He had an ample collection of greatest hits and he sung them nightly in Vegas or at the Fairmont or in Carnegie Hall—at that legendary forty-five-song concert in '62. People who were there that night still remember the thrill, all these years later.

But there was more to the life than performance. There were other things that mattered, deeply, to Tony Bennett.

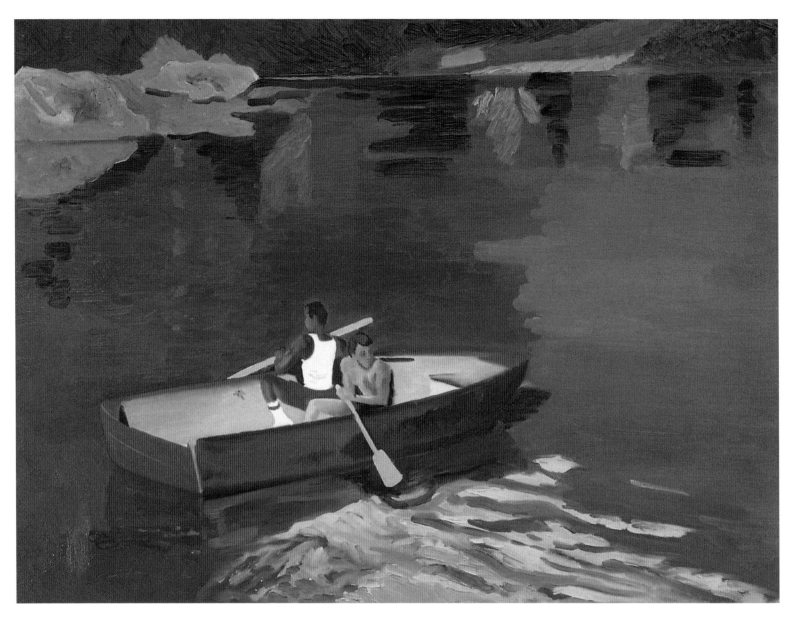

*Brotherhood,* oil on canvas, 30 x 40 inches

A STEP BACK, FOR JUST A MOMENT, to Thanksgiving 1945. Tony is stationed in Mannheim, Germany. He's made the rank of corporal in Special Services, and his assignment is, essentially, to sing with the band. Tony is walking the streets that Thanksgiving afternoon and, rather remarkably, he bumps into Frank Smith, a fellow serviceman but also an old buddy from the School of Industrial Art back in New York City. Frank is a singer, too; he and Tony used to harmonize. "I couldn't believe it, Frank Smith in Mannheim, Germany! I was thrilled."

So was Frank, and he takes his old friend to Thanksgiving services at a Baptist church he's found. Tony, in turn, invites Frank to join him for the special holiday meal—no C rations today—back at the mess. The two of them get as far as the lobby. An officer in Tony's company approaches in a fury, shouting, "Get your gear; you're pulling out of here!" He takes out a razor, cuts Tony's corporal stripes from his shirt, throws them to the ground, spits on them, and continues in his rage: "Get your ass out of here! You're no longer a corporal; you're a private again!"

The demotion sticks, for Tony indeed has been caught in blatant defiance of a military rule that is in full force in the European theater. Frank Smith is black, and the mess hall is segregated. Yes, Tony would have been allowed one guest for Thanksgiving dinner. No—no way—could it be a black man.

Tony's role in that drama may not have been so wholly benign as it is presented here; it's hard to believe that the argument with the officer was a one-way exchange, and very easy to believe that Tony offered a piece of his mind about army policy. For if there is a signature issue intrinsically, almost instinctually important to this man, it has always been equality. Civil rights. "No question, that incident changed my life forever," he says today. "Frank Smith was just a wonderful guy, and then that ridiculous thing happened—a human nightmare is what it was. I was ready for the change, and that did it. To have that happen in the army, where you're supposed to be fighting against injustice, ridiculous."

What had readied him for the epiphany surely had to do with growing up poor and Italian in the melting pot that was Depression-era New York, but also, in music and art, talent is color-blind. He had, even by 1945, lived in the worlds of music and art for a good little while. Tony could hear that Art Tatum was the greatest of all jazz pianists, and that Louis Armstrong and Duke Ellington were among the foremost musical titans of all time. And then later, as the first white singer to perform with the Basie band, and when he got to know these men—and Ella and Dinah and the other women, too—and they turned out to be kind and generous and a lot of fun . . . Well, then: The rationale for bigotry is what?

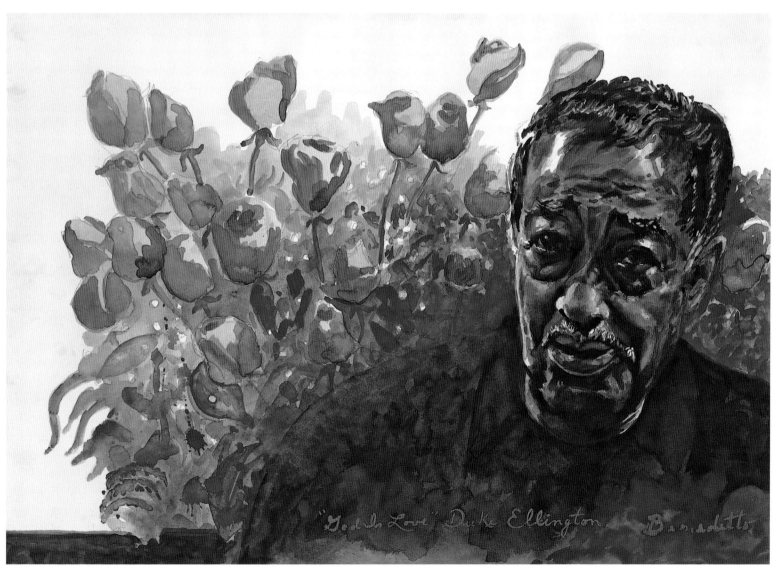

*Duke Ellington, "God Is Love,"* watercolor on paper, 14 x 20 inches

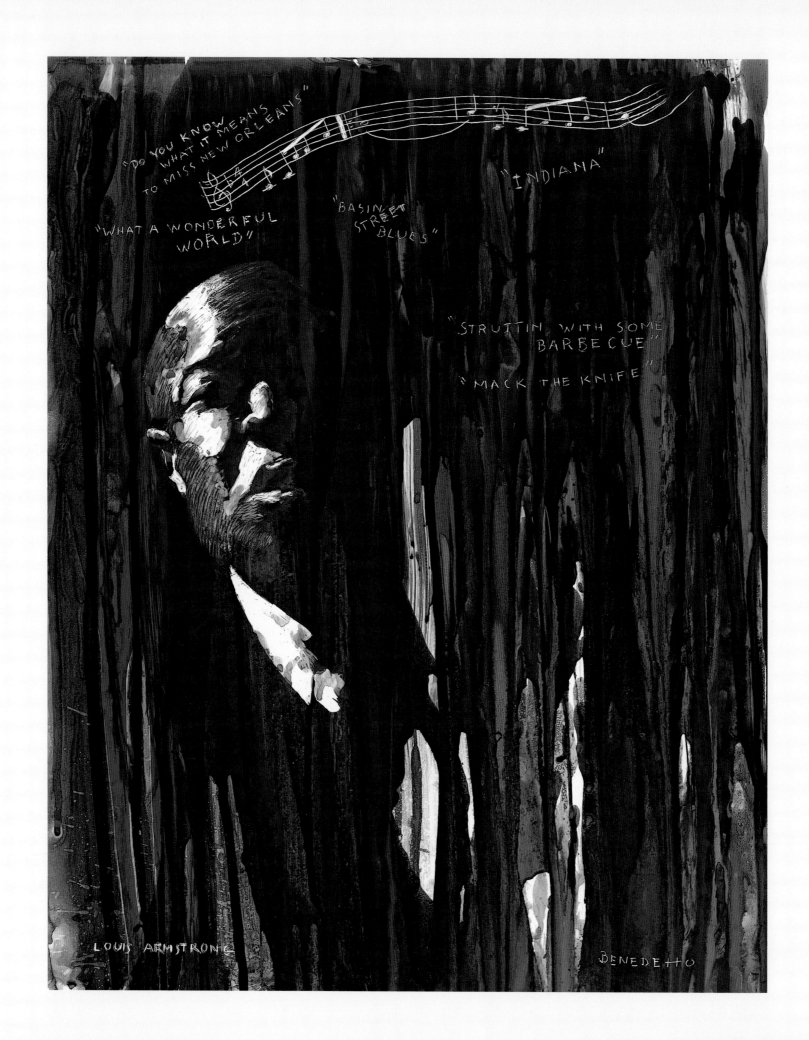

Discrimination simply never made any intellectual or ethical sense to Tony, and when he saw a chance to act on this thinking, he seized it. This got him busted by the brass in 1945, and it got him traveling south of the Mason-Dixon Line two decades later.

He had, of course, been shocked by the assassination of President Kennedy in November of 1963. This had spurred him to pay more attention to politics than had been his habit. He still today doesn't consider himself "a political person," but back then, as a man with many black friends and associates, he was pre-sensitized when the question was one of fairness. He read about what was going on in the South—the lunch counter sit-ins, the hosings, the killings—and he thought about more subtle things he had witnessed. He had had to visit his friend Nat Cole backstage rather than in the café after shows. He'd had to watch as, after a performance, the orchestra of his friend Duke

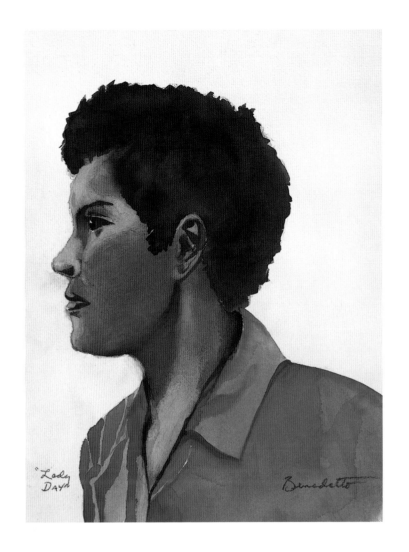

Ellington left the grand hotel in Miami where they had just played sensationally in order to bunk off-site at a crummy motel. "These things went beyond politics," Tony says. "Nat and Duke were geniuses, brilliant human beings who gave the world some of the most beautiful music it's ever heard, and yet they were treated like second-class citizens. The whole situation enraged me." And so: "When Harry Belafonte called me up and asked me to join Martin Luther King's civil rights march to Selma, Alabama, in 1965, I accepted."

Opposite Page: *Louis Armstrong,* scratchboard and gouache, 20 x 16 inches

Left: *Pearl Bailey,* ink on paper, 5 x 3 inches

Above: *Billie Holiday, "Lady Day,"* watercolor on paper, 16 x 11½ inches

*Stevie Wonder,*
pencil on paper,
7 x 5 inches

BENEDETTO

King was trying to attract attention, certainly, and so the presence of celebrities such as Bennett, Sammy Davis Jr., Shelley Winters, and Leonard Bernstein only helped. "I remember on the march, I noticed Jilly Rizzo, Sinatra's right-hand man, marching right next to me," Tony recalls today. "I said, 'Jilly, what are you guys doing here?' I looked at him, and I see he's got these brass knuckles on. He's wearing them! And he looks at me and says, 'Just in case any of these guys want trouble.' And I say, 'Jilly, this is supposed to be a peace march!'"

Despite the humor of that recollection—and as Jilly's precautionary measures suggest—it was hardly fun and games on the march. The threat of violence was constant, the mood ever ominous. When Tony and others performed for the protesters that night, they did so on a makeshift stage built of coffins.

It is interesting, then, when you look at 1965 and thereabouts: Dylan, Baez, Seeger, and others were singing about equality, and certainly they cared about it and were often active in the movement. But so was Tony Bennett. When Stevie Wonder handed Tony his Century Award at the Billboard Music Awards in December 2006, he stressed this. *My friend, Tony Bennett,* Stevie said, *had been there early, earlier than most, and has stayed the course ever since.* Stevie, who thinks the world of Tony as a singer, barely mentioned Tony's singing career—which, ostensibly, was what the trophy was about.

**Left:** *Jimmy Rushing,*
watercolor on paper,
22 x 15 inches

**Below:** *Ted Curson,*
chalk on paper,
8¼ x 11¾ inches

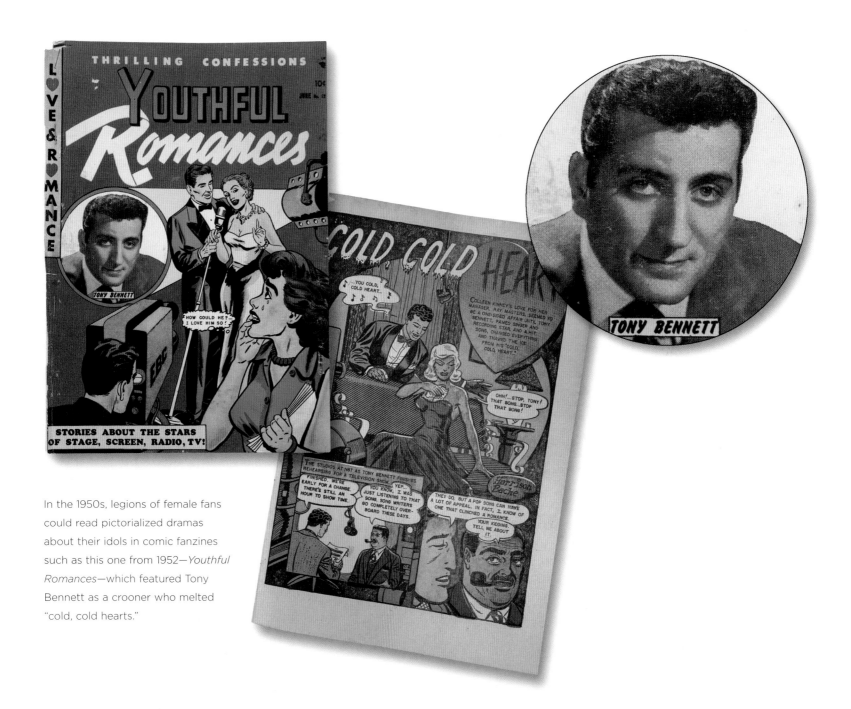

In the 1950s, legions of female fans could read pictorialized dramas about their idols in comic fanzines such as this one from 1952—*Youthful Romances*—which featured Tony Bennett as a crooner who melted "cold, cold hearts."

IN THE PERIOD OF EARLY STARDOM that was the 1950s and early 1960s, Tony's principal concerns were his career, his cause, his friends, and, certainly, his wife and kids. He had come from a tight and loving family unit, and he wanted one for his children.

At a club date in Ohio in 1951 he had met a fan who loved talking about jazz and aspired to attend art school. Tony courted Patricia Beech from afar, then urged her to move to New York. It's an often-told story that when Tony and Patricia married at St. Patrick's Cathedral in 1952, a substantial horde of teenyboppers turned up in black veils to mourn the loss of their idol. What is not usually part of the anecdote: Tony was not amused, and Patricia was near tears as she struggled to get through the mob and up the stairs of the cathedral. There's a story behind the story. Originally, Tony and Patricia had planned to wed on February 11, but Tony's manager, Ray Muscarella, who had been against the marriage from the first, worrying about its effect on Tony's heartthrob image, urged them to move the date back a day. February 12 was Lincoln's Birthday, and Muscarella was able to round up hundreds of high school girls on holiday for his publicity stunt; he supplied the mourning veils himself. Patricia never forgave him, and Tony wrote in his memoir, "Ray's attitude toward Patricia was one of the major reasons that Ray and I eventually split." That split would come in 1955, when Ray was replaced by Tony's

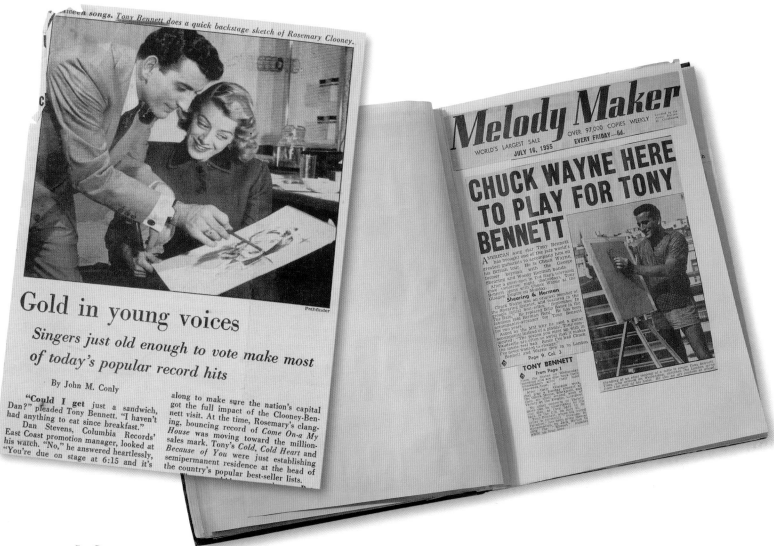

Above Left: *Pathfinder News Magazine*, a former Washington, D.C., periodical, ran this feature on Tony Bennett and Rosemary Clooney during a week-long tour visit at the Loew's Capitol Theater. The photo shows Tony doing a quick sketch of "Rosie" backstage before a performance.

Above Right: The July 1955 issue of British industry magazine *Melody Maker* announced that the jazz guitarist Chuck Wayne would accompany Tony on his British tour. Tony is shown "standing at an easel instead of a mike . . . [sketching] the London scene from the roof of his hotel."

*Danny,*
ink on
paper

sister, Mary—the first but notably not the last time that Tony would put his career in the hands of kin.

Patricia and Tony's first boy, D'Andrea, was born in 1954, and when Tony heard his wife calling the baby Danny, he loved the sound—it reminded him of Art Tatum playing "Danny Boy" so beautifully at a nightclub years earlier. At three weeks old, Danny, who is today his father's manager (and we'll get to that), hit the road with his parents. "I was determined that we stay together," says Tony. Patricia agreed.

# Tony made sure to have rooms in the basement designated for music and painting.

Danny's brother, Daegal, was born in October of 1955, and at that point it was decided that Patricia should be home with the boys when Tony toured. The Bennetts moved to the burbs of New Jersey, eventually building a house in Englewood—a town where today Daegal, who serves as engineer on many of Tony's discs, runs a recording studio, aptly named Bennett Studios. The house was designed in the Frank Lloyd Wright style, and Tony made sure to have rooms in the basement designated for music and painting. His big hope for the house was that it might "do Patricia and me some good." The constant separations forced by his career had seriously damaged their relationship, and Tony was realizing that you can't fulfill all your dreams just by dreaming them. He wanted the solid family life he remembered from Queens, but he too often was not there to make it happen.

Patricia and Tony separated under the strain, though he was determined to find a way to remain an important part of his sons' lives—something he has clearly been able to do.

This photograph of Tony with his sons Dae (left) and Danny (right) was taken in 2004 during a recording session for *The Art of Romance*, at the Bennett Studios in Englewood, New Jersey.

Below: *Bennett Studios*, ink on paper, 14 x 20½ inches

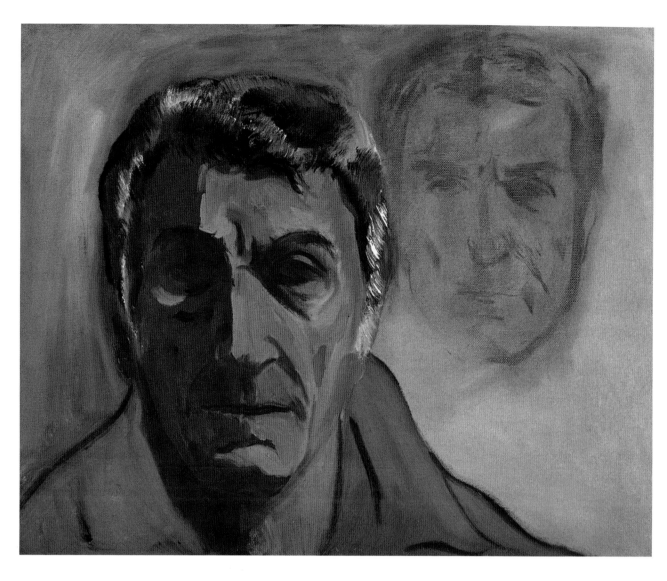

*Self-Portrait—
Two Faces,*
oil on canvas,
18 x 20 inches

In looking at the Zen of Bennett, you have to look at moments such as Christmas Eve 1965. A depressed Tony Bennett is spending a long, lonely night at the Gotham Hotel in New York City. In his life he has known thrilling highs and deep lows, but he's never been down like this before. The thirteen-year marriage is ending; his wife and two boys are at home, together for the holidays; he is in a hotel, desolate. Careerwise, too, things are less than aces. While he can still get a gig whenever he wants, he senses that, with rock growing ever more dominant, his music is slipping out of style. To Tony, at only thirty-nine, the future is feeling bleak.

He doesn't have to be here, alone in his room. He could be out; he could be enjoying some music. Tony's close friend Duke Ellington, whose orchestra has backed Bennett on many an occasion, is conducting the Sacred Concert only a few blocks away. That would be one way to capture some spirit on this cold Christmas Eve. But Tony just can't pull himself from the hotel.

He tries to sleep, but it is a fitful effort. Suddenly, he hears a noise. Figuring he's left the television on, he gets up to turn the switch. The noise continues; it's coming from the hall. Tony opens the door, and there stands the chorus from the Sacred Concert singing "(On a Clear Day) You Can See Forever." Ellington, having heard from famous drummer Louis Bellson that their good friend Tony was seriously in the dumps, has dispatched the singers for a private serenade.

"Wonderful gesture," Tony remembers now. "But that night was as bad as it gets."

Yes, it was—but two other episodes occurring at roughly that point in time would return, again and again, to point the way back to the heights.

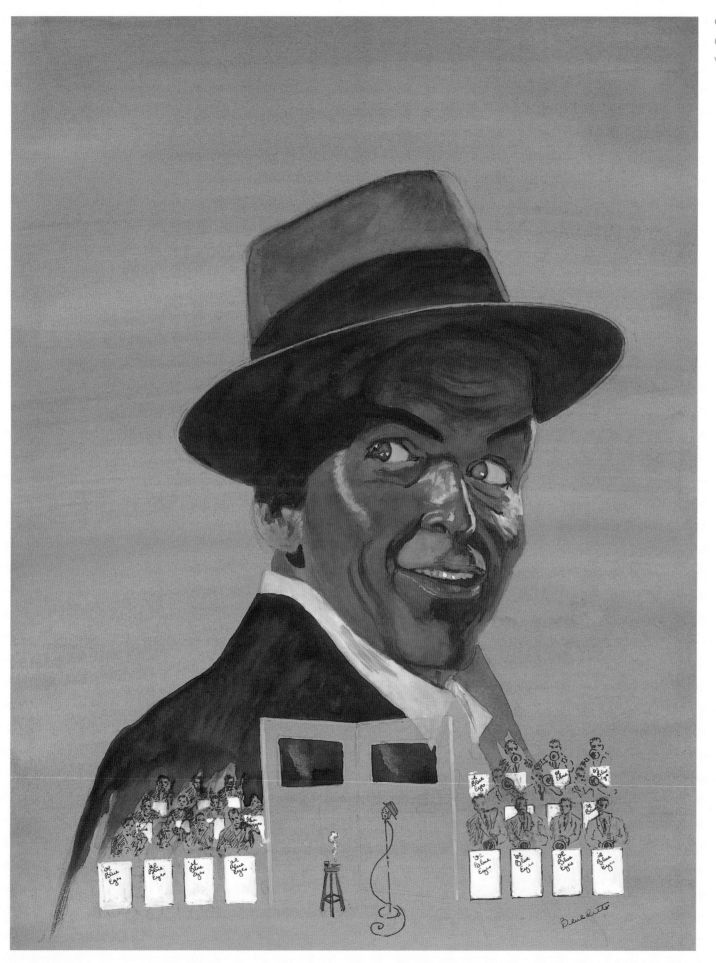

First, in a 1965 article in *LIFE*, Sinatra said the following: *For my money, Tony Bennett is the best singer in the business. He excites me when I watch him. He moves me. He's the singer who gets across what the composer has in mind, and probably a little more.*

"That quote would change my life," says Tony today. "Frank was always such a generous man."

What he gave Tony, in this instance, was a lifelong billboard. He bequeathed authorized status as a great among greats. Sinatra fans were now Bennett fans—forever. And when the music of Sinatra and Bennett would return to the fore, as certainly it must one day, the fans would recall what the Chairman had decreed.

Tony, the inveterate listener, the man who takes advice seriously, recalls the second episode. It happened a few years later, after Tony was remarried, to Sandra Grant, and had become the father of two lovely girls, Johanna and Antonia. It was

*Johanna,* oil on canvas, 26 x 20 inches

*Antonia,* watercolor on paper, 15 x 11 inches

the early seventies, and rock music was thundering throughout the land. Tony, who had been drained by the constant battles with the then-new Columbia Records president, Clive Davis, over Davis's insistence that his traditional pop artists cover contemporary chart-toppers (don't ask Tony about the album *Tony Sings the Great Hits of Today!*), had finally walked away from the label. "I left Columbia for one reason: They were forcing me to sing contemporary songs, and I just couldn't stand it," he says. "I actually regurgitated when I made that awful album— I got physically sick. You see, show business is a game. Everybody plays a certain game. My game—what I gravitated to intuitively— was to try to do definitive versions of popular songs. I just love a well-made popular song. If I really adore a song, I just get into the creative zone and try to get the definitive version of the song that would make the composer feel magnificent. Where he would

say, 'That's what I was trying to convey.' And Columbia wasn't letting me do that anymore."

So he left the label, and now he was wondering whether he should shift gears altogether, maybe even get back into film acting, in which he had briefly dabbled.

Tony picks up the tale: "It's gonna sound like I'm name-dropping here, but I'm not; I hope you realize that. This is about Cary Grant. Some of the best advice I ever got was from Cary Grant. As I said, I had done a little bit in movies, and I was asking him what I should do in the future. Here he was, this handsome man—the handsomest man in the world. He said to me, 'Don't do films. It's so boring on a set. You love to sing and paint. Follow your passion; those are your passions. Go travel the world, and become the best entertainer. You make people feel great—you're alive, they're alive! Sing! Paint!'

"And it's Cary Grant, right? So I thought I may as well listen.

"I just started working live shows all over and kept at it, and look what happened!"

*Cary Grant,* oil on canvas, 24 x 20 inches

*Still Life New York,* oil on canvas 20 x 16 inches

*Boo,* oil on canvas, 8 x 10 inches

THE CONVERSATIONS FOR THIS BOOK were conducted in early 2007 in Tony and Susan's magnificent apartment on Central Park South. It's fifteen floors up, and the view of the park as it extends north toward the horizon is stunning—just as stunning as the one from the Trustees Dining Room at the Metropolitan Museum of Art. The apartment itself is handsomely decorated without the least ostentation. Tony's studio where he paints is suitably disordered, as several works are always in progress.

Tony was, of course, a perfect host, generous with his time and consideration. We sat at opposite ends of a comfortable couch, the tape recorder running on an adjacent coffee table. From time to time, Boo, who is Tony and Susan's little white fur-ball of a Maltese, would trot over for a scratch on the head.

For the most part, the talk was effortless. There were a couple of times when Tony slowed down and considered a question more carefully, as when he went back to the early days with his family in Queens. But generally, everything just flowed, and there were a lot of smiles.

He surprised me at one point when we were discussing some of the more difficult times referenced just above. He traveled back to a subject I hadn't introduced, and hadn't talked to him about in more than a dozen years. I had asked him whether painting was ever, for him, cathartic. He thought for a moment, then seemed to start talking about one of his big hits, though it soon became clear he was talking about something wholly other.

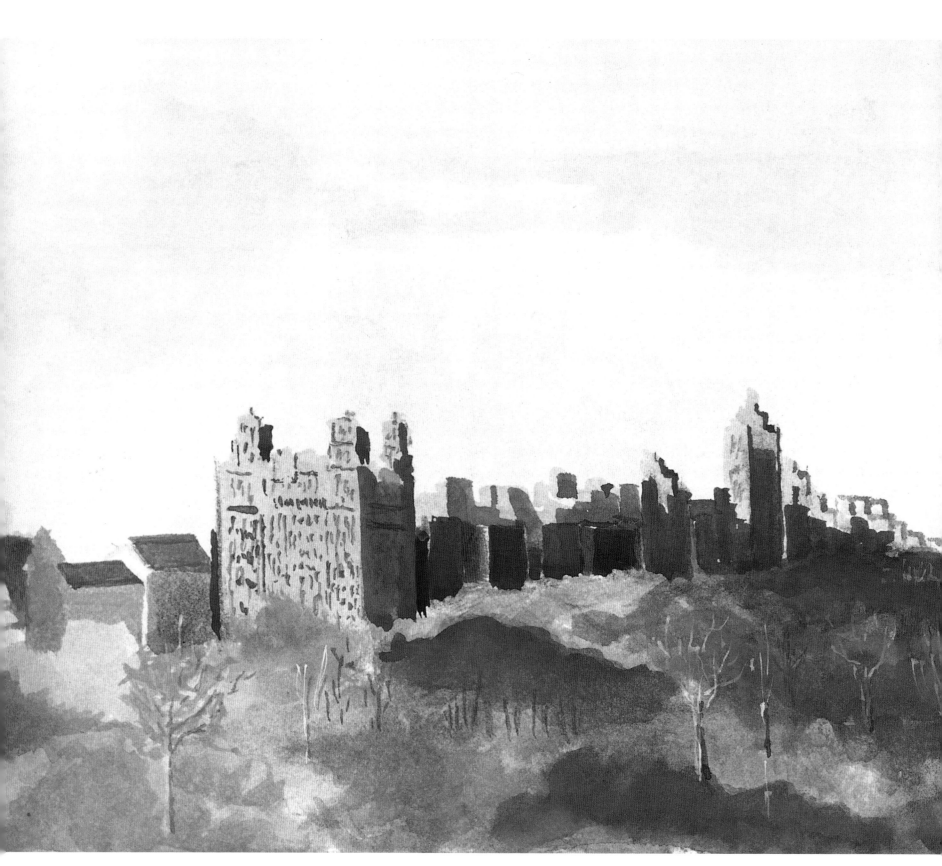

*Central Park Skyline,* watercolor on paper, 10¼ x 24 inches

"Look at that song 'The Good Life.' You know, the lyrics to 'The Good Life' really tell a whole story. That song is really about fame, and what *seems* to be the good life."

He started to sing, ever so lightly. He emphasized a few phrases over others as he traveled the song.

Oh, the good life,

Full of fun, seems to be the ideal.

The good life

Lets you *hide all the sadness you feel.*

You won't really fall in love for you can't take the chance.

Be *honest with yourself,*

Don't try to fake romance.

It's the good life

To be free to explore the unknown—

Like *the heartaches*

When you learn you must *face them alone.*

So please remember I still want you.

In case you wonder why,

Well just wake up,

Kiss the good life goodbye.

His singing voice yielded to his speaking voice as he recalled the dizzying dangers of showbiz fame. "The words of the song really say, it's good but also bad. The reality is, it's good and bad. 'Wake up, kiss the good life goodbye.' It's not just about being successful.

"You know, I'll tell you, you remember that dark period when I got into drugs and all that? We talked about that, remember? Well, I remember Pearl Bailey, when she was starting me out, she said, 'I'm starting you out and all, but down the road, look out for the helium in the brain.' And there's truth to that. You have to take care of yourself. When you have your health, you have everything."

**Opposite Page:** *Holiday in Paris,* watercolor and gouache on paper, 24 x 18 inches

**Above:** Pearl Bailey signed this ca. 1968 advance copy of her autobiography *Raw Pearl* with the touching dedication "To My Son Antonio, All my love and God keep you, Mama Pearl."

"The words of the song really say, it's good but also bad."

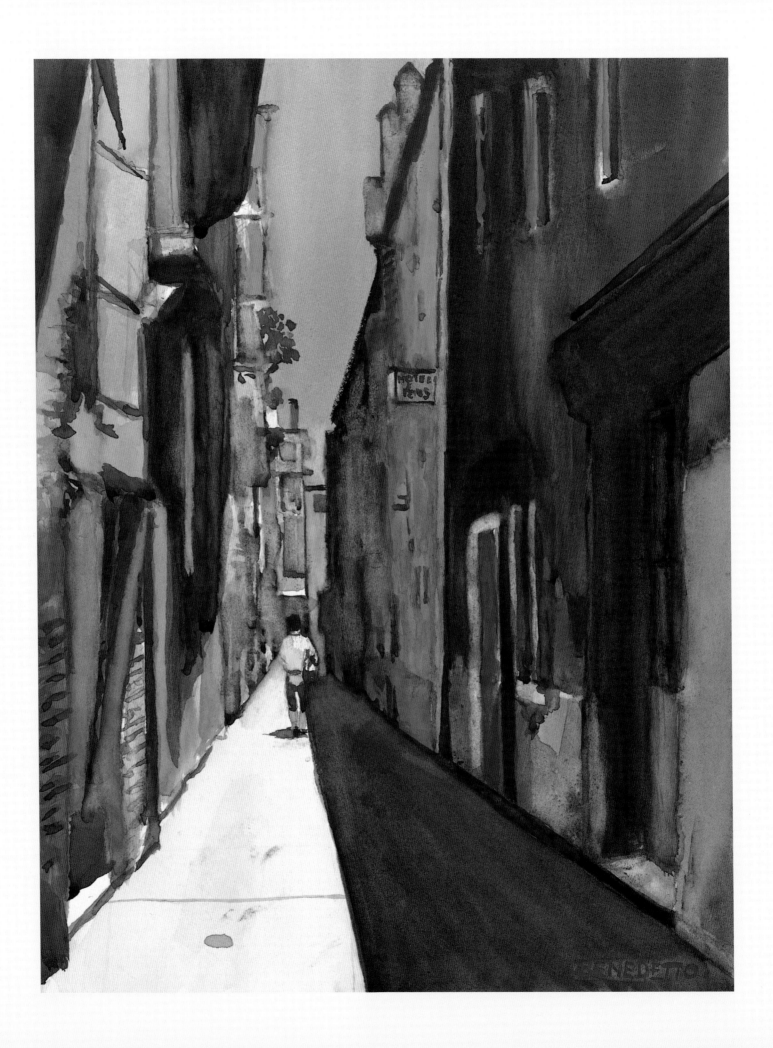

# "When you're at the canvas, you're alone. This is your own story."

"You ask about painting. One thing about painting is, the more you paint, the more you realize how beautiful life is. To be alive. How wonderful life is, what a gift we have. That helps you get past the bad times.

"Another thing that painting does: It keeps you real. You're by yourself. It's not a board meeting; it's not eleven guys making a decision. You're alone. When you're at the canvas, you're alone. This is your own story. And when you're painting, you're thinking about your own story. Just you.

"In fact, both singing and music are forms of meditation. People go to the ends of the world to search for calmness. Painting takes time; you're by yourself. You can paint for four hours and it seems like a minute. And in those four hours, you're facing your own story."

# "In fact, both singing and music are forms of meditation."

*Venice, Italy,* watercolor on paper, 14 1/2 x 11 1/2 inches

# DARK AND LIGHT

"The more you paint, the more you realize how beautiful life is. To be alive. How wonderful life is, what a gift we have. That helps you get past the bad times."

*Winter in Clio*,
watercolor on paper,
11 x 15 inches

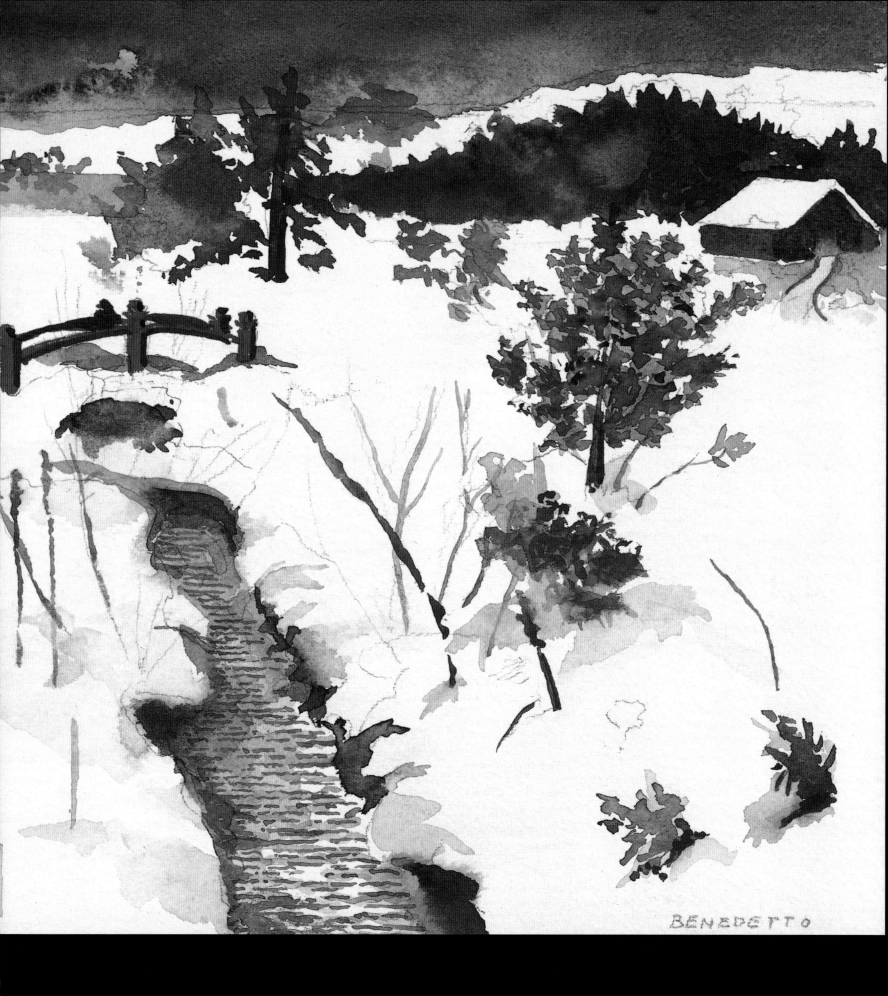

*Mar-a-Lago Courtyard,*
watercolor on paper,
11 x 15 inches

*w Orleans,*
*r on paper,*
*x 9 inches*

NEW ORLEANS

Benedetto

*The Amalfi Coast,*
watercolor on pape
15 x 11 inches

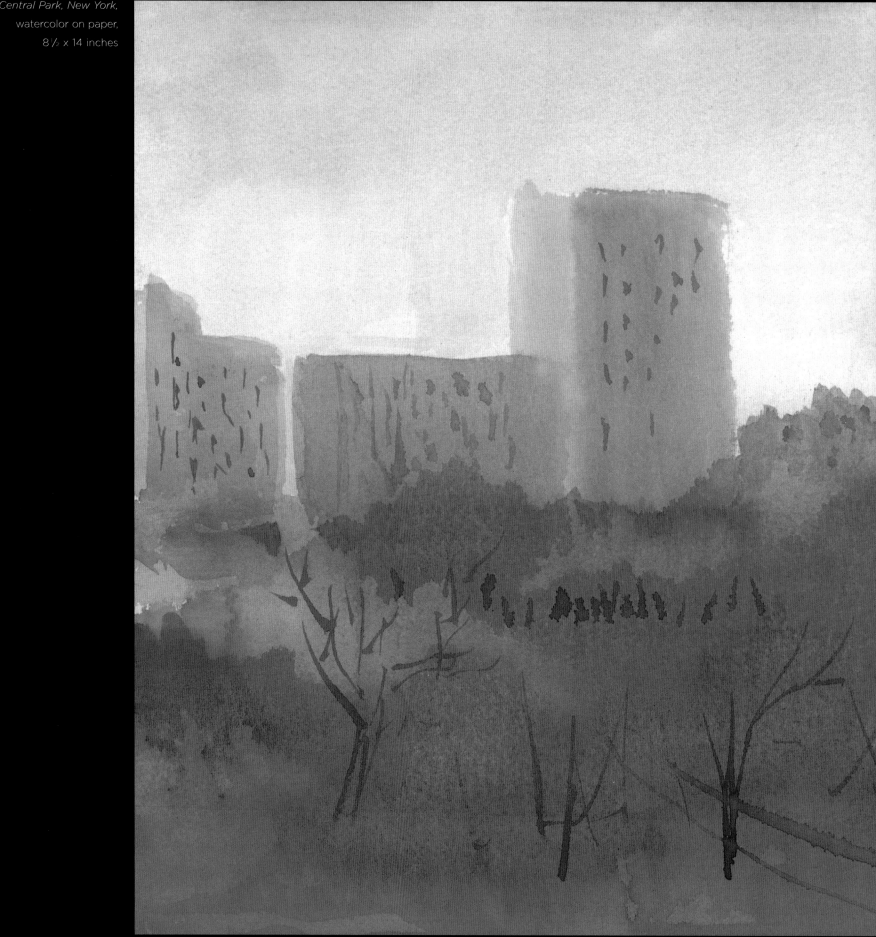

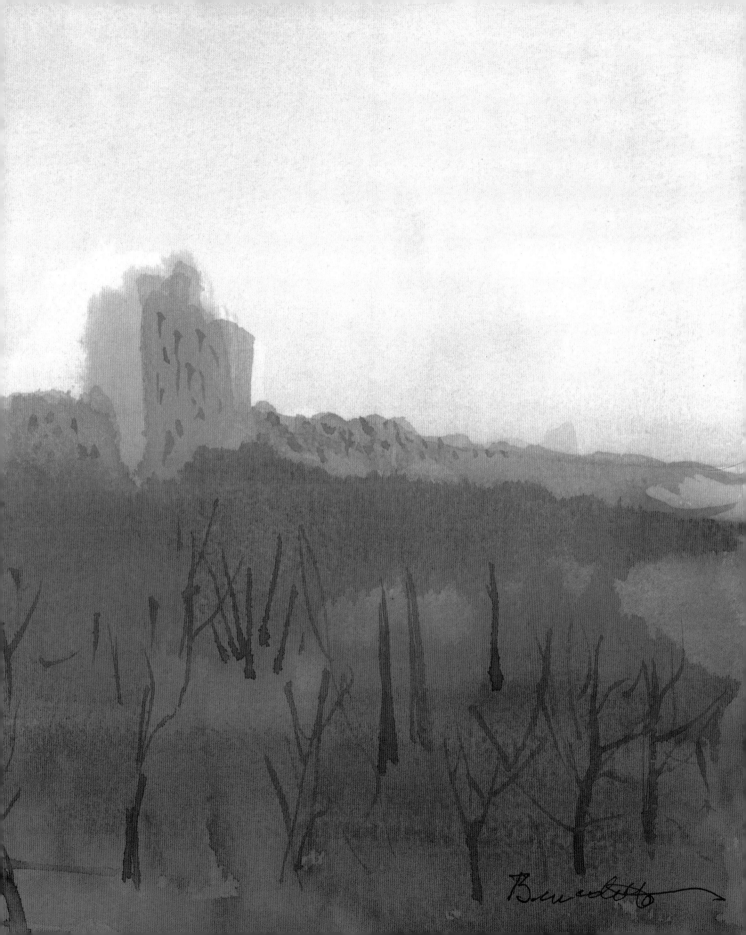

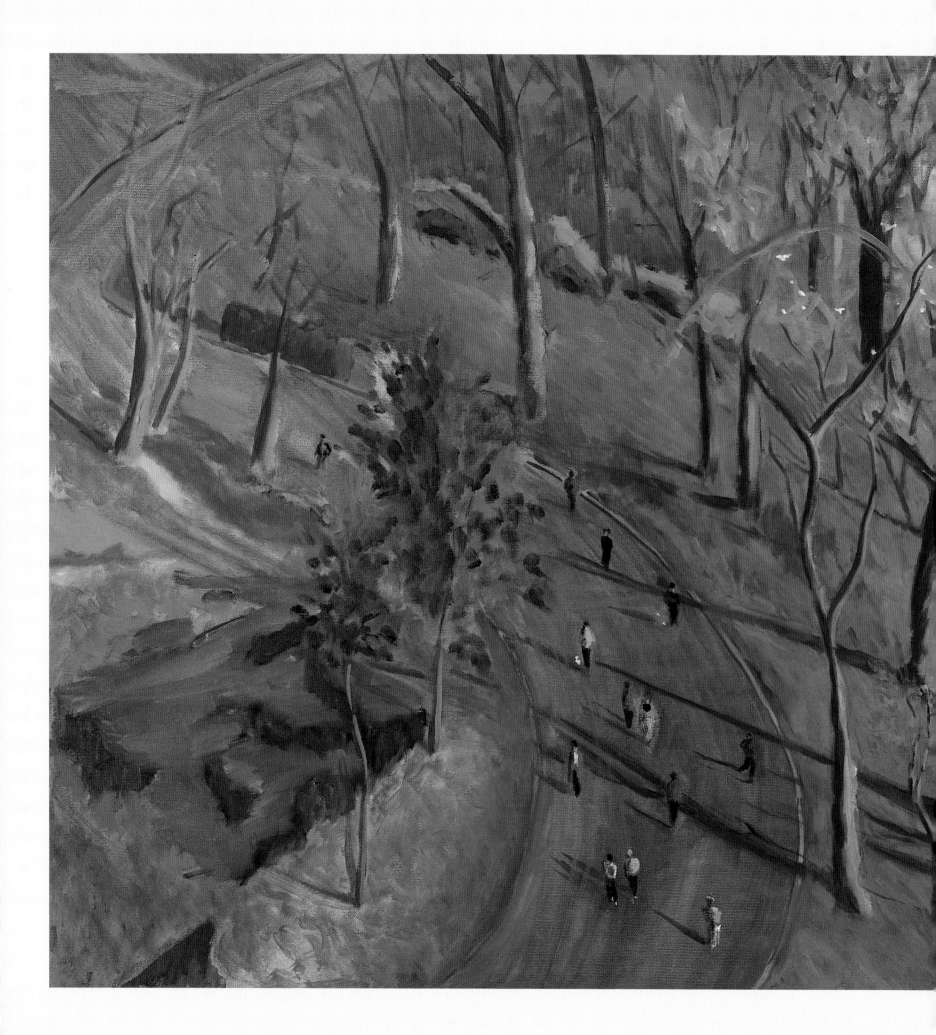

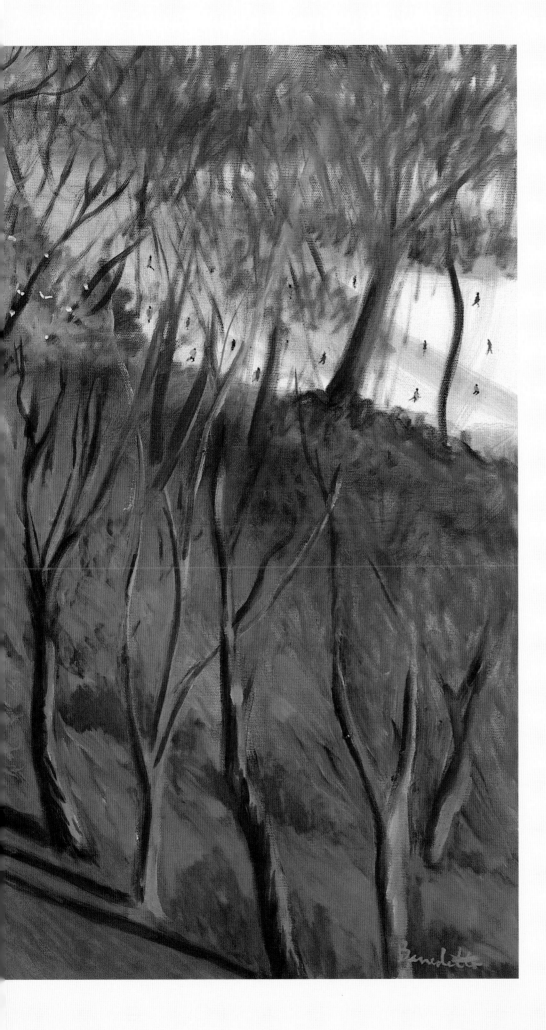

# PERSPECTIVE

Perspective

Tony was **all business**. He was trying **to get it right**, and he wasn't fooling around. He studied the sheet music between takes; he was working, working hard.

*I*n 1998 I was privileged to attend, at a midtown Manhattan studio, one of the sessions for what would become the wonderful CD *Bennett Sings Ellington/Hot and Cool.* When I arrived, Tony, dressed in a lustrous blue suit, was in the control room chatting with Herman Leonard, the renowned photographer from New Orleans who had spent much of his considerable lifetime chronicling the jazz world. For the pictures that would accompany this upcoming jazz disc, Tony wanted a jazz shooter. I said hi to Tony and was introduced to Mr. Leonard, and the small talk continued. I remember Leonard making a little joke about how jazz photography just hadn't been the same since everyone stopped smoking. Tony laughed warmly. I thought for a second and realized Leonard wasn't all wrong: In those great old black-and-white images by Gjon Mili, William Claxton, and Leonard himself, there was always smoke swirling in the air above and behind Lester Young or Charlie Parker, lending the picture mood and atmosphere.

Beyond the glass panes in this clean, well-lighted, and utterly haze-free studio, the members of a good-sized orchestra, who would play alongside the Ralph Sharon Quartet during today's session, milled about. And then, suddenly, their break was over, and everyone returned to his place. Tony's was up front, behind a music stand, facing the band.

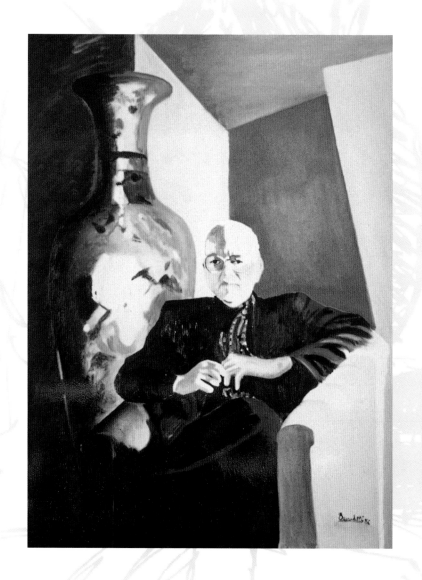

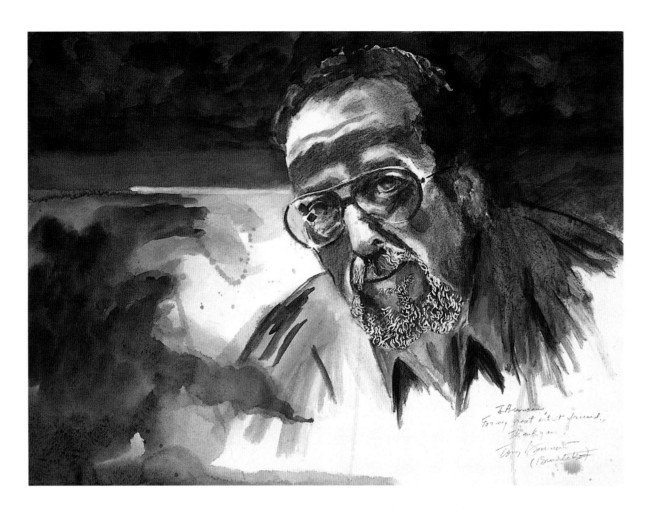

RALPH SHARON
JON BURR

It was fascinating to observe him at work. Theretofore, I had seen him sing only in a concert setting. As I watched on this day, I arrived at an obvious notion, that a good part of what a public performer needs to do is sell the song. So onstage there are lots of smiles, little dance steps, many gestures—ranging from a raised arm to help with a high note, to a hand over the heart to acknowledge applause. But here, in the studio, there was none of that. Tony was all business. He was trying to get it right, and he wasn't fooling around. He studied the sheet music between takes; he was working, working hard. I'm sure this is the same aspect you would see if you were watching Tony as he put oils to canvas. "I do get into a zone," he once told me. "It's similar in that way. The focus. In music and in painting, it's nice when you can find that zone.

Previous Pages: *Autumn in Central Park,* oil on canvas, 24 x 36 inches

Opposite Page: *Ralph Sharon,* oil on canvas, 43 x 30 inches

Above: *Herman Leonard,* watercolor on paper, 24 x 18 inches

Left: *Ralph Sharon and Jon Burr,* ink on paper, 5½ x 3½ inches

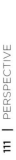

*Japanese Garden, Tokyo,*
oil on canvas

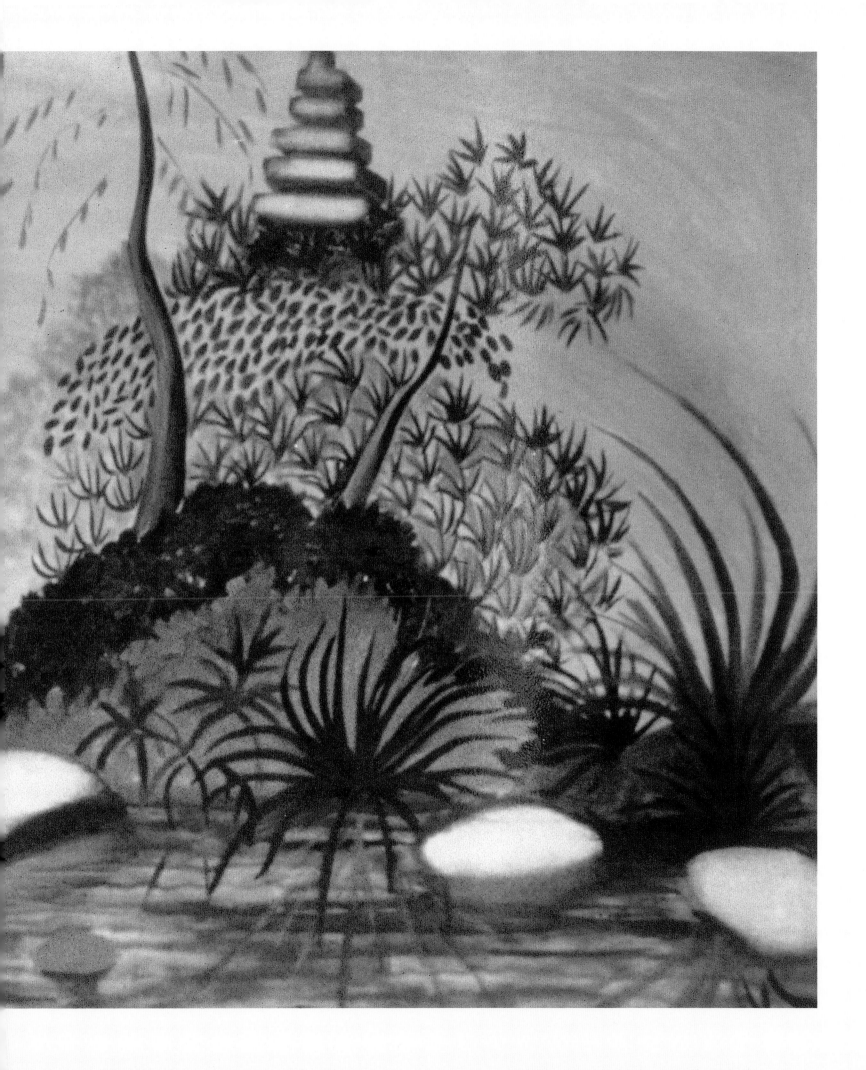

"Doesn't always happen. Sometimes I can be working on a painting or drawing for hours, and I think I'm not accomplishing anything at all. Other times I get so focused that I can nail it instantly. I remember when I started at the School of Industrial Art I did a sketch of my grandfather sleeping. I doubt that all these years later with all my training I could do it any better. That proves to me that there's a push and pull with the creative process. That's why I learned never to give up, even if it feels as if it's not happening the first time around. Keep going; keep plowing through it."

That day in the studio, no plowing was necessary. Tony was polite and appreciative—never demanding—with the musicians, who clearly were consummate professionals. Together, these gentlemen made wonderful music that afternoon, as Herman Leonard moved about the room making his pictures. There was no undue stress, and it took only three or four takes to notch a track.

*Grandfather Antonio Suraci,* ink on paper

"I remember when I started at the School of Industrial Art I did a sketch of my grandfather sleeping."

SELF PORTRAIT IN A REAR-VIEW WINDOW —

Right: *Self-Portrait in Rear-View Mirror,* pencil on paper

Below: *Jazz,* ink on paper

If this calmness that I speak of makes the session sound boring, be assured: It wasn't. Tony's singing was superb, exciting in a different way than I'd seen and heard in concert. Here, in a bright room facing a bunch of guys who were dressed in jeans and sweatshirts, Tony was able to conjure human emotion from a lyric just as capably as if he were on the hallowed stage of Carnegie Hall, surrounded by those cream-colored walls and a packed house of adoring fans. *How does he do it?* I wondered. His inspiration clearly comes from within.

He's intuitively an artist; Cary Grant must have seen that when he told him to stick with his art—his best art—and give it his all. That would be the way forward, even in the years when the road mightn't have seemed all that clear.

I think the factors behind Tony Bennett's survival—and, indeed, his resurgence—include good fortune, certainly, and the strong support of his family and friends, but also a kind of fortitude that is way beyond the norm, a fortitude reflected in his absolute inability to stop creating, to stop expressing himself, even when stopping would have been the expected thing.

# "It's **not about** making **money**; it's about **making music**."
## —Danny Bennett

*Stardust, Las Vegas,* watercolor and gouache on paper, 11 x 15 inches

Tony Bennett
Duets
*An American Classic*

*Featuring*
Bono
Michael Bublé
Elvis Costello
Celine Dion
Dixie Chicks
Billy Joel
Elton John
Juanes
Diana Krall
k.d. lang
John Legend
Paul McCartney
Tim McGraw
George Michael
Sting
Barbra Streisand
James Taylor
Stevie Wonder

*Duets: An American Classic* was released by Columbia in 2006. The multiplatinum Grammy Award–winning album features Tony singing duets of his greatest hits with eighteen of today's greatest artists, including Bono, Paul McCartney, Stevie Wonder, and Barbra Streisand.

As Tony candidly admits in his memoir, during much of the 1970s, particularly when he was based in Los Angeles, his was a wastrel's life: two hundred dates a year, living in the fast lane, and no longer an annuity in the form of a record contract. Danny Bennett, who wouldn't start managing his father until 1979 but who was watching all along, liked rock music, as most of his generation did, but realized the untenable compromises the record business was inflicting on true artists of a different style. "Those were such stupid days," Danny once told me. "They were telling Streisand to sing Dylan songs. So stupid."

Tony recalled the meeting for me—the one when he quit Columbia Records. As Tony was shutting the door on his way out, one of the suits in the room muttered, "Nobody leaves this label and is heard from again." Yes? Well, Columbia now proudly touts Tony as the artist who has been signed to their label the longest in their history, and his latest CD, *Duets: An American Classic,* was the company's biggest-selling album the year it was released.

It does seem remarkable, I thought as I watched him soar through Ellington's "Caravan," that Tony Bennett did not disappear for good as the door closed. But if the man has been two things throughout, they are these: He's been a belter, and

he's been a plugger. "No way he could've stopped then," Danny told me. "It's not about making money; it's about making music. I'm his son, but about one thing I can be objective. . . ." And here Danny resorted to language almost exactly like his father's, when Tony was telling the story about his own father singing from the mountaintop in Italy, filling the valley with song: "He is one of those people who has to do what they do. He will die singing."

An example of this compulsion? Abby Mann, the screenwriter and director who won an Oscar for his *Judgment at Nuremburg* script, once supplied me with a vivid one. Mann is Tony's lifelong friend and confessor, and he was there for Tony in the 1970s. "He was terribly depressed, at loose ends," Mann told me. "His second marriage was breaking up and he was trying to find himself. I was in a divorce at the same time, and we were helping one another get through. We were in Rio, I remember, in a club. This singer started singing in Portuguese. Tony started humming; then it just poured out of him. He was scat-singing away! Everyone was electrified. He wasn't drunk or anything. It was just . . .

"He was a very unhappy man, and still he sang."

"London By Night"

Benedetto "84

# "The fans in Britain are unlike anywhere else in the world. They're loyal. They never forget you."

*Inn on the Park*
*London England*

Tony does not call the extraordinary success and acclaim that have revisited him in recent years a comeback. To come back, you have to go away—and even when fewer (particularly in America) were listening, he never went away. As Tony says, "I was always working." He was singing on a daily basis, and painting—which had provided solace as long ago as his boyhood—also continued as a regular part of his life, even if that life was being lived off the American pop-culture radar screen.

It's interesting to step back briefly into what Tony calls "my English period," which lasted from late 1971 into 1974, with occasional stints back in the States. Tony had a new manager, a new record label, a new young family, and all the impetus in the world to jump-start a new phase. And so he did. He hearkened to advice he'd once been given by the bandleader Ted Lewis— "Do yourself a favor. Play England every year. The fans in Britain are unlike anywhere else in the world. They're loyal. They never forget you."—and he relocated with Sandy and Johanna to London. Lewis was proved right: In 1972 Tony sold out concerts all over Great Britain, starred in a musical television series, and selected and recorded his own music for discs that would be put out by MGM/Verve. "I worked hard while I was in England," Tony says in his autobiography, "but I also took

Opposite Page: *London by Night,* oil crayon on canvas paper, 10 x 8 inches

Above Right: *London,* ink on paper, 8 x 5½ inches

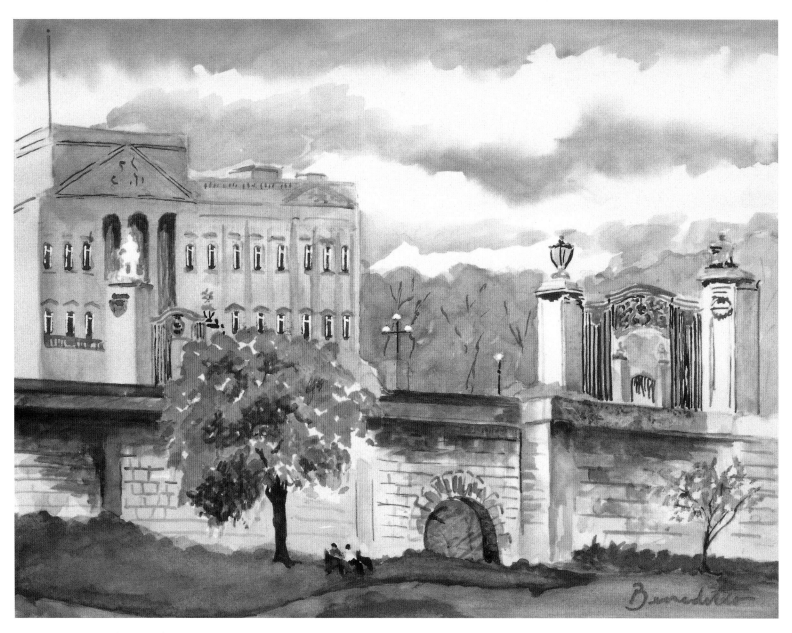

*Gardens at Buckingham Palace,* watercolor on paper, 12 x 16 inches

some time for my personal life, something I hadn't done in years. Sandra, Johanna, and I took in the lovely English sights and got to spend some good times together. I'd been painting whenever I could, but it was during this year in London that I really started to get serious about it. I found a wonderful professor of art, John Barnicoat, who gave me private instruction. I was staying in a flat next to the American embassy in Grosvenor Square, and he'd come over to my place and give me some lessons on technique. I became more serious about painting than I'd ever been, and I've never looked back. I was determined to become a skilled painter, no matter how hard I had to work at it."

Tony remembers those sessions with Barnicoat: "He was a great teacher, Professor Barnicoat. Fantastic guy. The only thing he ever said to me was, 'What kind of painting do you like?' I said, 'Impressionism.' He said, 'Okay, let's go to it.' He just allowed me to think. He never said, 'You're not getting it.' Nothing negative. He gave me freedom, and everything he allowed me to do just kind of flowed. He's a beautiful man. I still see him, whenever I go to London."

Under Barnicoat's tutelage, Tony improved to the point where he was honored with his first one-person exhibit as a painter at a gallery on London's Mount Street. In 2000, he exhibited in London

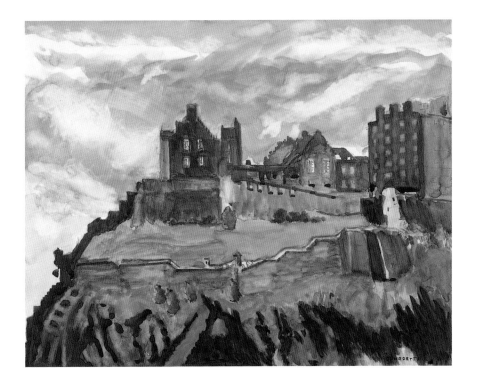

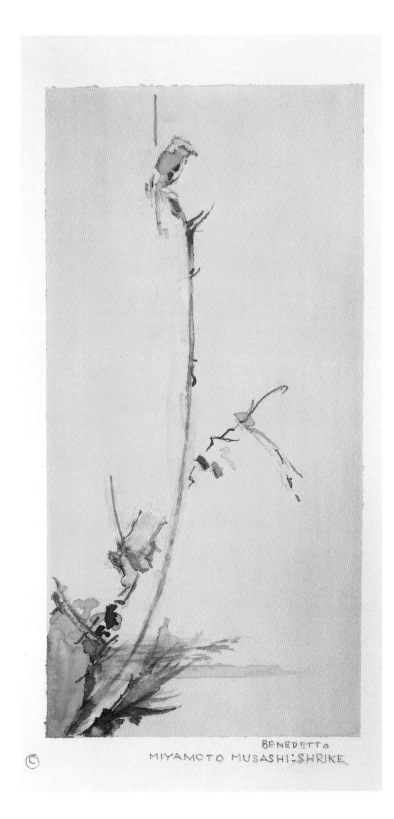

BENEDETTO
MIYAMOTO MUSASHI·SHRIKE.

again. "That was wonderful," he says, gazing back to the moment. "In Hampstead Heath it was—that's spiritual ground in Britain. It was up at the top of the hill, and you could look down at the whole city. That was wonderful. I remember my friend Peter O'Toole— now I sound like I'm name-dropping again, sorry—came to the opening. The *London Times* wrote me up as a very good painter. That was nice."

Tony got healthier in England; he took up tennis seriously, developing yet another passion that would remain with him the rest of his life. Free of Columbia Records, free of expectations, he felt liberated to experiment and grow. His friend Louis Bellson, who could roam as inspiringly as anyone in a drum solo, had told him, apropos of music specifically and art generally, "If you want to understand free form, you must first learn form before you can be truly free to experiment. You can't successfully break the rules until you learn what rules you're breaking." It so echoed what Kinstler had said, and both men, Tony was sure, were dead right. By now, by the time of his English period, Tony was a confident master of form in music and was working toward such mastery in painting. And so he played with form, expanded beyond it at times with help from artistic colleagues such as Barnicoat and the storied music producer Robert Farnon. It was an exhilarating time creatively. Back in America, too few heard or saw the fruits of it.

Tony's second daughter, Antonia, was born in the spring of 1974, and shortly thereafter the family relocated to Los Angeles—to a big house in Beverly Hills. A mistake? That really can't be said of any particular events or decisions in a life as full and successful as Tony's—who can possibly know what would have led to what?—but as he freely admits in his memoir, he was soon experiencing all that Southern California's showbiz society had to offer, "the good and the bad." The good included deep friendships with Fred Astaire, Cary Grant, Ella Fitzgerald, and others. Johnny Carson, who had featured Tony on his very first *Tonight Show,* was a pal, and asked Tony to perform on regular occasions. Carson was happy to have Tony bring along new paintings, too, to show the folks, and thus was Tony introduced to his fans as a visual artist. Of an appearance on the *Ed Sullivan Show,* Tony remembers, "Sullivan said to me, go out all week and just do sketches of the city. And I took a Sharpie or something like that, and just did all these sketches. The skyscrapers and all that. Cabs and all. And they blew them up, about six of them, and made that the set. They hung them behind me; it was very modern looking.

"Now, I was really knocked out about six months later. I was doing the Sullivan show again with Rosemary Clooney, and I went up to Sullivan's office that afternoon, and I couldn't believe it—he had the sketches in his office! Right there on his walls."

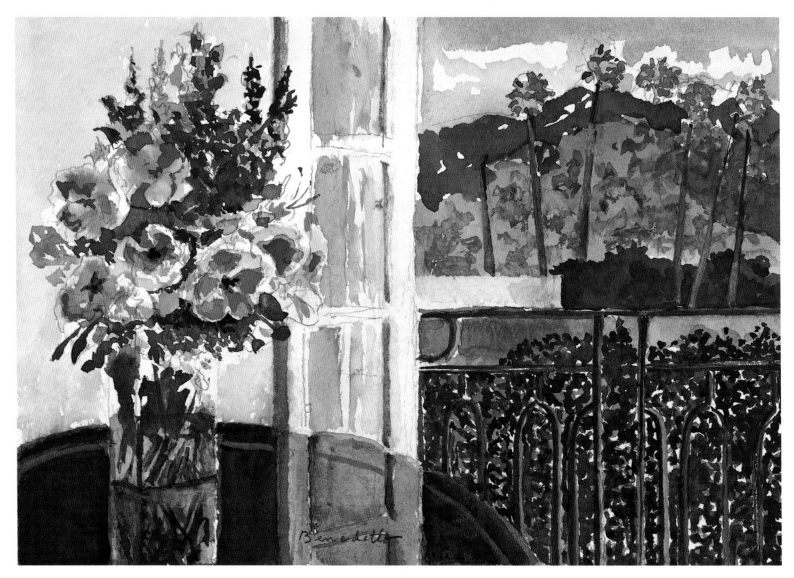

*Los Angeles Still Life,* watercolor on paper, 9 x 13 inches

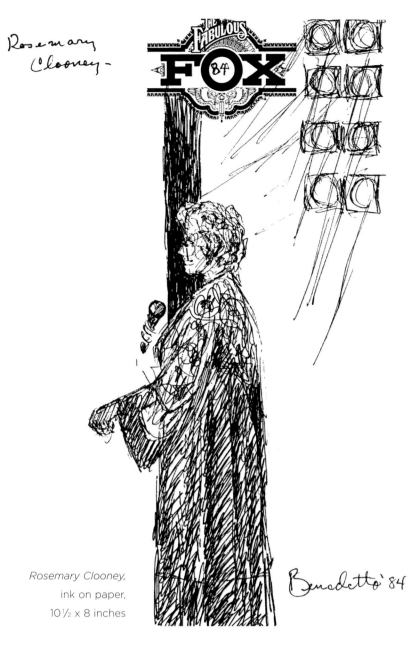

Rosemary Clooney –

*Rosemary Clooney,*
ink on paper,
10½ x 8 inches

In 1975 Tony realized a longtime dream when he and a
partner formed their own independent record label, Improv.
Again: A mistake? That's a tough claim to make if you listen to
some of the captivating music on old Improv discs, including
one of the two legendary albums Tony made with solo piano
accompaniment by the great Bill Evans. Their collaboration
was a magical summit meeting, and the music they produced,
accompanied in the studio only by an engineer, is sublime.
This is remarkable considering Evans was in the death grip
of his addiction to heroin, which would claim him by overdose
in 1976.

Shortly before his death but after he and Tony had finished
their work on the albums, Evans tracked Tony down in a small
Texas town where he was staying while on the road. "Bill, what
are you calling me here for?" Tony said.

In a desperate tone, Evans said, "I wanted to tell you one
thing: Just think truth and beauty. Forget about everything else.
Just concentrate on truth and beauty, that's all." The phrase
became something of a mantra for Tony even after it quickly took
on a shadow of sadness with Evans's death. That tragedy, says
Tony, "made me think hard about my own drug use. I knew that
somehow, something had to be done."

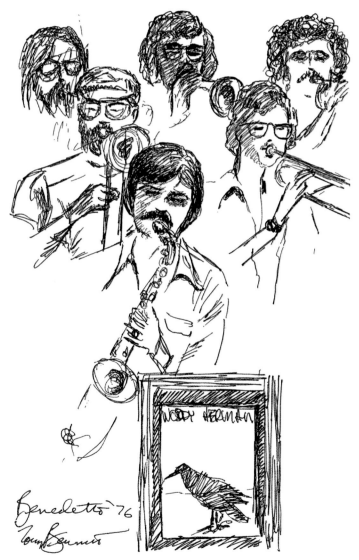

*Woody Herman,* ink on paper, 8½ x 5½ inches

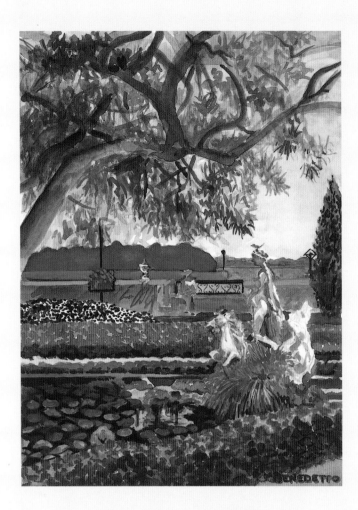

**Above Left:** *Cipriani Garden, Venice,*
watercolor on paper, 15 x 11 inches

**Below Left:** *A Garden in Florence,*
watercolor on paper, 8¾ x 11½ inches

**Opposite Page:** *Japanese Garden, Tokyo,*
watercolor on paper, 16 x 12 inches

Bennetto

He did shake his drug habit. Evans passing at such an early age moved Tony to take stock even at a time when his record label was failing commercially, and there were new worries, these of a financial kind. "One thing I'm not is a businessman," he says with a wry smile. His son Danny took a look at the books and realized Tony and Sandy were living in a deficit situation. He proposed a budget, and a new professional direction that included less Vegas and a strong push for a younger audience. Tony was fine with it—delighted with it—but with his relationship with Sandy already on the wane, the stripped-down lifestyle was the last straw. Tony's second marriage was headed for the rocks.

Somehow, all the trials, and the fact that he was coming out of the far end of them with a plan for the future, strengthened him. He had the perspective of a man who had tasted much that life can offer or inflict. At about this time, he gave an interview to the *Boston Globe* before a gig in Cohasset. He said at one point, with not a little contrition, "I used to take pills. Uppies. Downies. Sleepies. But no more. I'm in touch with myself. I'm healthier now than I ever have been. And I've become unbuggable."

*Unbuggable.* What a fine Tony Bennett word.

WHEN WE WERE WRAPPING UP THAT SESSION at the Metropolitan Museum in 1994, Tony at one point gazed out at the streetlights in Central Park and reflected upon the advice given him by Abby Mann. "He always told me to do it by yourself—keep going forward, and be loyal to yourself." It seemed like he was marveling that that strategy had led to this current windfall of success.

"I'm not sure what did it, really," he says. "It's been crazy, this whole thing with the kids, the young generation. Danny did all that. He said, 'Just trust me, Dad.' He put me on *The Simpsons*, and then MTV. I said, 'Hey, what's going on? I'm not used to this.' He said, 'Trust me.'

"All of a sudden, kids!"

"Remember last summer?" asked Susan, who at the time was already Tony's companion of eight years. She was sitting opposite, facing Tony. "In Sienna. We were at this museum, and all these American kids just mobbed you. It was like you were the Beatles."

As if to add counterpoint to this discussion, three mature women wearing aprons arrived from the kitchen for two reasons: They wanted to twist Tony's arm and have him reconsider his decision to skip dessert, and they wanted to shake Tony's hand and tell him they loved him. Tony politely accepted both their chocolate and their adulation.

And then the evening, which had begun as afternoon, was over. We moved to the cloakroom, where Tony continued on about the kids. "What I know is, I sing the way I always sang," he said as he pulled on his topcoat, then helped Susan into hers. "And I know that these kids are the most enthusiastic fans I've had in my entire career."

*Susan in the Garden,* oil on canvas 24 x 36 inches

"I sing the way I always sang, and I know that these kids are the most enthusiastic fans I've had in my entire career."

# PERSPECTIVE

"There's a push and pull with the **creative process**. That's why I learned **never to give up**, even if it feels as if it's not happening the first time around. **Keep going**; keep plowing through it."

*Spring in Manhattan,*
watercolor on paper,
15 x 22 inches

BENEDETTO

Benedetto

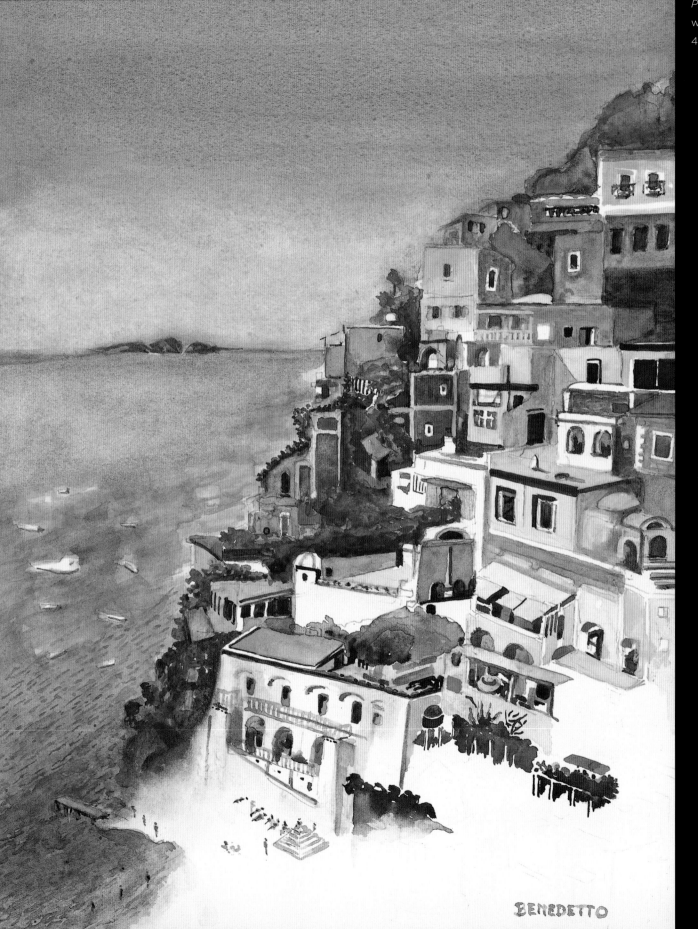

*Positano, Italy,*
watercolor on paper
4¼ x 5½ inches

BENEDETTO

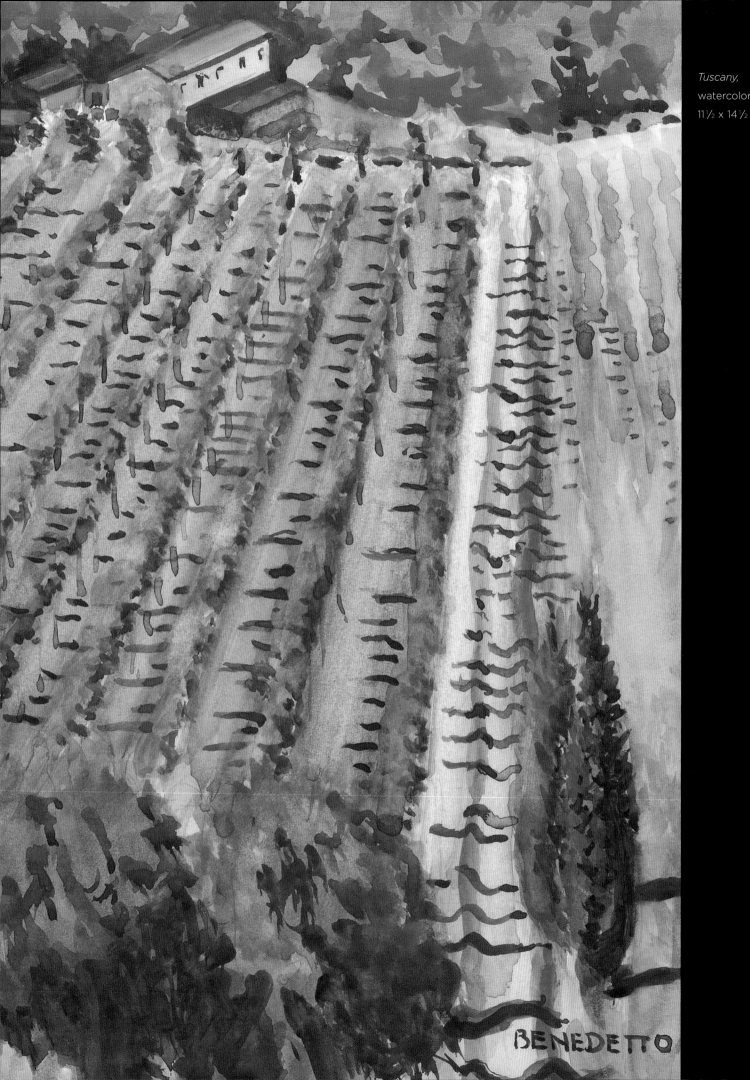

*Tuscany,*
watercolor on p
11 ½ x 14 ½ inche

BENEDETTO

BENEDETTO

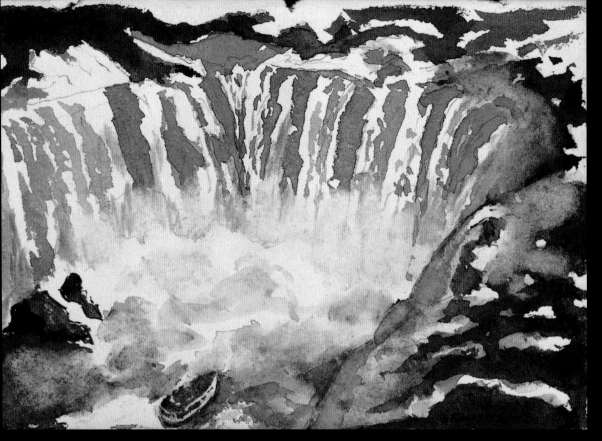

*Niagara Falls,*
watercolor on paper,
5 x 7 inches

*Central Park, West Side,*
watercolor on paper,
9 x 12 inches

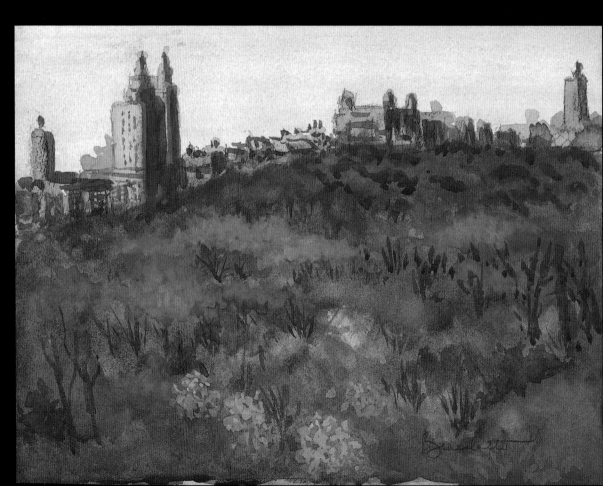

*House in the Trees,*
watercolor on paper,
14 x 20 inches

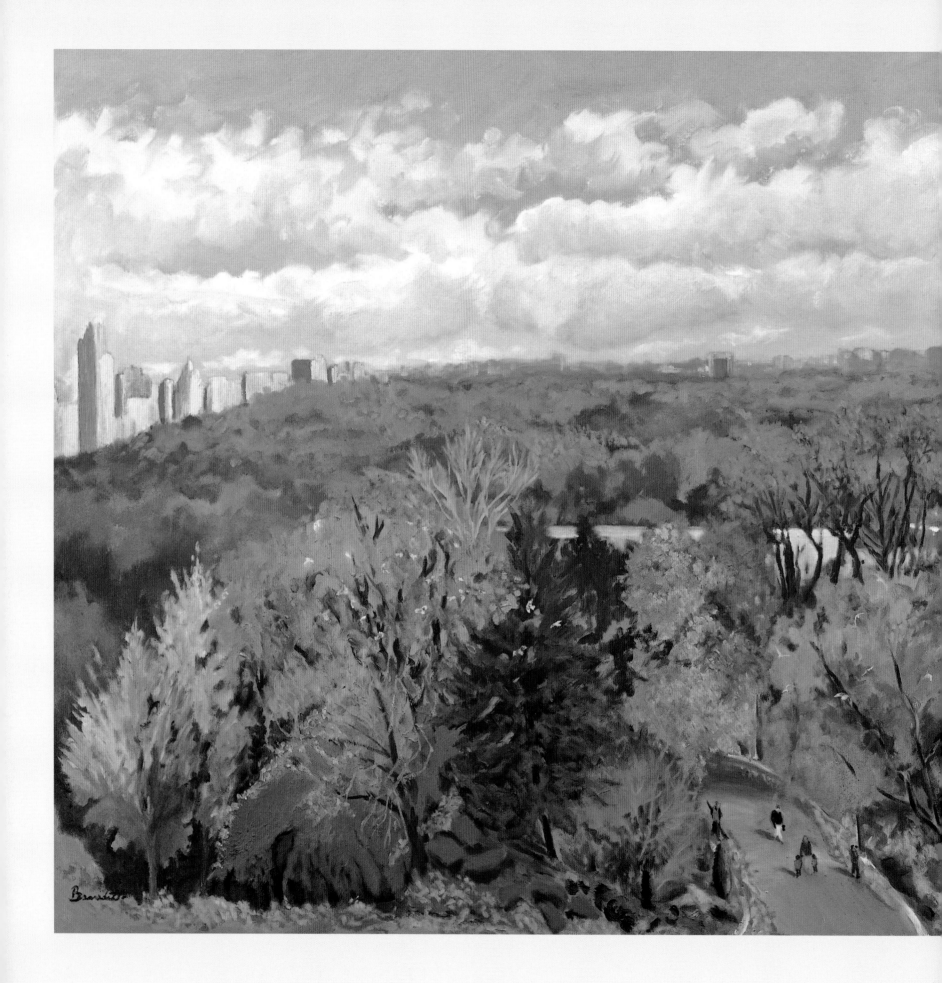

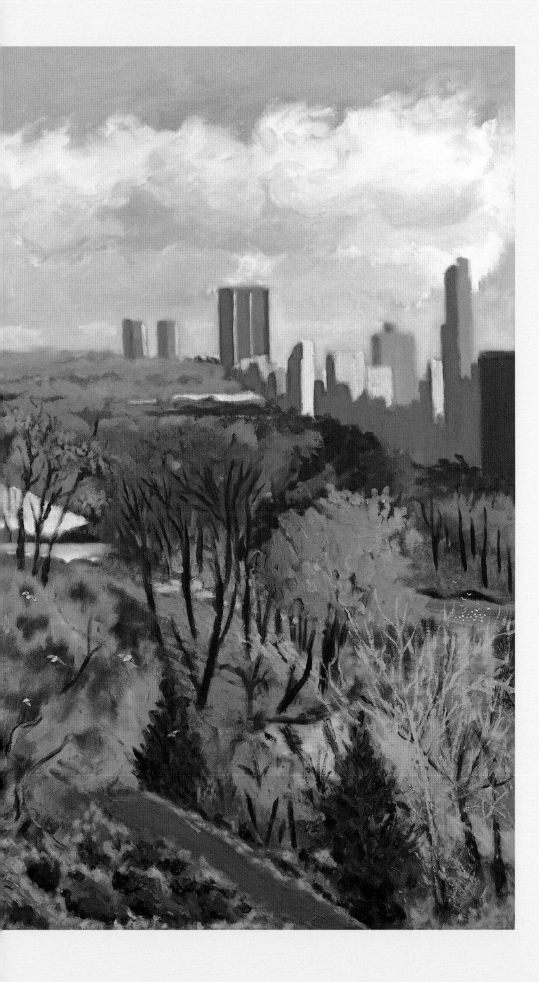

Mastery

# David Hockney tries everything and he's accomplished at everything.

*F*ans have always appreciated or admired Tony; they've been thrilled by him and moved by him. In recent years, they have marveled at him. There was that moment beneath the bleachers at the MTV taping, with Elvis Costello gushing aloud about Tony's way with a song—and I have seen and overheard others.

At CD signings (from a woman who has been in Tony's fan club since the 1950s): "He's even more handsome now than he was when I was a girl."

After a concert at Carnegie Hall: "He's got more energy than a twenty-year-old. He's singing better than ever."

At the art exhibits: "Somehow, these *are* the paintings that Tony Bennett would paint."

**Previous Pages:** *Central Park,* oil on canvas, 36 x 60 inches

The Butler Institute of American Art in Youngstown, Ohio, held an exhibition of Tony Bennett's art in 1994. The exhibition poster features his painting entitled *Homage to Hockney,* oil on canvas, 36 x 24 inches; the work is in the permanent collection of the museum. About David Hockney, Tony says: "He tries everything and he's accomplished at everything. I like his portraits; I like his landscapes. I like what he does with color; I like what he does with charcoal and shadow."

*Tony Bennett/Benedetto*

THE BUTLER INSTITUTE OF AMERICAN ART
YOUNGSTOWN • OHIO

*Dayl Crow,*
oil on canvas,
60 x 80 inches

*Battle of Hampton Roads,*
watercolor on canvas,
17 7/8 x 23 7/8 inches

One of my favorites came during Tony's seventy-fifth-birthday celebration in the summer of 2001, which was held, yes, at the New York Metropolitan Museum of Art. This time we were in the Temple of Dendur room, an awesome setting (no other adjective applies) for a party. Primarily, you've got this massive ancient Nubian temple, indoors, as a backdrop. Quite a place for a party.

The guest list, as reflected in all the happy faces in the room, was perfectly Tony. There were just plain folks, and anonymous senior citizens from Queens and New Jersey—friends of the family, friends of the birthday boy for a long, long time. And there were De Niro, Scorsese, Trump, Katie Couric, and many other A-listers who were, indeed, good friends of the celebrant.

There was dinner; there were toasts. The Ralph Sharon Quartet backed Tony on a couple of songs, and Billy Joel serenaded him with "I Wanna Be Around." It was a fabulous time.

When dinner was over, my wife, Luci, and I found ourselves near the coat check, standing next to Paul Shaffer, the bandleader on David Letterman's show. We made small talk about kids and school and music; he was a most affable and amiable man. The subject of Tony came up.

"Wasn't he wonderful?" Paul said, smiling broadly. "Very cool. Very cool. He's still got it, for sure. He's got more of it! He's a very, very jazzy guy."

Below: *Michael's Pub,* ink on paper, 5 x 3¾ inches

Opposite Page: The front cover of Tony's seminal 1989 album, *Astoria: Portrait of the Artist,* shows him as a young man in 1942 standing on the street where he grew up in Astoria—in the back cover photograph Tony stands on the same street in 1989.

IT WOULD BE A LARGE MISTAKE to think that Tony's marvelous renaissance has been floated only by "the kids" in his audience, or somehow manufactured by Danny's management strategy. Tony's original fans were nothing but thrilled to welcome his music again, and baby boomers were ready to find the great songs and appreciate the great singers. "If something was meant to last, it was meant to last" is the way Tony sees it. "Sure, some of it's been surprising. But I always try to be a person who looks ahead, and I always felt good things were going to happen."

Even before he was back in the headlines, Tony was back working at Columbia Records—with full creative control—and was making marvelous, mature records. Two LPs he made before he got to the tribute or homage albums—the Sinatra, Astaire, Billie Holiday, and Ellington discs—were warm, introspective, heartfelt, honest, and, at times, painful. *The Art of Excellence* became, in 1986, his first album to chart in nearly fifteen years. In 1990, Tony dug even deeper for *Astoria: Portrait of the Artist.* His version of "Speak Low" on this collection is stunning, and his wiser look at "The Boulevard of Broken Dreams," which had been his very first single back in 1950, is shattering. "I've actually done three versions of that song," says Tony. "There was one with a tango—Mitch Miller, you know. The *Astoria* version I think of as

## "I always felt good things were going to happen."

*Central Park Skyline,* watercolor on paper, 6½ x 15 inches

the humanitarian version. Looking out my window here and seeing all this wonderful opulence, but then looking in the street there and seeing the homeless in Central Park—thinking about this have-and-have-not world of ours, which is quite tragic. . . ."

All of that is in the song, even if Tony's own life was coming together wonderfully, the pieces falling almost magically into place. Ralph Sharon, after fifteen years stationed in San Francisco, was willing to tour again, and had come back into the fold as

Tony's pianist and musical director. Tony was in a delightfully happy relationship with smart young Susan Crow, an educator. And then came the Grammy Awards, and the Letterman show, and the kids. But most of all, Susan, Danny, Daegal, his daughters, Johanna and Antonia, his four grandchildren . . . a huddle of family, friends, and loved ones, back on top.

"Things are very good for me right now, for us," Tony said shortly after the MTV concert taping in 1994, while of course

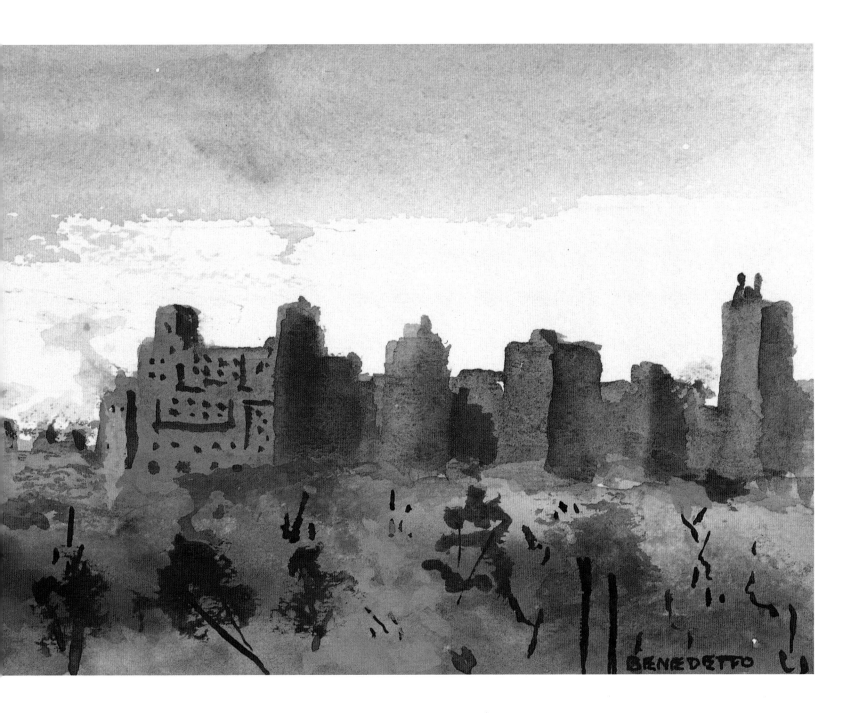

unable to suppose that the success and acclaim would continue for a decade more—and, indeed, forever. "I guess that's obvious—things are very good for us. I'm looking forward to this coming year, 1995. I'm gonna cut back some.

"I'll be able to devote more time to painting. Susan and I will travel. And also, we're really looking forward to getting into that new apartment." He referred again to the apartment of his long-ago dreams, the one with the afternoon light and the sublime view of the park—the park that, as he talked, he was riding through in the limo. The car swept southward past Tavern on the Green, all aglitter with thousands of white lights strewn through the trees surrounding. "Hey, Susan, Tommy Flanagan's playing Tavern this week," Tony said. "Great pianist. I've always loved singing with him. He's still great after all these years."

Of whom was he speaking?

NOW, TODAY, TONY IS SITTING in that marvelous apartment, looking out on his beloved park, and bringing affairs up to date. "It just never stopped," he says. "One thing after another. I've really had a blessed life."

In that life, he has changed, matured. While he has remained resolute about the style of music and painting that he has chosen for his concentration—beauty, it can be said, is his constant muse— his approach to and delivery of his art are somewhat different and in some ways more profound. To look briefly at the singing: Tony's voice has deepened, and now resonates with a heightened "quarter-to-three" feel. And his later interpretations have an insight that is breathtaking. "You know what he's doing?" asks the XM Radio host Dick Golden, a lover of this music who has been a friend of Tony's since the 1960s. "Given this last chance to record, he's doing definitives. Just as he's always wanted to do—definitives. He's nailing some of these songs to the wall. When Sinatra recorded 'Night and Day,' that was it, right? Well, listen to Tony's 'Dancing in the Dark.' Listen to how he refound 'Steppin' Out' with that rhythm. Listen to what he does with Weill's 'Speak Low.' I mean, it's just unbelievable."

"I've **really** had a **blessed** life."

"I REMEMBER CLIFFORD"

Tony, for his part, doesn't believe in unbelievable—never has. He believes in staying true. "I once asked Count Basie what I should do," he says. (There he goes again with the quoting.) "Some of my friends were trying to sing rock, and I didn't know what to do. Basie told me in that sly, wise way of his, 'Why change an apple?'" So Tony stuck with what had brought him to the dance, and at the time he continued to slide. But, hey, look at him now.

He is asked whether he is still finding out new things about singing. "Sure," he says quickly. "Oh, yes. Every day. I do some music every day. Sometimes I'll just sing softly while I'm shaving. Work on holding notes. Like this." He hums a few scales lightly. "Some singers start to wobble when they get older. I once asked Sinatra what he'd do to beat wobbling, and he said if that ever happened to him, he'd quit. I've been working on holding the notes without vibrato. Abe Katz, the first trumpet for the New York Philharmonic, he told me he holds notes flat, no vibrato, and they don't wobble. It can work with singing, too." He performs another flat, perfect scale, then one with vibrato in the notes. The latter is pretty enough, but, yes, fragile.

Opposite Page: *I Remember Clifford,*
ink on paper, 4½ x 4 inches

Right: *Count Basie Band,*
ink on paper, 11 x 8¾ inches

*James Moody,*
watercolor on paper,
11½ x 11½ inches

As for the painting, "Right now, I'm studying values, so that colors all match one another. It's like a musician finding chords that all relate to one another. It's all connected.

"I like impressionism still, but I'm interested in all kinds of painting. I'm very interested in aborigine painting. It's very similar to music, the way that aborigine paintings look. It's the only type of painting that looks like music. Here, I'll show you." He leads the way through the apartment to one of his two studios; the other, larger one is down on the fifth floor, and provides a different vantage of the park. He moves to the desk, where sit brushes, paints, and a few works in progress. He picks up, first, a calendar that features twelve pictures made by Australian aboriginal artists. "You look at these paintings, see, they look like music. See? It's a musical look, the swirls and dots. There's nothing else like it. And, so, look at this—" He picks up a small oil portrait of the late trumpeter Dizzy Gillespie. "Many years ago I did this thing of Dizzy. And now I'm applying this aborigine-type background to it. I'm combining the aboriginal influence with musicians.

"So, it's different. Just one thing I'm doing just now. I'm enjoying it.

"You see, for me, it's simple—it's the love of painting. I would call it recreation. It's the love of painting. I don't like to have someone say, 'Paint this.' I'm not into that. I just paint what I like, and I'm in a perpetual search for what I'm looking for.

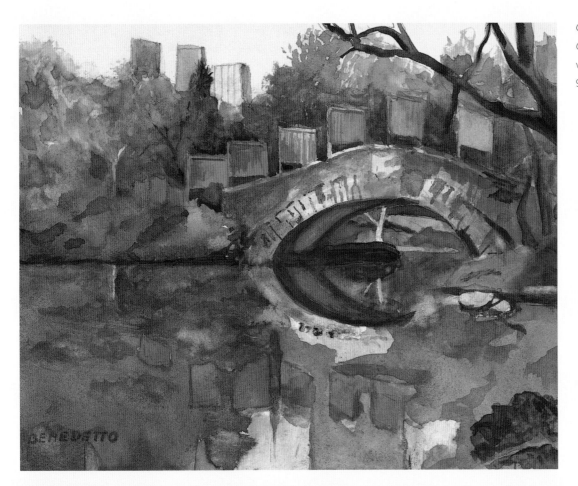

*Christo's Gates in
Central Park, New York,*
watercolor on paper,
9 x 11½ inches

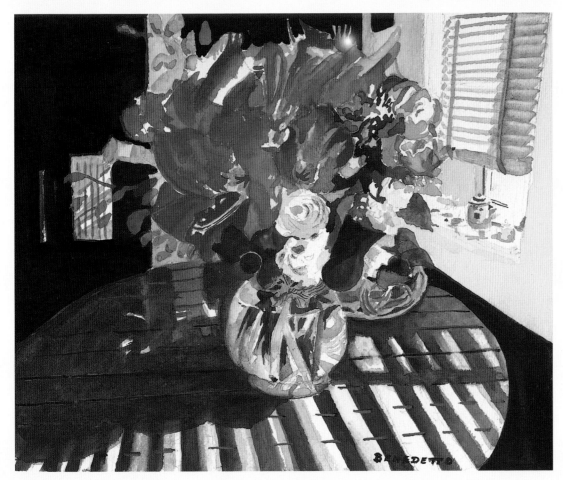

*Flowers #1,*
watercolor on paper,
15 x 18 inches

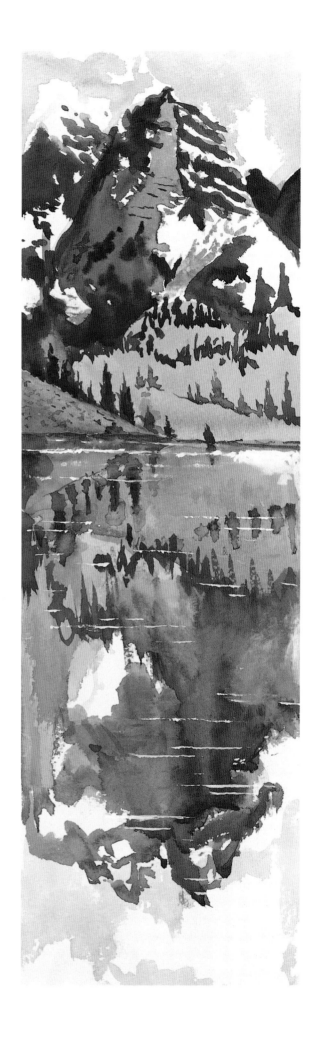

# "I'm looking to grow. To learn."

"Painting is a vacation for me at all times. If Susan says to me, we should go on vacation somewhere, I don't feel like doing that. I'm on vacation all the time. As I travel, I'm on vacation—sketching and singing. These are things I love to do.

"Susan and I were in Big Sur. It's really the best spot in the whole country, Big Sur. We'd drive twenty-five miles, stop the car, and I'd put out my easel and paint. Those were some of the best paintings I'd ever done. No matter where you looked, you didn't have to say, 'What should I paint today?'

"There are three quotes about painting that I love. One is by Hokusai, the Japanese painter, who said, 'When I'm a hundred, I'll get better. When I'm a hundred and five, I'll still have to study more. But when I'm a hundred and ten, I'll have it.' Isn't that great? He called himself the 'Mad Old Painter.'

"And the same with da Vinci. Leonardo, on his deathbed, said, 'Has anyone ever finished anything?'

"And Michelangelo, when he finished the Sistine Chapel, said, 'I'm still learning.'

"So that is it, that's the whole premise of what I do—the search. I'm looking to grow. To learn. It comes slow. You learn more and more about why you want to paint, and you learn more and more about what it is you're really looking for."

Left: *Maroon Bells*, watercolor on paper, 22½ x 7¾ inches

Opposite Page Above: *Winter Holiday—2001*, watercolor on paper, 7 x 10 inches

Opposite Page Below: *Carmel Highlands, California*, watercolor on paper, 14¼ x 20 inches

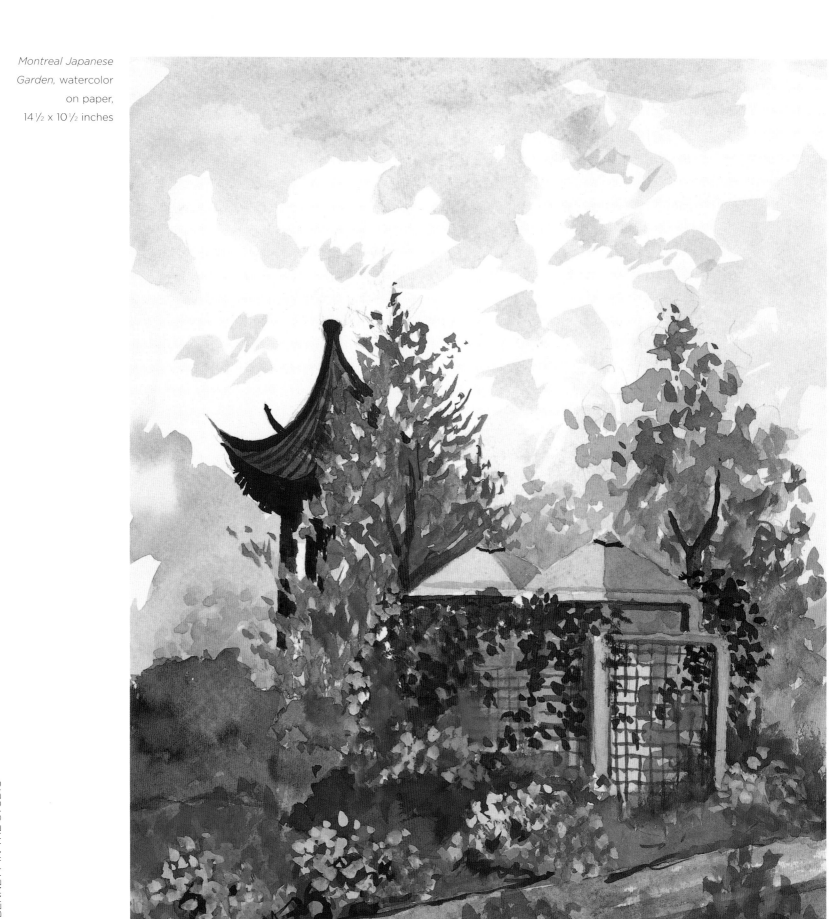

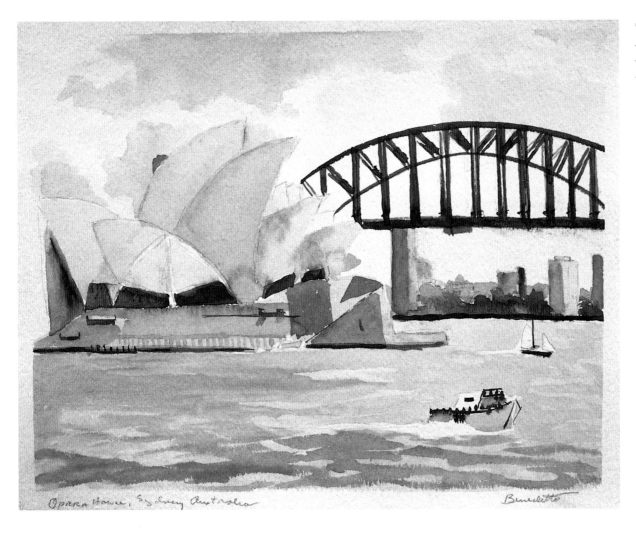

*Opera House,*
*Sydney, Australia,*
watercolor on paper,
11 x 13 ¾ inches

*Kyoto,*
watercolor on paper,
7 ¼ x 10 ¾ inches

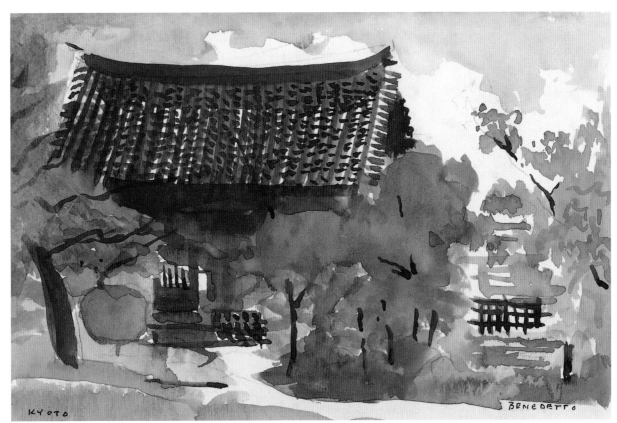

*The Hills of Tuscany,*
watercolor on paper,
10½ x 15½ inches

the HILLS of FLORENCE.
June 2nd. '01.

BENEDETTO

'01

In 2006, IT SEEMED AS IF ALL THE WORLD paused to applaud Tony Bennett. There have probably been more well-noted eightieth birthdays than Tony's, but there haven't been a whole lot of them. Everyone from Astoria to Alaska to Asia to the Aussie Outback knew that Tony was turning eighty. He was everywhere. He had a new (and sensational) chart-topping CD of duets with the crème de la crème of pop, jazz, country—you name it—pitching in, everyone from Streisand to Bono, Paul McCartney, Stevie Wonder, and the Dixie Chicks, to jazz pianist Bill Charlap on board. He had a new (and sensational) television special directed by *Chicago*'s Rob Marshall on NBC, which drew critical huzzahs after it's gala red-carpet debut at Manhattan's splendiferous Ziegfeld Theatre. He had sold-out show after sold-out show on what is clearly a never-ending lifelong tour. The National Endowment for the Arts named him a Jazz Master. The Kennedy Center honored him with a life achievement award. The Smithsonian selected one of his paintings, *Central Park*, for its permanent collection. "What a year!" Tony says when asked to consider it. He laughs. "I mean, I never had a better time in my life. It was a

blessing, what happened to me. The ups and downs of life that you go through, and then something like that. It's a big payoff for everything that's happened before; that's the way I see it.

"Every day was a birthday," he continues. "All year long. From the first day of the year right through. The Jazz Master, the Smithsonian—one birthday after another. The Smithsonian: On the steps going down there are the greatest painters, the greatest American painters. And I look, and there on the easel is my *Central Park* painting. Wow. The *Duets* CD. That was Danny's idea. I wasn't sure, but . . . Well, that record got the equivalent of a Presley treatment! And the film! Rob Marshall, just the best director I ever met in the world, he made it look great.

On September 28, 2006, the *New York Times* applauded a concert by Tony Bennett and his quartet (Lee Musiker on piano, Paul Langosch on bass, Harold Jones on drums, and Gray Sargent on guitar) at the Theater at Madison Square Garden.

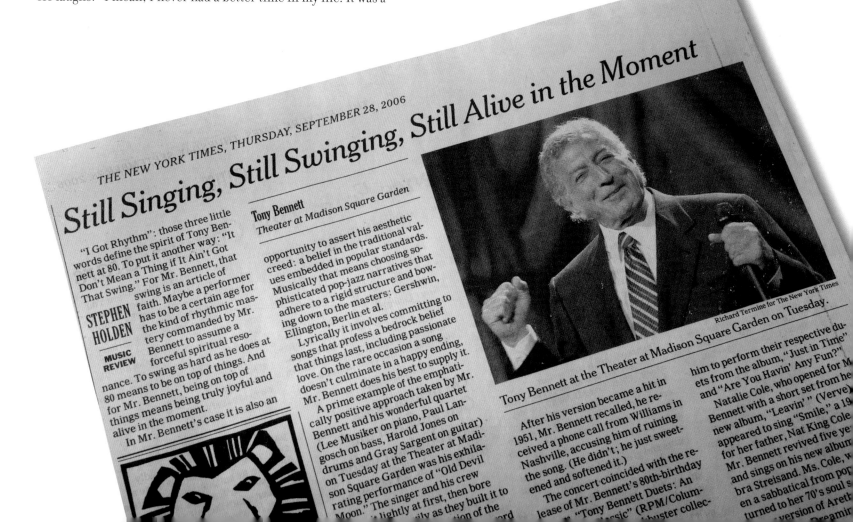

THE NEW YORK TIMES, THURSDAY, SEPTEMBER 28, 2006

# Still Singing, Still Swinging, Still Alive in the Moment

**Tony Bennett**
Theater at Madison Square Garden

**STEPHEN HOLDEN**

MUSIC REVIEW

"I Got Rhythm": those three little words define the spirit of Tony Bennett at 80. To put it another way: "It Don't Mean a Thing if It Ain't Got That Swing." For Mr. Bennett, that swing is an article of faith. Maybe a performer has to be a certain age for the kind of rhythmic mastery commanded by Mr. Bennett to assume a forceful spiritual resonance. To swing as hard as he does at 80 means to be on top of things. And for Mr. Bennett, being on top of things means being truly joyful and alive in the moment.

In Mr. Bennett's case it is also an opportunity to assert his aesthetic creed: a belief in the traditional values embedded in popular standards. Musically that means choosing sophisticated pop-jazz narratives that adhere to a rigid structure and bowing down to the masters: Gershwin, Ellington, Berlin et al.

Lyrically it involves committing to songs that profess a bedrock belief that things last, including passionate love. On the rare occasion a song doesn't culminate in a happy ending, Mr. Bennett does his best to supply it.

A prime example of the emphatically positive approach taken by Mr. Bennett and his wonderful quartet (Lee Musiker on piano, Paul Langosch on bass, Harold Jones on drums and Gray Sargent on guitar) on Tuesday at the Theater at Madison Square Garden was his exhilarating performance of "Old Devil Moon." The singer and his crew lightly at first, then bore it lightly at first, then built it to ... as they built it to ... tion of the ...

Tony Bennett at the Theater at Madison Square Garden on Tuesday.

Richard Termine for The New York Times

After his version became a hit in 1951, Mr. Bennett recalled, he received a phone call from Williams in Nashville, accusing him of ruining the song. (He didn't; he just sweetened and softened it.)

The concert coincided with the release of Mr. Bennett's 80th-birthday "Tony Bennett Duets: An ... ssic" (RPM/Colum-... buster collec-

... him to perform their respective duets from the album, "Just in Time" and "Are You Havin' Any Fun?"

Natalie Cole, who opened for Mr. Bennett with a short set from her new album, "Leavin'" (Verve), appeared to sing "Smile," a ... for her father, Nat King Cole. Mr. Bennett revived five ye... and sings on his new album ... bra Streisand. Ms. Cole, w... en a sabbatical from po... turned to her 70's soul ... version of Are...

# "Life is a gift, and we should all cherish it."

*Still Life—Purple Flowers in Crystal Vase,*
watercolor on paper, 20 x 14 ¼ inches

"The year was just . . ." It was just one big rolling party, one that seems destined to continue. At year's end, Tony and Danny announced a new coast-to-coast tour of America in 2007. "It's got one sponsor," Tony says with a big smile. "AARP!" That happens to be the American Association of Retired Persons, and Tony is certainly a fitting symbol for how vital life can be for a senior citizen. But then, of course, there's the irony: He has never retired, and surely never will. "I'm still on that journey to communicate how beautiful life is," he says. "Life is a gift, and we should all cherish it.

"Simple as that."

He is asked if there ever might come a day when he hangs it up.

In answering, he returns to that note he hit early on, and that Danny hit as well: the one about compulsion. He shades the story a bit differently this time, and adds a little humor. "The late Joe Williams, the great singer, told me one time when I met him on a plane, he told me, 'It's not that you want to sing; you have to sing.'

"I said, 'Thanks, Joe, for that. Now I don't have to go to a psychiatrist.'

"But really, that's it; I have to do it. And I'm far from finished."

# "Casals was living in Puerto Rico. And I met him. And he said the greatest thing I ever heard."

I WANTED TO ASK TONY A LAST QUESTION, and I went back to what had first struck me about this generous man: *So-and-so told me this; So-and-so did that for me.* I started thinking about what an interesting thing this leitmotif was. It traced a history of American culture, from a first-person perspective, that was altogether remarkable and, I would wager, singular. Tony had told me, through the years, about receiving advice from George Burns and Jack Benny (not to mention his own uncle) during the waning years of vaudeville, from Sinatra and Crosby and Ella and Nat during the glory years of popular singing, from Duke and the Count and Louis Armstrong on jazz, from Martin Luther King Jr. on the value of pacifism (King's counsel helped Tony overcome a pugnaciousness that had landed him in more than a couple of fights), from Judy Garland on the perils of stardom and from Rosemary Clooney on perseverance, from Cary Grant on following your most lucid muse, from Allen Ginsberg on book buying in New York and what it takes to sing

Blake, from his own son Danny and from Elvis Costello on the kids these days.

I asked Tony to look to the future, as he always does, and also to the past, and to ponder who was the wisest person—the very wisest—he ever knew, and how the advice of this sage might apply tomorrow.

"Pablo Casals," he said without pause. He explained why, recalling his meeting with the famed cellist: "I met him on a whim. I was working at a café in Puerto Rico, and the café owner said, 'You look bored. Let me introduce you to someone.' Casals and Picasso had left Spain because of Franco and the fascism, and Casals was living in Puerto Rico. And I met him. And he said the greatest thing I ever heard: 'At any given moment you can learn.' Isn't that wonderful? The way he spoke. The way he spoke . . ."

"I'm eighty," said Tony contentedly. And then he reiterated what Casals—and Leonardo and Michelangelo and all the others—had taught him. "I still have so much to learn."

*Golden Gate Bridge,* watercolor on paper, 22 x 15 inches

Benedetto

# THE MASTER

"I'm still on that journey to communicate how beautiful life is. . . . And I'm far from finished."

*Gondola, Venice,*
watercolor on paper,
15 x 20 inches

*San Donato in Poggio,*
watercolor on paper,
11 ½ x 14 ½ inches

San Donato in Pog

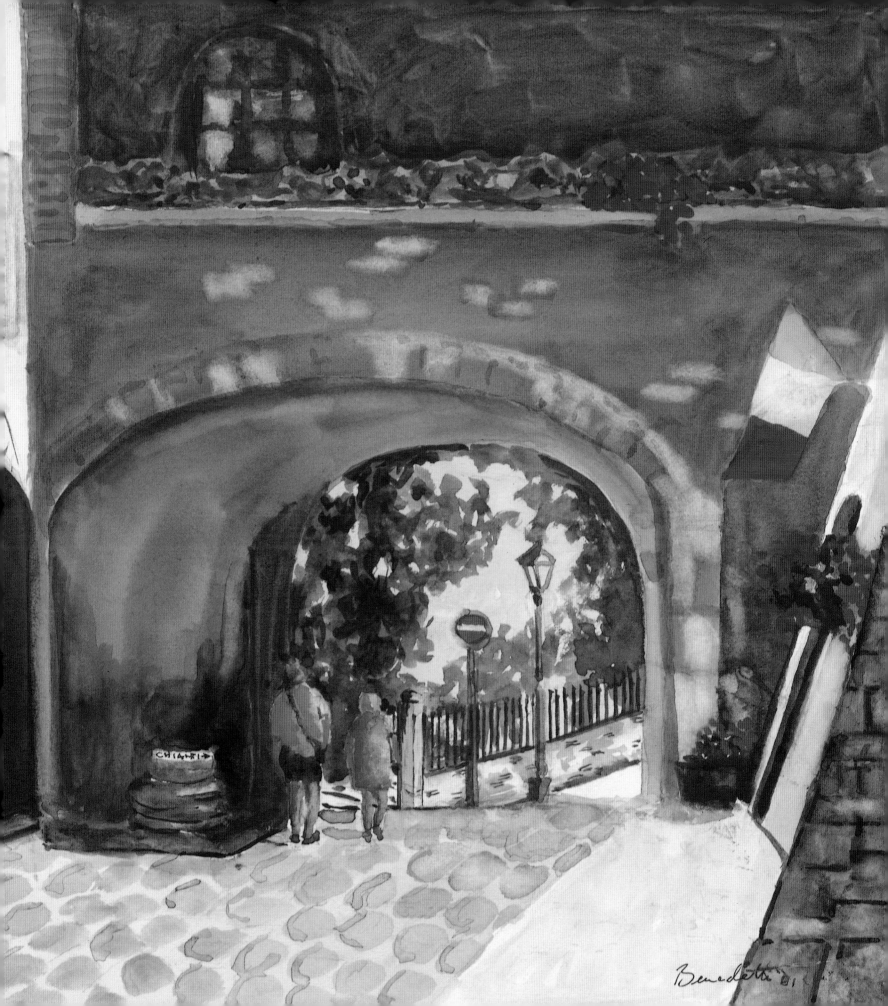

*Still Life at the Crow's Landing,*
watercolor on paper,
15 x 20 inches

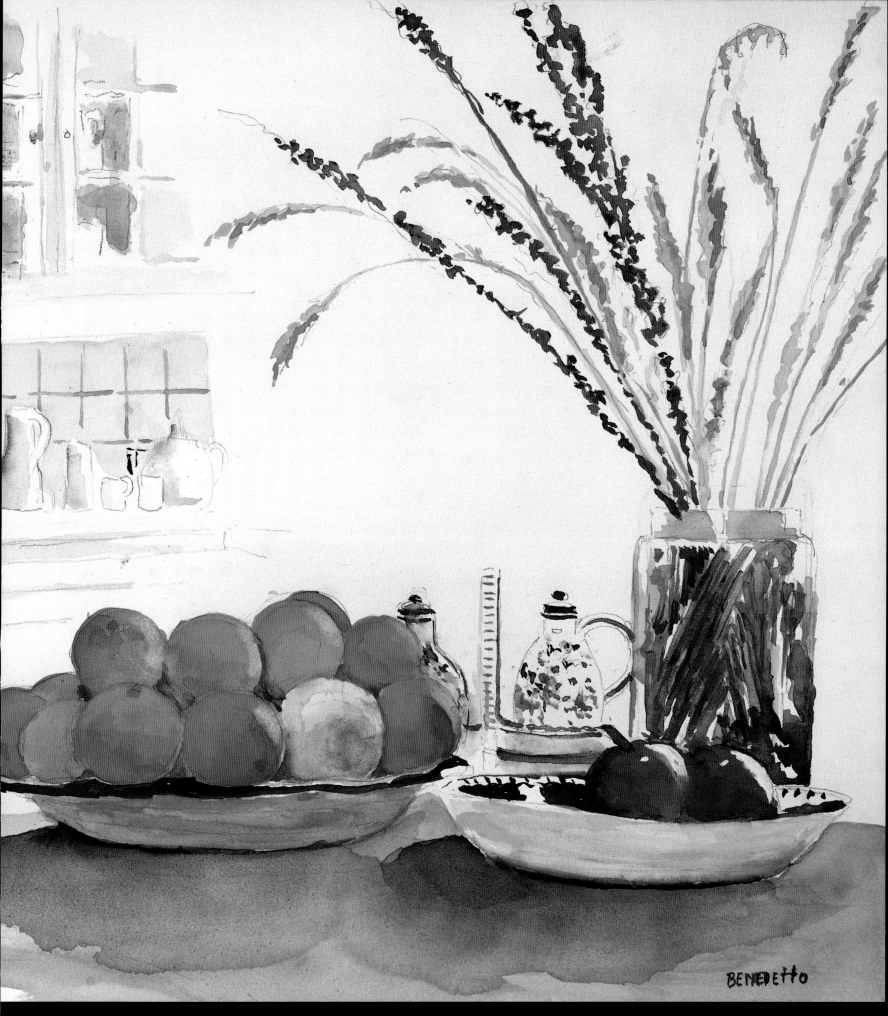

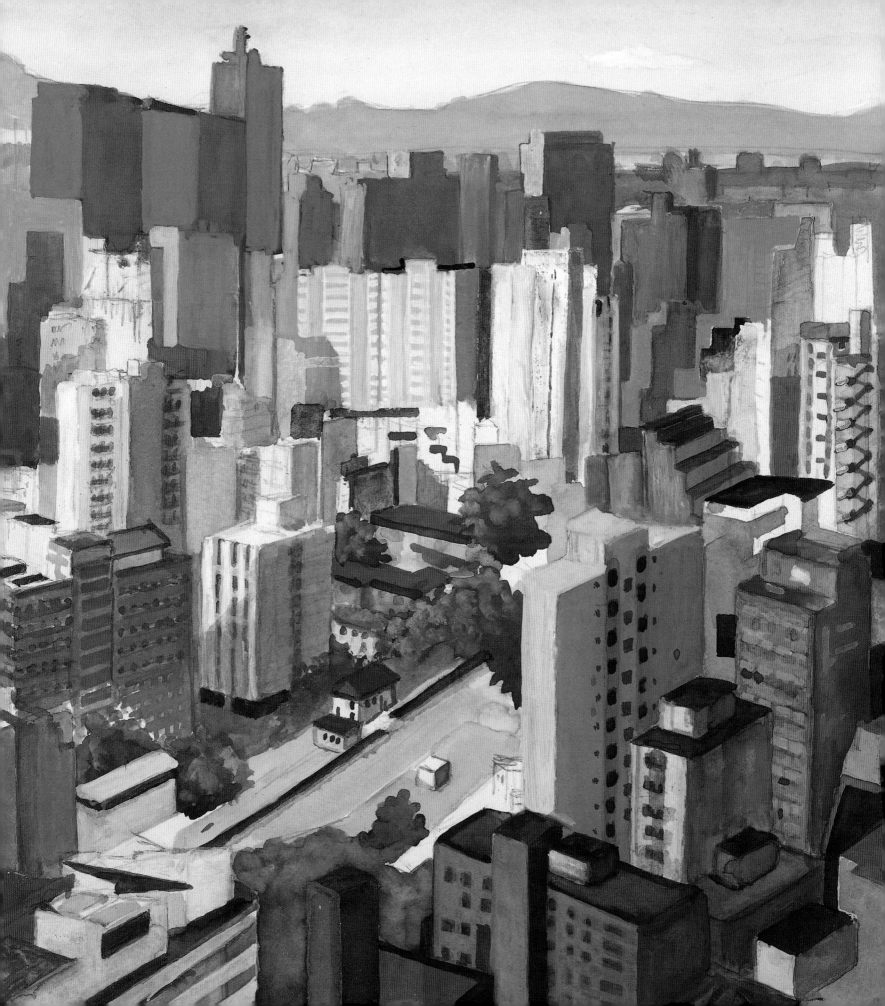

*Kickin' Up Dirt Series—*
*Kentucky Derby,*
watercolor on paper,
14 1/2 x 11 1/2 inches

BENEDETTO

*Self-Portrait,*
oil on canvas,
18 x 14 inches

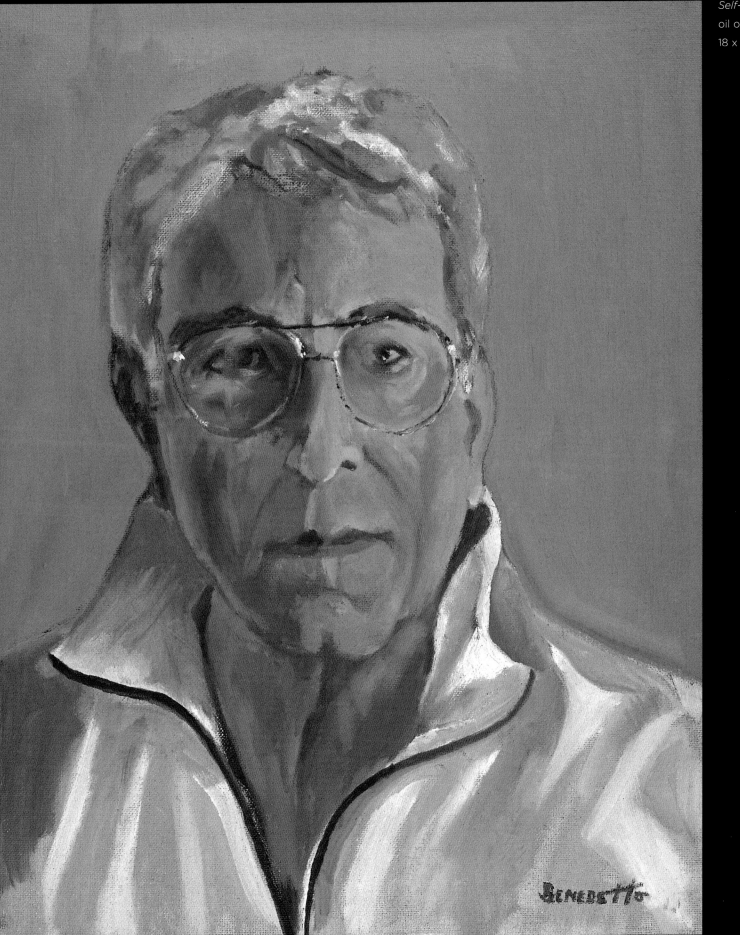

# CODA

"I've got to sing. I've got to paint."

*Lou Columbo's Jam Session,*
pencil on paper,
6 x 8½ inches

*For Quincy,*
*my great friend,*
*Tony Bennett / Benedetto*

*Quincy Jones,*
watercolor on paper,
14 x 20 inches

*Phil Ramone,*
ink on paper,
4½ x 3¼ inches

*Musician,*
ink on paper,
5 x 3¾ inches

*Jack Mahew,*
ink on paper,
5 ½ x 4 ½ inches

*Blue Note,*
ink on paper,
5 x 3 ¾ inches

"THE BEST IS YET TO COME."

CY COLEMAN

Barbara Streisand as Fanny Brice.

Cy Coleman,
ink on paper,
5½ x 3¾ inches

Barbra Streisand,
ink on paper,
8¼ x 5½ inches

MONTMARTRE

BENEDETTO

SCOTT HAMILTON

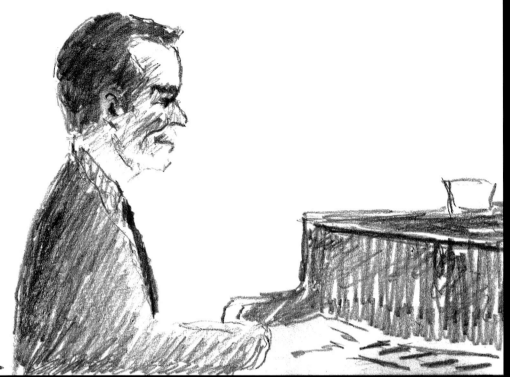

*Hyannis, Cape Cod,*
*Lee Musiker, Aug. 2002,*
pencil on paper,
6 x 8½ inches

HYANNIS,
LEE CAPE COD
MUSIKER
AUG. 2002

*Charles DeForest,*
ink on paper,
5½ x 4 inches

CHARLES DEFORREST

Bruckter

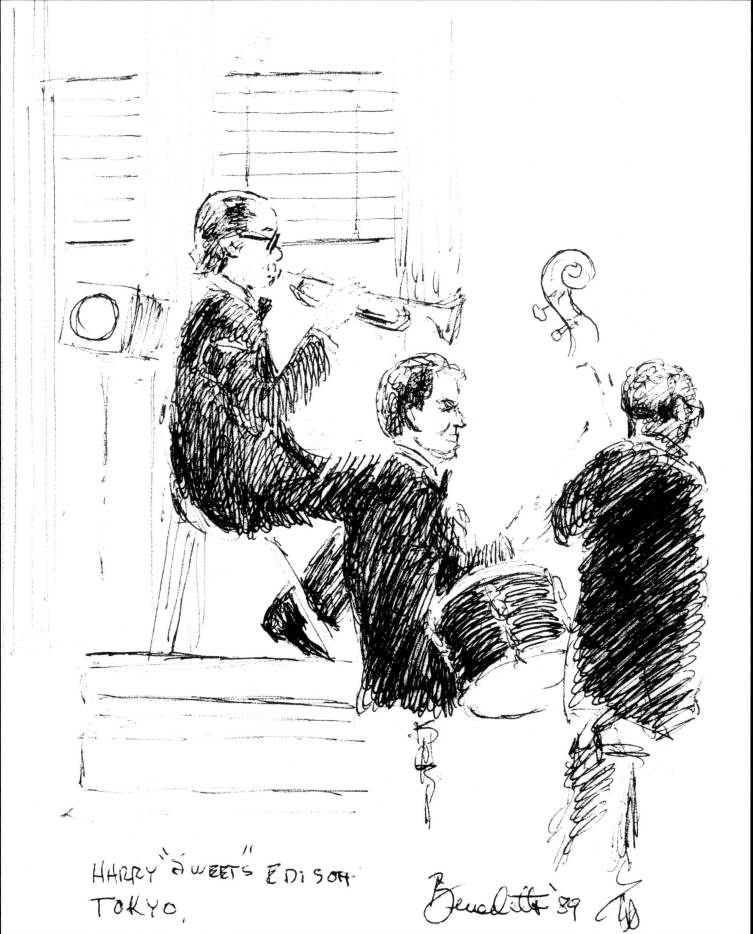

HARRY "SWEET'S" EDISON.
TOKYO,

Benedetti '89

GERRY MULLIGAN

'DOUG' RICHARDSON

Doug Richardson,
pencil on paper,
6½ x 5 inches

Gerry Mulligan,
ink on paper,
5½ x 3¾ inches

Gray Sargent,
pencil on paper

CANDIDO"

MR. B"

**Above Left:**
*Candido,*
ink on paper

**Above Right:**
*Billy Eckstine,*
ink on paper,
6 x 4 inches

**Left:**
*Birdland,*
pencil on paper

*Diana Ross,*
ink on paper,
8 1/2 x 5 1/4 inches

*Ray Charles—*
*Blue Note, Aug. '89,*
ink on paper,
5 x 3 1/4 inches

RONNIE ZITO

*Ronnie Zito,*
ink on paper,
5 x 4 ¼ inches

DIZZY

LONDON `82

*Ronnie Scott's, London '82,*
ink on paper

*Louis Armstrong,*
oil on canvas,
20 x 16 inches

*Sinatra, Young and Old,*
pencil on paper

BENEDETTO

*Self-Portrait,*
charcoal on paper,
17 x 14 inches

# APPENDIX

*Lunch in Venice,* pencil on paper, 8 x 11 inches

# MUSIC

## SPECIAL PERFORMANCES

### FOR PRESIDENTS OF THE UNITED STATES

Dwight D. Eisenhower

John F. Kennedy

Lyndon B. Johnson

Gerald Ford

Jimmy Carter

Ronald Reagan

George H. W. Bush

William J. Clinton

George W. Bush

### FOR BRITISH ROYALTY IN LONDON

**1965** Royal Command Performance at the London Palladium in the presence of Her Majesty Queen Elizabeth II and HRH Prince Philip, Duke of Edinburgh

**1966** Performance at Grosvenor House in the presence of Her Majesty the Queen Mother

**1970** Performance at Buckingham Palace in the presence of HRH Prince Philip, Duke of Edinburgh

**1972** National Playing Fields Association Charity Gala with Louis Armstrong in the presence of HRH Princess Alexandra

**1982** Royal Variety Gala at the Barbican Theatre in the presence of TRH the Prince and Princess of Wales

**1995** Royal Command Performance at the Dominion Theatre

**1996** Royal Albert Hall performance in the presence of Her Majesty Queen Elizabeth II and Nelson Mandela, president of South Africa

**2002** The Party at the Palace, Queen's Jubilee concert, in the presence of Her Majesty Queen Elizabeth II

Tony celebrates with his daughters Johanna (left) and Antonia (right) at the Kennedy Center Awards in December 2005.

## SPECIAL AWARDS AND HONORS

**1996** Primetime Emmy Awards: Outstanding Performance for a Variety or Music Program

**1996** Cable Ace Awards: Performance in a Music Special or Series

**1998** Juvenile Diabetes Research Foundation: Humanitarian of the Year Award

Tony Bennett was awarded the Living Legend Award by the Library of Congress in April 2000.

**2000** United Nations: Citizen of the World Award

**2000** American Cancer Society: Humanitarian Award

**2000** Library of Congress Living Legend Award

**2001** George Washington University: Honorary Doctor of Music Degree

**2002** The King Center: Salute to Greatness Award

**2002** ASCAP: Pied Piper Lifetime Achievement Award

**2003** Songwriters Hall of Fame: Towering Song Award and Towering Performance Award

**2005** Kennedy Center for the Performing Arts Honoree

**2006** National Endowment for the Arts: Jazz Master

**2006** ASCAP: Legacy Award

**2006** Billboard Century Award

**2007** United Nations Humanitarian Award

**2007** Inductee in Civil Rights Walk of Fame

# GRAMMY® AWARDS

*All title genres are Traditional Pop unless noted.*

### 1962 (5th Awards)
**Record of the Year**
> I Left My Heart in San Francisco
> (Genre: General)

**Best Solo Vocal Performance, Male**
> I Left My Heart in San Francisco
> (Genre: Pop)

### 1992 (35th Awards)
**Best Traditional Pop Vocal Performance**
> Perfectly Frank

1962 Grammy Award for "I Left My Heart in San Francisco"

### 1996 (39th Awards)
**Best Traditional Pop Vocal Performance**
> Here's to the Ladies

### 1997 (40th Awards)
**Best Traditional Pop Vocal Performance**
> Tony Bennett on Holiday

### 1999 (42nd Awards)
**Best Traditional Pop Vocal Performance**
> Bennett Sings Ellington: Hot & Cool

The envelope please . . . In 1994 Tony won the Grammy Award for Best Traditional Pop Vocal Performance for *MTV Unplugged*. His co-nominees were Rosemary Clooney, Michael Crawford, Diane Schuur, and Barbra Streisand.

### 1993 (36th Awards)
**Best Traditional Pop Vocal Performance**
> Steppin' Out

### 1994 (37th Awards)
**Album of the Year**
> MTV Unplugged

**Best Traditional Pop Vocal Performance**
> MTV Unplugged (Genre: General)

Tony and Danny Bennett display their Grammys for *Duets* at the 2006 Grammy Awards.

### 2001 (44th Awards)
**Lifetime Achievement Award**

### 2002 (45th Awards)
**Best Traditional Pop Vocal Album**
> Playin' with My Friends: Bennett Sings the Blues

### 2003 (46th Awards)
**Best Traditional Pop Vocal Album**
> A Wonderful World
> (award shared with k.d. lang)

1994 Grammy Award for *MTV Unplugged*

### 2005 (48th Awards)
**Best Traditional Pop Vocal Album**
> The Art of Romance

### 2006 (49th Awards)
**Best Pop Collaboration with Vocals**
> For Once in My Life
> (award shared with Stevie Wonder)

**Best Traditional Pop Vocal Album**
> Duets: An American Classic

# DISCOGRAPHY

## ALBUMS AND CDS

### THE FIFTIES

**July 1952**

*Because of You* (Columbia)
>Because of You
>Boulevard of Broken Dreams
>While We're Young
>I Wanna Be Loved
>Once There Lived a Fool
>The Valentino Tango
>I Won't Cry Anymore
>Cold, Cold Heart

**February 1955**

*Cloud 7* (Columbia)
>I Fall in Love Too Easily
>My Baby Just Cares for Me
>My Heart Tells Me
>Old Devil Moon
>Love Letters
>My Reverie
>Give Me the Simple Life
>While the Music Plays On
>I Can't Believe You're in Love with Me
>Darn That Dream

**October 1955**

*Alone At Last* (Columbia)
>Sing, You Sinners
>Somewhere Along the Way
>Since My Love Has Gone
>Stranger in Paradise
>Here in My Heart
>Please, Driver (Once Around the Park Again)

**ca. 1955–56**

*The Voice of Your Choice* (UK Philips)
>There'll Be No Teardrops Tonight
>Take Me Back Again
>Something's Gotta Give
>Stranger in Paradise
>Close Your Eyes
>What Will I Tell My Heart?
>Tell Me That You Love Me
>How Can I Replace You?

**March 1956**

*Because of You* (Columbia)
>Close Your Eyes
>I Can't Give You Anything But Love
>Boulevard of Broken Dreams
>Because of You
>May I Never Love Again
>Cinnamon Sinner

**January 1957**

*Tony Bennett Showcase* (Columbia)
>It Had to Be You
>You Can Depend on Me
>I'm Just a Lucky So and So
>Taking a Chance on Love
>These Foolish Things
>I Can't Give You Anything But Love
>Boulevard of Broken Dreams
>I'll Be Seeing You
>Always
>Love Walked In
>Lost in the Stars
>Without a Song

**December 1957**

*The Beat of My Heart* (Columbia)
>Let's Begin
>Lullaby of Broadway
>Let There Be Love
>Love for Sale
>Army Air Corps Song
>Crazy Rhythm
>The Beat of My Heart
>So Beats My Heart for You
>Blues in the Night
>Lazy Afternoon
>Let's Face the Music and Dance
>Just One of Those Things

**July 1958**

*Long Ago and Far Away* (Columbia)
>It Could Happen to You
>Every Time We Say Goodbye
>Long Ago (And Far Away)
>It Amazes Me
>The Way You Look Tonight
>Be Careful, It's My Heart
>My Foolish Heart
>Time After Time
>Fools Rush In

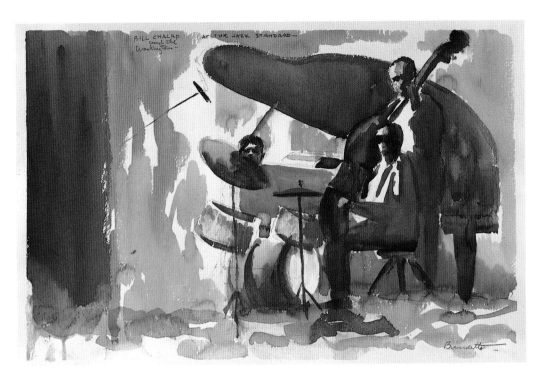

*Bill Charlap at Jazz Standard*, watercolor on paper, 15 x 22 inches

A Cottage for Sale
Blue Moon
So Far

**November 1958**
*A String of Hits,* Record 1, Compilation (Columbia)
    Stranger in Paradise
    Cold Heart
    Because of You
    Rags to Riches
    Boulevard of Broken Dreams
    Young and Warm and Wonderful
    In the Middle of an Island
    Ça, C'est l'Amour
    Just in Time
    There'll Be No Teardrops Tonight
    Anywhere I Wander
    Sing, You Sinners

**July 1959**
*Hometown, My Town* (Columbia)
    The Skyscraper Blues
    Penthouse Serenade (When We're Alone)
    By Myself
    I Cover the Waterfront
    Love Is Here to Stay
    The Party's Over

**August 1959**
*Blue Velvet* (Columbia)
    Blue Velvet
    I Won't Cry Anymore
    Have a Good Time
    Congratulations to Someone
    Here Comes that Heartache Again
    While We're Young
    Solitaire
    My Heart Won't Say Goodbye
    Until Yesterday
    Funny Thing
    May I Never Love Again
    It's So Peaceful in the Country

**September 1959**
*In Person! With Count Basie* (Columbia)
    Just in Time
    When I Fall in Love
    Taking a Chance on Love
    Without a Song
    Fascinatin' Rhythm

Solitude
Pennies from Heaven
Lost in the Stars
Firefly
There Will Never Be Another You
Lullaby of Broadway
Ol' Man River

**THE SIXTIES**

**February 1960**
*To My Wonderful One* (Columbia)
    Wonderful One
    Till
    September Song
    Suddenly
    I'm a Fool to Want You
    We Mustn't Say Goodbye
    Autumn Leaves
    Laura
    April in Paris
    Speak Low
    Tenderly
    Last Night When We Were Young

**July 1960**
*Alone Together* (Columbia)
    Alone Together
    This Is All I Ask
    Out of This World
    Walk in the Country
    I'm Always Chasing Rainbows
    Poor Butterfly
    After You've Gone
    Gone with the Wind
    It's Magic
    How Long Has This Been Going On?
    For Heaven's Sake

**October 1960**
*A String of Hits,* Record 2, Compilation (Columbia)
    Smile
    You'll Never Get Away from Me
    I Am
    Put on a Happy Face
    Love Look Away
    I'll Bring you a Rainbow
    Ask Anyone in Love
    You Can't Love Them All
    Baby Talk to Me
    Firefly

The Night That Heaven Fell
Climb Ev'ry Mountain

**November 1960**
*A String of Harold Arlen* (Columbia)
    When the Sun Comes Out
    Over the Rainbow
    House of Flowers
    Come Rain or Come Shine
    For Every Man There's a Woman
    Let's Fall in Love
    Right as the Rain
    It Was Written in the Stars
    What Good Does It Do?
    Fun to Be Fooled
    This Time the Dream's on Me
    I've Got the World on a String

**1961**
*Bennett & Basie: Strike Up the Band* (Roulette)
    Strike Up the Band
    I Guess I'll Have to Change My Plans
    Chicago
    With Plenty of Money and You
    Growing Pains
    Life Is a Song
    I've Grown Accustomed to Her Face
    Jeepers Creepers
    Anything Goes
    Poor Little Rich Girl
    Are You Having Any Fun?

**February 1961**
*Tony Sings for Two* (Columbia)
    I Didn't Know What Time It Was
    Bewitched
    Nobody's Heart Belongs to Me
    I'm Thru with Love
    My Funny Valentine
    The Man That Got Away
    Where or When
    A Sleepin' Bee
    Happiness Is a Thing Called Joe
    Mam'selle
    Just Friends
    Street of Dreams
    Skylark (outtake on CD)

**August 1961**

*My Heart Sings* (Columbia)

Don't Worry 'Bout Me
Dancing in the Dark
I'm Coming, Virginia
My Heart Sings
It Never Was You
You Took Advantage of Me
Close Your Eyes
Stella by Starlight
More Than You Know
My Ship
Lover Man
Toot, Toot, Tootsie! (Goodbye)

**March 1962**

*Mr. Broadway: Tony's Greatest Broadway Hits,*
Compilation (Columbia)

Just in Time
You'll Never Get Away from Me
Put on a Happy Face
Follow Me
Climb Ev'ry Mountain
Love Look Away
Comes Once in a Lifetime
The Party's Over (edited)
Baby Talk to Me
Begin the Beguine
Stranger in Paradise
Lazy Afternoon

**June 1962**

*I Left My Heart in San Francisco* (Columbia)

I Left My Heart in San Francisco
Once Upon a Time
Tender Is the Night
Smile
Love for Sale
Taking a Chance on Love
Candy Kisses
Have I Told You Lately?
The Rules of the Road
Marry Young
I'm Always Chasing Rainbows
The Best Is Yet to Come

**August 1962**

*Tony Bennett at Carnegie Hall* (Columbia)

Lullaby of Broadway
Just in Time

All the Things You Are
Stranger in Paradise
Love Is Here to Stay
Climb Ev'ry Mountain
Ol' Man River
It Amazes Me
Firefly
I Left My Heart in San Francisco
How About You/April in Paris
Solitude
I'm Just a Lucky So and So
Always
Anything Goes
Blue Velvet
Rags to Riches
Because of You
What Good Does It Do?
Lost in the Stars
One for My Baby
Lazy Afternoon
Sing, You Sinners
Love Look Away
Sometimes I'm Happy
My Heart Tells Me
De Glory Road

**1963**

*Tony Bennett Meets Gene Krupa* (Sandy Hook)

Have I Told You Lately?
April in Paris
Just in Time
I Left My Heart in San Francisco
Sometimes I'm Happy
Small World Isn't It?
Sunday
Fascinatin' Rhythm

**February 1963**

*I Wanna Be Around* (Columbia)

The Good Life
If I Love Again
I Wanna Be Around
Love Look Away (UK only)
I've Got Your Number (US album)
Until I Met You
Let's Face the Music and Dance
If You Were Mine
I Will Live My Life for You
Someone to Love

It Was Me
Quiet Nights of Quiet Stars (Corcovado)

**July 1963**

*This Is All I Ask* (Columbia)

Keep Smiling at Trouble
Autumn in Rome
True Blue Lou
The Way That I Feel
This Is All I Ask
The Moment of Truth
Got Her Off My Hands
    (But Can't Get Her Off My Mind)
Sandy's Smile
Long About Now
Young and Foolish
Tricks
On the Other Side of the Tracks

**January 1964**

*The Many Moods of Tony* (Columbia)

The Little Boy
When Joanna Loved Me
A Taste of Honey
Soon It's Gonna Rain
The Kid's a Dreamer
So Long, Big Time
Don't Wait Too Long
Caravan
Spring in Manhattan
I'll Be Around
You've Changed
Limehouse Blues

**May 1964**

*When Lights Are Low* (Columbia)

Nobody Else But Me
When Lights Are Low
On Green Dolphin Street
Ain't Misbehavin'
It's a Sin to Tell a Lie
I've Got Just About Everything
Judy
Oh! You Crazy Moon
Speak Low
It Had to Be You
It Could Happen to You
The Rules of the Road

**November 1964**
*Who Can I Turn To?* (Columbia)
- Who Can I Turn To?
- Wrap Your Troubles in Dreams
- There's a Lull in My Life
- Autumn Leaves
- I Walk a Little Faster
- The Brightest Smile in Town
- I've Never Seen
- Between the Devil and the Deep Blue Sea
- Listen, Little Girl
- Got the Gate on the Golden Gate
- Waltz for Debbie
- The Best Thing to Be Is a Person

**April 1965**
*If I Ruled the World: Tony Bennett*
*(Songs for the Jet Set)* (Columbia)
- Song of the Jet
- Fly Me to the Moon (In Other Words)
- How Insensitive
- If I Ruled the World
- Love Scene
- My Ship (UK album)
- Take the Moment (US album)
- Then Was Then and Now Is Now
- Sweet Lorraine
- The Right to Love
- Watch What Happens
- All My Tomorrows
- Lazy Afternoon (UK album)
- Two by Two (US album)

**July 1965**
*Tony Bennett's Greatest Hits,* Compilation
(Columbia)
- I Left My Heart in San Francisco
- I Wanna Be Around
- Quiet Nights of Quiet Stars (Corcovado)
- When Joanna Loved Me
- The Moment of Truth
- Who Can I Turn To?
- The Good Life
- A Taste of Honey
- This Is All I Ask
- Once Upon a Time
- The Best Is Yet to Come
- If I Ruled the World

**1965**
*The Oscar* Soundtrack (CBS)
- The Theme from *The Oscar*
  (Maybe September)

**January 1966**
*The Movie Song Album* (Columbia)
- The Theme from *The Oscar*
  (Maybe September)
- Girl Talk
- The Gentle Rain
- Emily
- The Pawnbroker
- Samba de Orfeu
- The Shadow of Your Smile
- Smile
- The Second Time Around
- The Days of Wine and Roses
- Never Too Late
- The Trolley Song

**August 1966**
*A Time for Love* (Columbia)
- A Time for Love
- The Very Thought of You
- Trapped in the Web of Love
- My Funny Valentine
- In the Wee Small Hours of the Morning
- Yesterdays
- Georgia Rose
- The Shining Sea
- Sleepy Time Gal
- Touch the Earth
- I'll Only Miss Her When I Think of Her

**March 1967**
*Tony Makes It Happen* (Columbia)
- On the Sunny Side of the Street
- A Beautiful Friendship
- Don't Get Around Much Anymore
- What Makes It Happen?
- The Lady's in Love with You
- Can't Get Out of This Mood
- I Don't Know Why (I Just Do)
- I Let a Song Go Out of My Heart
- Country Girl
- Old Devil Moon
- She's Funny That Way

**December 1967**
*For Once in My Life* (Columbia)
- They Can't Take That Away from Me
- Something in Your Smile
- Days of Love
- Broadway/Crazy Rhythm/Lullaby of Broadway
- For Once in My Life
- Sometimes I'm Happy
- Out of This World
- Baby, Dream Your Dream
- How Do You Say Auf Wiedersehen?
- Keep Smiling at Trouble (Trouble's a Bubble)

**July 1968**
*Yesterday I Heard the Rain* (Columbia)
- Yesterday I Heard the Rain
- Hi-Ho
- Hushabye Mountain
- Home Is the Place
- Love Is Here to Stay
- Get Happy
- A Fool of Fools
- I Only Have Eyes for You
- Sweet Georgie Fame
- Only the Young
- There Will Never Be Another You

**November 1968**
*Snowfall: The Tony Bennett Christmas Album*
(Columbia)
- Snowfall
- My Favorite Things
- The Christmas Song
- Medley: We Wish you a Merry Christmas,
  Silent Night, O Come, All Ye Faithful,
  Jingle Bells, Where Is Love?
- Christmasland
- I Love the Winter Weather/
  I've Got My Love to Keep Me Warm
- White Christmas
- Winter Wonderland
- Have Yourself a Merry Little Christmas
- I'll Be Home for Christmas (CD only)

**April 1969**
*Greatest Hits Volume 2,* Compilation (Columbia)
- People
- For Once in My Life
- The Shadow of Your Smile
- Yesterday I Heard the Rain

My Favorite Things

Watch What Happens

Fly Me to the Moon (In Other Words)

How Insensitive (edited)

Georgia Rose

A Time for Love

The Gentle Rain

**July 1969**

*Just One of Those Things*, Compilation (Columbia)

Let's Begin

Lullaby of Broadway

Let There Be Love

Love for Sale

Crazy Rhythm

The Beat of My Heart

Blues in the Night

Lazy Afternoon

Let's Face the Music and Dance

Just One of Those Things

**July 1969**

*I've Gotta Be Me* (Columbia)

I've Gotta Be Me

Over the Sun

Play It Again, Sam

Alfie

What the World Needs Now Is Love

Baby, Don't You Quit Now

That Night

They All Laughed

A Lonely Place

Whoever You Are, I Love You

Theme from Valley of the Dolls

**December 1969**

*Tony Sings the Great Hits of Today* (Columbia)

MacArthur Park

Something

The Look of Love

Here, There and Everywhere

Live for Life

Little Green Apples

Eleanor Rigby

My Cherie Amour

Is That All There Is?

Here

Sunrise, Sunset

# THE SEVENTIES

## ca. 1970

*16 Most Requested Songs*, Compilation (Columbia)

Because of You

Stranger in Paradise

Rags to Riches

Boulevard of Broken Dreams

Cold, Cold Heart

Just in Time

I Left My Heart in San Francisco

I Wanna Be Around

Who Can I Turn To?

For Once in My Life

This Is All I Ask

Smile

Tender Is the Night

The Shadow of Your Smile

Love Story (Where Do I Begin)

The Good Life

## October 1970

*Something* (Columbia)

Something

The Long and Winding Road

Everybody's Talkin'

On a Clear Day

Coco

Think How It's Gonna Be

Wave

Make It Easy on Yourself

Come Saturday Morning

When I Look in Your Eyes

Yellow Days

What a Wonderful World

## December 1970

*All-Time Hall of Fame Hits*, Compilation (Columbia)

Because of You

Cold, Cold  Heart

Rags to Riches

One for My Baby/It Had to Be You

I Left My Heart in San Francisco

I Wanna Be Around

This Is All I Ask

The Good Life

The Shadow of Your Smile

Who Can I Turn To

Yesterday I Heard the Rain

For Once in My Life

**January 1971**

*Get Happy Live with the London Philharmonic Orchestra* (Columbia)

I Left My Heart in San Francisco

I Want to Be Happy

If I Ruled the World

Get Happy

Tea for Two

Let There Be Love

Love Story (Where Do I Begin)

The Trolley Song

I Left My Heart/I Wanna Be Around

Old Devil Moon

Country Girl

There Will Never Be Another You

Wave

On the Sunny Side of the Street

For Once in My Life

What the World Needs Now Is Love

I'll Begin Again

Closing Theme—San Francisco

**February 1971**

*Love Story* (Columbia)

Love Story (Where Do I Begin)

Tea for Two

I Want to Be Happy

Individual Thing

I Do Not Know a Day I Did Not Love You

They Can't Take That Away from Me

When Joanna Loved Me

Country Girl

The Gentle Rain

Soon It's Gonna Rain

A Taste of Honey

I'll Begin Again

**February 1971**

*Love Songs*, Double Compilation (CBS)

Alone Together

Bewitched

The Very Thought of You

Tender Is the Night

I Only Have Eyes for You

Where or When

Laura

Penthouse Serenade

I Cover the Waterfront

Stella by Starlight

Tenderly

I'm Thru with Love
September Song
My Funny Valentine
The Days of Wine and Roses
Street of Dreams
The Second Time Around
It Had to Be You
Till
Love for Sale

## August 1971
*The Very Thought of You,* Compilation (Columbia)
Just in Time
Don't Get Around Much Anymore
The Very Thought of You
Stranger in Paradise
The Second Time Around
Stella by Starlight
It's Magic
Laura
If I Love Again
I'll Be Around

## 1972
*Tony Bennett's Greatest Hits No. 7* (MGM Verve)
My Love
O Sole Mio
The Good Things in Life
Cute
Mimi
London by Night
On the Sunny Side of the Street
Let's Do It
Sophisticated Lady
Living Together, Growing Together
Tell Her It's Snowing (Short Version)
Give Me Love

## 1972
*The Good Things in Life* (MGM Verve)
The Good Things in Life
O Sole Mio
Passing Strangers
The End of a Love Affair
Oh! Lady Be Good
Blues for Breakfast
Mimi

Invitation
Someone to Light up My Life
It Was You
Cute
The Midnight Sun
London by Night
The Good Things in Life (Closing)

## January 1972
*Summer of '42,* Compilation (Columbia)
The Summer Knows
Walk About
It Was Me
I'm Losing My Mind
Till
Somewhere Along the Line
Coffee Break
More and More
Irena
My Inamorata
The Shining Sea

## May 1972
*With Love* (Columbia)
Here's That Rainy Day
Remind Me
How Beautiful Is Night (With You)
Maybe This Time
The Riviera
Street of Dreams
Love
Twilight World
Lazy Day
Easy Come, Easy Go
Harlem Butterfly
Dream

## August 1972
*All-Time Greatest Hits* (Columbia)
Something
Love Story (Where Do I Begin)
Maybe This Time
Just in Time
For Once in My Life
I Left My Heart in San Francisco
Because of You
Boulevard of Broken Dreams
Stranger in Paradise
I Wanna Be Around
A Time for Love

Who Can I Turn To?
This Is All I Ask
Smile
Sing, You Sinners
Firefly
The Shadow of Your Smile
Put on a Happy Face
Love Look Away
Rags to Riches

## March 1973
*Tony!* Compilation (Columbia)
Who Can I Turn To?
Yellow Days
Smile
Alfie
The Look of Love
Something
There's a Lull in My Life
MacArthur Park
I'll Only Miss Her When I Think of Her
The Second Time Around

## 1973
*Listen Easy* (Philips)
Love Is the Thing
Rain, Rain (Don't Go Away)
The Hands of Time
I Concentrate on You
At Long Last Love
If I Could Go Back
On the Sunny Side of the Street
The Garden (Once in a Garden)
My Funny Valentine
How Little We Know
Tell Her That It's Snowing

## June 1973
*Sunrise, Sunset,* Compilation (Columbia)
The Days of Wine and Roes
Climb Ev'ry Mountain
Yesterdays
She's Funny That Way
You'll Never Get Away from Me
Sunrise, Sunset
Love Story (Where Do I Begin)
The Party's Over
Put on a Happy Face
Begin the Beguine
Don't Get Around Much Anymore

**September 1973**

*Tony Bennett Sings 10 Rodgers & Hart Songs* (Improv)

 This Can't Be Love

 Blue Moon

 The Lady Is a Tramp

 Lover

 Manhattan

 Spring Is Here

 Have You Met Miss Jones?

 Isn't It Romantic?

 Wait Till You See Her

 I Could Write a Book

**September 1973**

*Tony Bennett Sings More Great Rodgers & Hart*
(Improv)

 Thou Swell

 The Most Beautiful Girl in the World

 There's a Small Hotel

 I've Got Five Dollars

 You Took Advantage of Me

 Wish I Were in Love Again

 This Funny World

 My Heart Stood Still

 My Romance

 Mountain Greenery

**1974**

*The Trolley Song,* Compilation (Embassy)

 Alfie

 The Days of Wine and Roses

 There Will Never Be Another You

 What the World Needs Now Is Love

 A Beautiful Friendship

 She's Funny That Way

 Fascinatin' Rhythm

 Old Devil Moon

 I've Gotta Be Me

 Girl Talk

 The Trolley Song

**1974**

*When I Fall in Love,* Compilation

 When I Fall in Love

 Taking a Chance on Love

 Pennies from Heaven

 Ol' Man River

 Play It Again, Sam

 They All Laughed

 The Gentle Rain

 Firefly

How About You?

April in Paris

Solitude

Country Girl

**ca. 1975**

*The Golden Touch of Tony,* Compilation

 I Left My Heart in San Francisco

 Just in Time

 Blue Velvet

 A Taste of Honey

 Cold, Cold Heart

 For Once in My Life

 This Is All I Ask

 Rags to Riches

 If I Ruled the World

 In the Middle of an Island

 Smile

 Don't Wait Too Long

 Can You Find It in Your Heart?

 One for My Baby

 Stranger in Paradise

 Fly Me to the Moon (In Other Words)

 My Funny Valentine

 Climb Ev'ry Mountain

 Spring in Manhattan

 I Wanna Be Around

 The Good Life

 Solitaire

 The Shadow of Your Smile

 Here in My Heart

 Who Can I Turn To?

**ca. 1975**

*Spotlight on . . . Tony Bennett,* Compilation (Philips)

 The End of a Love Affair

 Passing Strangers

 All That Love Went to Waste

 Love Is the Thing

 On the Sunny Side of the Street

 The Garden (Once in a Garden)

 Invitation

 Someone to Light Up My Life

 If I Could Go Back

 The Hands of Time

 O Sole Mio

 Some of These Days

 The Midnight Sun

 It Was You

 London by Night

My Love

Oh! Lady Be Good

Cute

I Concentrate on You

Mimi

Tell Her That It's Snowing

Blues for Breakfast

At Long Last Love

My Funny Valentine

How Little We Know

Rain, Rain (Don't Go Away)

The Good Things in Life

Give Me Love, Give Me Peace

**1975**

*The Tony Bennett/Bill Evans Album* (Fantasy)

 Young and Foolish

 The Touch of Your Lips

 Some Other Time

 When in Rome

 We'll Be Together Again

 My Foolish Heart

 Waltz for Debbie

 But Beautiful

 The Days of Wine and Roses

**1975**

*Life Is Beautiful* (Improv)

 Life Is Beautiful

 All Mine

 Bridges

 Reflections

 Experiment

 This Funny World

 As Time Goes By

 I Used to Be Color Blind

 Lost in the Stars

 There'll Be Some Changes Made

**May 1975**

*Tony Bennett Sings,* Compilation (Columbia)

 Fly Me to the Moon (In Other Words)

 Who Can I Turn To?

 If I Ruled the World

 The Trolley Song

 Sweet Lorraine

 My Favorite Things

 Candy Kisses

 Put on a Happy Face

 A Taste of Honey

Country Girl
They Can't Take That Away from Me
Climb Ev'ry Mountain

**May 1975**
*Let's Fall in Love with the Songs of Harold Arlen
and Cy Coleman,* Compilation (Columbia)
  When the Sun Comes Out
  House of Flowers
  Come Rain or Come Shine
  Let's Fall in Love
  Over the Rainbow
  Right As the Rain
  It Was Written in the Stars
  Fun to Be Fooled
  This Time the Dream's on Me
  I've Got the World on a String
  I've Got Your Number
  On the Other Side of the Tracks
  Firefly
  The Rules of the Road
  The Riviera
  The Best Is Yet to Come
  I Walk a Little Faster
  It Amazes Me
  Baby, Dream Your Dream
  Then Was Then, and Now Is Now

**1976**
*At Long Last Love,* Compilation (Philips)
  Someone to Light up My Life
  At Long Last Love
  How Little We Know
  It Was You
  Passing Strangers
  If I Could Go Back
  End of Love Affair
  My Love
  I Concentrate on You
  O Sole Mio
  The Midnight Sun
  Living Together, Growing Together

**1977**
*Tony Bennett & Bill Evans Together Again* (Improv)
  The Bad and the Beautiful
  Lucky to Be Me
  Make Someone Happy
  The Two Lonely People
  A Child Is Born

You're Nearer
You Don't Know What Love Is
Maybe September
Lonely Girl
You Must Believe in Spring

**May 1977**
*The McPartlands and Friends Make
Magnificent Music* (Improv)
  Watch What Happens
  While We're Young
  In a Mellow Tone
  'S Wonderful/I Left My Heart
    in San Francisco

**ca. 1977**
*Stage and Screen Hits,* Compilation (DBM)
  Cole Porter Selection 10-Song Medley
  Experiment
  One
  This Funny World
  Lost in the Stars
  As Time Goes By
  I Used to Be Color Blind
  Mr. Magic
  The Most Beautiful Girl in the World
  There's a Small Hotel
  I've Got Five Dollars
  I Wish I Were in Love Again
  Manhattan
  The Lady Is a Tramp
  My Romance
  Mountain Greenery
  Lucky to Be Me
  Make Someone Happy
  You're Nearer
  You Don't Know What Love Is
  Lonely Girl
  You Must Believe in Spring

**ca. 1978**
*The Unforgettable Tony Bennett,* Compilation
(Castle)
  There'll Be Some Changes Made
  Blue Moon
  The Lady Is a Tramp
  Lover
  Manhattan
  I Could Write a Book
  Spring Is Here

A Child Is Born
Make Someone Happy
Life Is Beautiful
Maybe September
Lonely Girl
You Don't Know What Love Is
Thou Swell
There's a Small Hotel
As Time Goes By

**THE EIGHTIES**
**May 1986**
*The Art of Excellence* (Columbia)
  Why Do People Fall in Love?
  Moments Like This
  What Are You Afraid Of?
  When Love Was All We Had
  So Many Stars
  Everybody Has the Blues
  How Do You Keep the Music Playing?
  City of the Angels
  Forget the Woman
  A Rainy Day
  I Got Lost in Her Arms
  The Day You Leave Me

**March 1987**
*Tony Bennett/Jazz,* Compilation (Columbia)
  I Can't Believe You're in Love with Me
  Don't Get Around Much Anymore
  Stella by Starlight
  On Green Dolphin Street
  Let's Face the Music and Dance
  I'm Through with Love
  Solitude
  Lullaby of Broadway
  Dancing in the Dark
  I Let a Song Go Out of My Heart
  When Lights Are Low
  Just One of Those Things
  Crazy Rhythm
  Judy
  Give Me the Simple Life
  Street of Dreams
  Love Scene
  While the Music Plays On
  Close Your Eyes
  Out of This World

**October 1987**

*Bennett/Berlin* (Columbia)

They Say It's Wonderful

Isn't This a Lovely Day?

All of My Life

Now It Can Be Told

The Song Is Ended

When I Lost You

Cheek to Cheek

Let Yourself Go

Let's Face the Music and Dance

Shakin' the Blues Away

Russian Lullaby

White Christmas

**December 1989**

*Astoria: Portrait of the Artist* (Columbia)

When Do the Bells Ring for Me?

I Was Lost I Was Drifting

A Little Street Where Old Friends Meet

The Girl I Love

It's Like Reaching for the Moon

Speak Low

The Folks Who Live on the Hill

Antonia

A Weaver of Dreams/
   There Will Never Be Another You

Body and Soul

Where Do You Go from Love?

The Boulevard of Broken Dreams

Where Did the Magic Go?

I've Come Home Again

## THE NINETIES

**1991**

*Forty Years: The Artistry of Tony Bennett,*
4-CD Compilation (Columbia)

**Disc One**

The Boulevard of Broken Dreams

Because of You

Cold, Cold Heart

Blue Velvet

Rags to Riches

Stranger in Paradise

While the Music Plays On

May I Never Love Again

Sing, You Sinners

Just in Time

Lazy Afternoon

Ça, C'est l'Amour

I Get a Kick Out of You

It Amazes Me

Penthouse Serenade

Lost in the Stars

Lullaby of Broadway

Firefly

A Sleepin' Bee

The Man That Got Away

Skylark

September Song

Till

**Disc Two**

Begin the Beguine

Put on a Happy Face

The Best Is Yet to Come

This Time the Dream's on Me

Close Your Eyes

Toot, Toot, Tootsie! (Goodbye)

Dancing in the Dark

Stella by Starlight

Tender Is the Night

Once Upon a Time

I Left My Heart in San Francisco

Until I Met You

If I Love Again

I Wanna Be Around

The Good Life

It Was Me

Spring in Manhattan

The Moment of Truth

This Is All I Ask

A Taste of Honey

When Joanna Loved Me

I'll Be Around

**Disc Three**

Nobody Else But Me

It Had to Be You

I've Got Just About Everything

Who Can I Turn To?

Waltz for Debbie

I Walk a Little Faster

Wrap Your Troubles in Dreams

If I Ruled the World

Fly Me to the Moon (In Other Words)

Love Scene

Sweet Lorraine

The Shadow of Your Smile

I'll Only Miss Her When I Think of Her

Baby, Dream Your Dream

Smile

Song from *The Oscar*

Maybe September

Emily

The Very Thought of You

A Time for Love

Country Girl

**Disc Four**

Days of Love

Keep Smiling at Trouble

For Once in My Life

Who Cares (So Long as You Care for Me)

Hi-Ho

Baby, Don't You Quit Now

Something

I Do Not Know a Day I Did Not Love You

Old Devil Moon

Remind Me

Maybe This Time

Some Other Time

My Foolish Heart

But Beautiful

How Do You Keep the Music Playing?

What Are You Afraid Of?

Why Do People Fall in Love?/People

I Got Lost in Her Arms

When I Lost You

Shakin' the Blues Away

Antonia

When Do the Bells Ring for Me?

**1993**

*Perfectly Frank* (Columbia)

Time After Time

I Fall in Love Too Easily

East of the Sun (West of the Moon)

Nancy

I Thought About You

Night and Day

I've Got the World on a String

I'm Glad There Is You

A Nightingale Sang in Berkeley Square

I Wished on the Moon

You Go to My Head

The Lady Is a Tramp

I See Your Face Before Me

Day In, Day Out

Indian Summer

Call Me Irresponsible
Here's That Rainy Day
Last Night When We Were Young
I Wish I Were in Love Again
A Foggy Day
Don't Worry 'Bout Me
One for My Baby
Angel Eyes
I'll Be Seeing You

## 1994
*Steppin' Out* (Columbia)
Steppin' Out with My Baby
Who Cares?
Top Hat, White Tie and Tails
They Can't Take That Away from Me
Dancing in the Dark
Shine on Your Shoes
He Loves and She Loves
They All Laughed
I Concentrate on You
You're All the World to Me
All of You
Nice Work If You Can Get It
It Only Happens When I Dance with You
Shall We Dance?
You're So Easy to Dance With/
    Change Partners/Cheek to Cheek
I Guess I'll Have to Change My Plans
That's Entertainment
By Myself

## 1994
*MTV Unplugged* (Columbia)
Old Devil Moon
Speak Low
It Had to Be You
I Love a Piano
It Amazes Me
The Girl I Love
Fly Me to the Moon
You're All the World to Me
Rags to Riches
When Joanna Loved Me
The Good Life/I Wanna Be Around
I Left My Heart in San Francisco
Steppin' Out with My Baby

Moonglow (duet with k.d. lang)
They Can't Take That Away from Me
    (duet with Elvis Costello)
A Foggy Day
All of You
Body and Soul
It Don't Mean a Thing
    (If It Ain't Got That Swing)
Autumn Leaves/Indian Summer

## 1995
*Here's to the Ladies* (Columbia)
People
I'm in Love Again
Somewhere Over the Rainbow
My Love Went to London
Poor Butterfly
Sentimental Journey
Cloudy Morning
Tenderly
Down in the Depths
Moonlight in Vermont
Tangerine
God Bless the Child
Daybreak
You Showed Me the Way
Honeysuckle Rose
Maybe This Time
I Got Rhythm
My Ideal

## 1997
*Tony Bennett on Holiday* (Columbia)
Solitude
All of Me
When a Woman Loves a Man
Me, Myself and I (Are All in Love with You)
She's Funny That Way (I Got a Woman,
    Crazy for Me)
If I Could Be with You (One Hour Tonight)
Willow Weep for Me
Laughing at Life
I Wished on the Moon
What a Little Moonlight Can Do
My Old Flame
The Ole Devil Called Love
Ill Wind (You're Blowing Me No Good)
These Foolish Things (Remind Me of You)
Some Other Spring

Crazy She Calls Me
Good Morning, Heartache
Trav'lin' Light
God Bless the Child
    (duet with Billie Holiday)

## 1998
*The Playground* (Columbia/RPM)
The Playground
Ac-Cent-Tchu-Ate the Positive
Dat Dere
Little Things (duet with Elmo)
Put on a Happy Face
    (duet with Rosie O'Donnell)
Because We're Kids
My Mom
Swinging on a Star
Bein' Green (duet with Kermit the Frog)
When You Wish Upon a Star
(It's Only) A Paper Moon
The Inch Worm
The Bare Necessities
Make the World Your Own
All God's Chillun Got Rhythm

## 1999
*Tony Bennett Sings Ellington: Hot & Cool*
(Columbia/RPM)
Do Nothin' Till You Hear from Me
Mood Indigo
She's Got It Bad (And That Ain't Good)
Caravan
Chelsea Bridge
Azure
I'm Just a Lucky So and So
In a Sentimental Mood
Don't Get Around Much Anymore
Sophisticated Lady
In a Mellow Tone
Day Dream
Prelude to a Kiss
It Don't Mean a Thing
    (If It Ain't Got That Swing)

**2000**

*The Ultimate Tony Bennett,* Compilation
(Columbia/RPM)

    I Left My Heart in San Francisco

    Because of You

    Rags to Riches

    Just in Time

    Stranger in Paradise

    The Boulevard of Broken Dreams

    I Wanna Be Around

    The Good Life

    The Shadow of Your Smile

    Put on a Happy Face

    If I Ruled the World

    Smile

    Night and Day

    How Do You Keep the Music Playing?

    Mood Indigo

    Blue Velvet

    Steppin' Out with My Baby

    When Joanna Loved Me

    When Do the Bells Ring for Me?

    The Best Is Yet to Come

**2001**

*Playin' with My Friends: Bennett Sings the Blues*
(Columbia/RPM)

    Alright, Okay, You Win

        (duet with Diana Krall)

    Everyday (I Have the Blues)

        (duet with Stevie Wonder)

    Don't Cry Baby

    Good Morning, Heartache

        (duet with Sheryl Crow)

    Let the Good Times Roll

        (duet with B. B. King)

    Evenin' (duet with Ray Charles)

    I Gotta Right to Sing the Blues

        (duet with Bonnie Raitt)

    Keep the Faith, Baby (duet with k.d. lang)

    Old Count Basie Is Gone

    Blue and Sentimental (duet with Kay Starr)

    New York State of Mind

        (duet with Billy Joel)

    Undecided Blues

    Blues in the Night

    Stormy Weather (duet with Natalie Cole)

    Playin' with My Friends

        (duet with various artists)

**2002**

*The Essential Tony Bennett* (Columbia/RPM)

    **Disc One**

    Because of You

    Cold, Cold Heart

    Blue Velvet

    Rags to Riches

    Stranger in Paradise

    Sing, You Sinners

    The Boulevard of Broken Dreams

    Just in Time

    It Amazes Me

    Love Look Away

    Lost in the Stars

    Firefly

    Put on a Happy Face

    The Best Is Yet to Come

    Tender Is the Night

    Once Upon a Time

    I Left My Heart in San Francisco

    I Wanna Be Around

    The Good Life

    This Is All I Ask

    When Joanna Loved Me

    The Rules of the Road

    **Disc Two**

    Who Can I Turn To? (When Nobody

        Needs Me)

    If I Ruled the World

    Fly Me to the Moon (In Other Words)

    The Shadow of Your Smile

    Smile

    The Very Thought of You

    For Once in My Life

    Yesterday I Heard the Rain

    My Favorite Things

    I Do Not Know a Day I Did Not Love You

    Maybe This Time

    How Do You Keep the Music Playing?

    When Do the Bells Ring for Me?

    Night and Day

    Last Night When We Were Young

    Steppin' Out with My Baby

    It Don't Mean a Thing

        (If It Ain't Got That Swing)

    Mood Indigo

    Keep the Faith, Baby (duet with k.d. lang)

**2002**

*A Wonderful World\** (Columbia/RPM)

    Exactly Like You

    La Vie en Rose

    I'm Confessin' (That I Love You)

    You Can Depend on Me

    What a Wonderful World

    That's My Home

    A Kiss to Build a Dream On

    I Wonder

    Dream a Little Dream of Me

    You Can't Lose a Broken Heart

    That Lucky Old Sun

        (Just Rolls Around Heaven All Day)

    If We Never Meet Again

    *\*All are duets with k.d. lang.*

**2004**

*Fifty Years: The Artistry of Tony Bennett,*
5-CD Compilation/Boxed Set (Columbia)

    **Disc One**

    The Boulevard of Broken Dreams

    Because of You

    Cold, Cold Heart

    Blue Velvet

    Rags to Riches

    Stranger in Paradise

    While the Music Plays On

    May I Never Love Again

    Sing, You Sinners

    Just in Time

    Lazy Afternoon

    Ça, C'est l'Amour

    I Get a Kick Out of You

    It Amazes Me

    Penthouse Serenade (When We're Alone)

    Lost in the Stars

    Lullaby of Broadway

    Firefly

    A Sleepin' Bee

    The Man That Got Away

    Skylark

    September Song

    Till

    **Disc Two**

    Begin the Beguine

    Put on a Happy Face

    The Best Is Yet to Come

    This Time the Dream's on Me

Close Your Eyes
Toot, Toot, Tootsie! (Goodbye)
Dancing in the Dark
Stella by Starlight
Tender Is the Night
Once Upon a Time
I Left My Heart in San Francisco
Until I Met You
If I Love Again
I Wanna Be Around
The Good Life
It Was Me
Spring in Manhattan
The Moment of Truth
This Is All I Ask
A Taste of Honey
When Joanna Loved Me
I'll Be Around

**Disc Three**
Nobody Else But Me
It Had to Be You
I've Got Just About Everything
Who Can I Turn To? (When Nobody
    Needs Me)
Waltz for Debby
I Walk a Little Faster
Wrap Your Troubles in Dreams
    (And Dream Your Troubles Away)
If I Ruled the World
Fly Me to the Moon (In Other Words)
Love Scene
Sweet Lorraine
The Shadow of Your Smile
I'll Only Miss Her When I Think of Her
Baby, Dream Your Dream
Smile
Song from *The Oscar* (Maybe September)
Emily
The Very Thought of You
A Time for Love
Country Girl
Days of Love

**Disc Four**
Keep Smiling at Trouble (Trouble's a Bubble)
For Once in My Life
Who Cares? (So Long As You Care for Me)
Hi-Ho
Baby, Don't You Quit Now
Something
Cold, Cold Heart
I Do Not Know a Day I Did Not Love You
Old Devil Moon (Live)
Remind Me
Maybe This Time
Some Other Time
My Foolish Heart
But Beautiful
How Do You Keep the Music Playing?
What Are You Afraid Of
Why Do People Fall in Love?/People
I Got Lost in Her Arms
Shakin' the Blues Away
Antonia
When Do the Bells Ring for Me?

**Disc Five**
East of the Sun (West of the Moon)
New York, New York
Steppin' Out with My Baby
They All Laughed
They Can't Take That Away from Me
Speak Low (Live)
Solitude
I Wished on the Moon
When a Woman Loves a Man
That Ole Devil Called Love
The Way You Look Tonight
Ac-Cent-Tchu-Ate the Positive
Bein' Green
Mood Indigo
Day Dream
Azure
Sophisticated Lady
Alright, Okay, You Win
Let the Good Times Roll
Evenin'
La Vie en Rose
What a Wonderful World

**2004**
*The Art of Romance* (Columbia/RPM)
    Close Enough for Love
    All in Fun
    Where Do You Start?
    Little Did I Dream
    I Remember You
    Time to Smile
    All for You
    The Best Man
    Don't Like Goodbyes
    Being Alive
    Gone with the Wind

**2006**
*Duets: An American Classic* (Columbia/RPM)
    Lullaby of Broadway
        (duet with the Dixie Chicks)
    Smile (duet with Barbra Streisand)
    Put on a Happy Face
        (duet with James Taylor)
    The Very Thought of You
        (duet with Paul McCartney)
    The Shadow of Your Smile
        (duet with Juanes)
    Rags to Riches (duet with Elton John)
    The Good Life (duet with Billy Joel)
    Cold, Cold Heart (duet with Tim McGraw)
    If I Ruled the World
        (duet with Celine Dion)
    The Best Is Yet to Come
        (duet with Diana Krall)
    For Once in My Life
        (duet with Stevie Wonder)
    Are You Havin' Any Fun?
        (duet with Elvis Costello)
    Because of You (duet with k.d. lang)
    Just in Time (duet with Michael Bublé)
    The Boulevard of Broken Dreams
        (duet with Sting)
    I Wanna Be Around (duet with Bono)
    Sing, You Sinners (duet with John Legend)
    I Left My Heart in San Francisco
        (piano accompaniment by Bill Charlap)
    How Do You Keep the Music Playing?
        (duet with George Michael)

## SINGLES

### 1950

Boulevard of Broken Dreams
Don't Cry, Baby
I Can't Give You Anything but Love
I Wanna Be Loved
Just Say I Love Her
Kiss You
Let's Make Love
One Lie Leads to Another
Our Lady of Fatima
Sing, You Sinners

### 1951

Beautiful Madness
Because of You
Blue Velvet
Cold, Cold Heart
I Won't Cry Anymore
Once There Lived a Fool
Silly Dreamer
Since My Love Has Gone
Solitaire
Valentino Tango
While We're Young

### 1952

Anywhere I Wander
Congratulations to Someone
Have a Good Time
Here in My Heart
I'm Lost Again
Please, My Love
Roses of Yesterday
Sleepless
Somewhere Along the Way
Stay Where You Are
Take Me
You Could Make Me Smile Again

### 1953

Here Comes That Heartache Again
I'll Go
I'm the King of Broken Hearts
No One Will Ever Know
Rags to Riches
Someone Turned the Moon Upside Down
Stranger in Paradise
Why Did It Have to Be Me?

### 1954

Cinnamon Sinner
Funny Thing
Madonna, Madonna
My Heart Won't Say Goodbye
Not As a Stranger
Please, Driver
Shoo-Gah (My Pretty Sugar)
Take Me Back Again
There'll Be No Teardrops Tonight
Until Yesterday

### 1955

Afraid of the Dark
Close Your Eyes
(Come Back and) Tell Me That You Love Me
Come Next Spring
Don't Tell Me Why
Heart
How Can I Replace You?
It's Too Soon to Know
May I Never Love Again
Punch and Judy Love

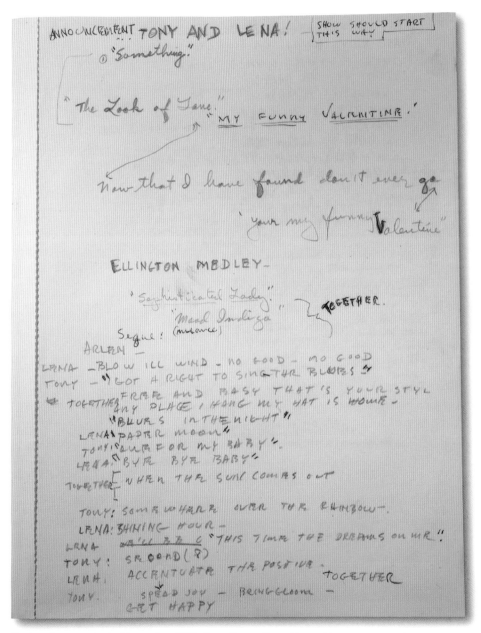

During four weeks in November 1974, Tony Bennett and Lena Horne appeared on Broadway together in a special concert appropriately entitled *Tony and Lena Sing*. Here are Tony's notes on the announcement for the show, and possibilities for the songbook.

What Will I Tell My Heart?
Whatever Lola Wants

**1956**

Can You Find It in Your Heart?
Capri in May
Forget Her
From the Candy Store on the Corner
  (to the Chapel on the Hill)
Happiness Street (Corner Sunshine Square)
Just in Time
The Autumn Waltz

**1957**

Ça, C'est l'Amour
I Am
(I Never Felt More) Like Falling in Love
In the Middle of an Island
No Hard Feelings
One for My Baby
One Kiss Away from Heaven
Sold to the Man with the Broken Heart
Weary Blues from Waitin'

**1958**

Alone at Last
Blue Moon
Crazy Rhythm
Firefly
Love, Look Away
Love Song from *Beauty and the Beast*
  (Love Me, Love Me, Love Me)
Now I Lay Me Down to Sleep
The Beat of My Heart
The Night That Heaven Fell
Young and Warm and Wonderful
You're So Right for Me

**1959**

Ask Anyone in Love
Being True to One Another
Climb Ev'ry Mountain
It's So Peaceful in the Country
Smile
The Cool School
You Can't Love 'Em All
You'll Never Get Away from Me

**1960**

Ask Me
Baby, Talk to Me
Follow Me
I'll Bring You a Rainbow
Marriage-Go-Round
Put on a Happy Face
Ramona
Somebody
Till

**1961**

Close Your Eyes
I'm Coming, Virginia
Marry Young
Tender Is the Night
The Best Is Yet to Come
Toot, Toot, Tootsie! (Goodbye)

**1962**

Candy Kisses
Comes Once in a Lifetime
Have I Told You Lately?
I Left My Heart in San Francisco
I Wanna Be Around
I Will Live My Life for You
Once Upon a Time

**1963**

Don't Wait Too Long
Limehouse Blues
Spring in Manhattan
The Good Life
The Little Boy
The Moment of Truth
This Is All I Ask
True Blue Lou

**1964**

A Taste of Honey
It's a Sin to Tell a Lie
The Kid's a Dreamer
Waltz for Debby
When Joanna Loved Me
Who Can I Turn To? (When Nobody Needs Me)

**1965**

Fly Me to the Moon (In Other Words)
How Insensitive
I Only Miss Her When I Think of Her
If I Ruled the World
Take the Moment
The Best Thing to Be Is a Person
The Brightest Smile in Town
The Shadow of Your Smile
There's a Lull in My Life

**1966**

A Time for Love
Baby, Dream Your Dream
Country Girl
Georgia Rose
The Very Thought of You
Touch the Earth
What Makes It Happen

**1967**

Days of Love
For Once in My Life
Keep Smiling at Trouble
Something in Your Smile

Columbia Records awarded this gold record to
Tony in 1953 to commemorate the printing of
his one millionth record of "Rags to Riches."

**1968**

A Fool of Fools
Hi-Ho
Hushabye Mountain
My Favorite Things
Sweet Georgie Fame
The Glory of Love
Where Is Love?
Yesterday I Heard the Rain

**1969**

A Lonely Place
Before We Say Goodbye
Coco
I've Gotta Be Me
Little Green Apples
MacArthur Park
Over the Sun
People
Play It Again, Sam
They All Laughed
What the World Needs Now Is Love
Whoever You Are, I Love You

**1970**

Eleanor Rigby
Everybody's Talkin'
I'll Begin Again
Something
Think How It's Gonna Be

**1971**

How Beautiful Is Night (With You)
I Do Not Know a Day I Did Not Love You
I Want to Be Happy
I'm Losing My Mind
Love Story (Where Do I Begin)
More and More
Remind Me
Somewhere Along the Line
Tea for Two
The Riviera
The Summer Knows
Walkabout

**1972**

Easy Come, Easy Go
Living Together, Growing Together
Love
Maybe This Time
O Sole Mio
The Good Things in Life
Twilight World

**1973**

All That Love Went to Waste
Give Me Love, Give Me Peace
I Wish I Were in Love Again
If I Could Go Back
Love Is the Thing
My Love
Some of These Days
Tell Her It's Snowing

**1975**

Life Is Beautiful
Mr. Magic
One
There'll Be Some Changes Made

**1976**

There's Always Tomorrow

**1990**

When Do the Bells Ring?

**1993**

Steppin' Out
White Christmas

**2001**

New York State of Mind

**2002**

What a Wonderful World

**2004**

All for You/Time to Smile

**2006**

Just in Time

This 1963 gold record commemorates sales of over $1,000,000 for "I Left My Heart in San Francisco."

# ART

## PERMANENT MUSEUM COLLECTIONS

*Central Park*
Oil on canvas
Smithsonian American Art Museum,
Washington, DC

*Homage to Hockney*
Oil on canvas
Butler Institute of American Art,
Youngstown, OH

*Boy on Sailboat, Sydney Bay*
Oil on canvas
National Arts Club, New York, NY

*Louis by Bennett*
Oil on canvas
Louis Armstrong House, Corona, NY

*Ella Fitzgerald*
Watercolor and gouache on paper
The Ella Fitzgerald Collection at the
Smithsonian National Museum of
American History, Washington, DC

*Battle of Hampton Roads*
Watercolor on paper
Mariners' Museum, Newport News, VA

*"Why Lincoln Matters,"* Printed on the cover of 2004 edition of *Lincoln On Democracy*, edited and introduced by Mario M. Cuomo and Harold Holzer.

*Ken Gordon, London Singer,*
oil on canvas, 24 x 20 inches

## COMMISSIONED PAINTINGS

*Brotherhood*
Oil on canvas
Commissioned by the United Nations
on the occasion of its 50th anniversary

*Peace—United Nations May Day*
Watercolor on paper
Commissioned by the United Nations
on the occasion of its 40th anniversary

*Kickin' Up Dirt Series—Kentucky Derby*
Watercolor on paper
Commissioned for the 2000 Kentucky Derby

*Louis Armstrong*
Scratchboard
Commissioned by the Montreal Jazz Festival
and released as a limited-edition serigraph

*Holiday in Paris*
Watercolor and gouache on paper
Commissioned by Givenchy

## AMERICAN CANCER SOCIETY HOLIDAY CARDS

For the past fifteen years, Tony Bennett has painted a holiday scene that is reprinted as a card for the American Cancer Society's Holiday Card Collection. The cards are sold to raise money for cancer research, education, advocacy, and patient and family service programs. For further information on the American Cancer Society's Holiday Card Collection please go to www.cancer.org or contact American Cancer Society, 2 Lyon Place, White Plains, NY 10601 (1 800-ASC-2345).

**Holiday Card Collection**
*Still Life on Green,* 1992
*Switzerland,* 1993
*Seasons Greetings,* 1994
*Aspen,* 1995
*Blizzard of '96,* 1996
*Holiday Bouquet,* 1997

*John Benedetto,* watercolor on paper

*Winter in Central Park,* 1998*
*Mountain at Dawn,* 1999
*Lake Tahoe Holiday,* 2000
*Winter Holiday,* 2001*
*New York Snowstorm,* 2002
*Happy Holidays,* 2003
*Happy Holidays,* 2004
*Happy Holidays in Clio,* CA, 2005
*Winter in Clio,* 2006*
*Images of these cards can
  be found in this book.

## SOLO EXHIBITIONS

**2005**

Eckert Fine Art, Naples, FL (December)

Oliver Elliot and Sebastian Fine Art,
  Carmel, CA (September)

Catto Gallery, London, England (April)

**2004**

P & C Fine Art Gallery, Washington, DC (August)

**2003**

Aspen Grove Fine Arts, Aspen, CO (June)

**2002**

Eckert Fine Art, Naples, FL (March)

**2001**

Butler Institute of American Art,
  Butler Trumbull Branch (satellite museum),
  Howland, OH, in honor of the 5th anniversary
  of the Butler Trumbull Branch (June)

Kentucky Derby Museum, Louisville, KY (April)

**2000**

Newbury Fine Arts, Boston, MA (December)

Eckert Fine Art, Indianapolis, IN (October)

Catto Gallery, London, England (May)

Eckert Fine Art, Naples, FL (February)

**1999**

Powell Street Gallery, San Francisco, CA (October)

**1998**

Cape Cod Museum of Art,
  Dennis, MA (August)

Savannah College of Art and Design,
  Savannah, GA (May)

**1997**

National Arts Club, New York, NY (November)

Vilda B. de Porro Gallery,
  Palm Beach, FL (March)

**1996**

Newbury Fine Arts, Boston, MA (December)

Hanson Gallery, San Francisco, CA (November)

Marco Fine Arts, Los Angeles, CA (November)

Eleanor Ettinger Gallery, New York, NY
  (September)

**1995**

Gallery Henoch, New York, NY (September)

**1994**

Butler Institute of American Art,
  Youngstown, OH, in honor of the museum's
  75th anniversary (October)

**1993**

Elysium Arts, New York, NY (October)

*Jerry Rush,* oil on canvas, 17 x 24 inches

# INDEX

*Sinatra School Logo,*
ink on paper,
8 x 5½ inches

# PHOTO CREDITS

All images supplied courtesy of Benedetto Arts except as noted below.

For more information on the artwork of Tony Bennett, please visit www.benedettoarts.com.

Photographed by Dan Lipow from the archives of Tony Bennett:
Pages 29, 44, 47 (bottom left), 77, 84, 85 (top), 97, 140, 156, 187, 188 (top, right, and left), 201, 202, 203

Bill Evans *Blue in Green* album cover used with permission and © Concord Music Group, Inc.:
Page 45

Tony Bennett *Duets* album cover used with permission of Columbia Records, © Sony BMG Music Entertainment: Page 117

Reproduction photograph of Tony Bennett *Astoria* front and back album cover by Dan Lipow, used with permission of Columbia Records, © Sony BMG Music Entertainment: Page 143

© Mike Blake/Reuters/Corbis: Page 188 (bottom)

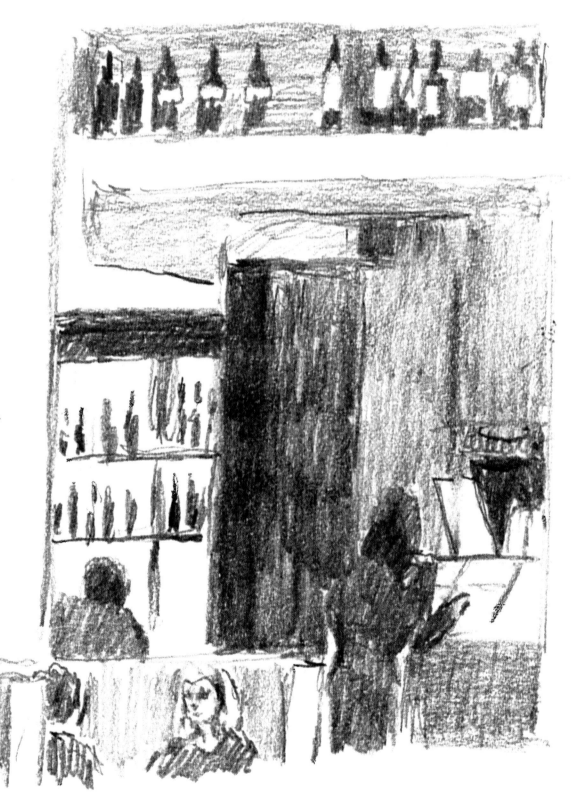

*Wine Bar,*
pencil on paper,
6 x 4 inches

# CD CONTENTS

## Pop ART Songs

**BY TONY BENNETT**

Over the years I have recorded a number of songs that are so well crafted that they are truly pieces of art. In the same category as Ravel's "Bolero," there are songs that are more impressionistic and transcend to a high level of style and sophistication. On this CD, I have personally selected a few of my favorite selections of this genre.

—Tony Bennett

1. **MY SHIP (From "Lady In The Dark")**
   2:36, USSM16200227
   (I. Gershwin / Kurt Weill)
   Performer: Tony Bennett with Ralph Sharon & His Orchestra
   Originally Released 1962
   SONY BMG MUSIC ENTERTAINMENT

2. **HI-HO**
   4:40, USSM16800246
   (G. Gershwin / I. Gershwin)
   Performer: Tony Bennett
   Orchestrator: Torrie Zito
   Originally released 1968
   SONY BMG MUSIC ENTERTAINMENT

3. **BUT BEAUTIFUL**
   3:34, USFI87500158
   (J. Burke / J. Van Heusen)
   Performer: Tony Bennett with Bill Evans on piano
   (P) 1975 Fantasy Records
   Courtesy of Fantasy/Concord Music Group

4. **THE VERY THOUGHT OF YOU**
   4:31, USSM16600254
   (Ray Noble)
   Performer: Tony Bennett with Bobby Hackett on trumpet
   Originally released 1966
   SONY BMG MUSIC ENTERTAINMENT

5. **MY FOOLISH HEART**
   3:04, USSM10400691
   (N. Washington / V. Young)
   Performer: Tony Bennett with Frank DeVol & His Orchestra
   Originally released 1958
   SONY BMG MUSIC ENTERTAINMENT

6. **IT WAS ME**
   3:04, USSM10602626
   (G. Becaud / N. Gimbel)
   Performer: Tony Bennett
   Originally released 1962
   SONY BMG MUSIC ENTERTAINMENT

Selection # A 709252
This Compilation (P) 2007 SONY BMG MUSIC ENTERTAINMENT

Photograph of Tony Bennett on CD by Mark Seliger

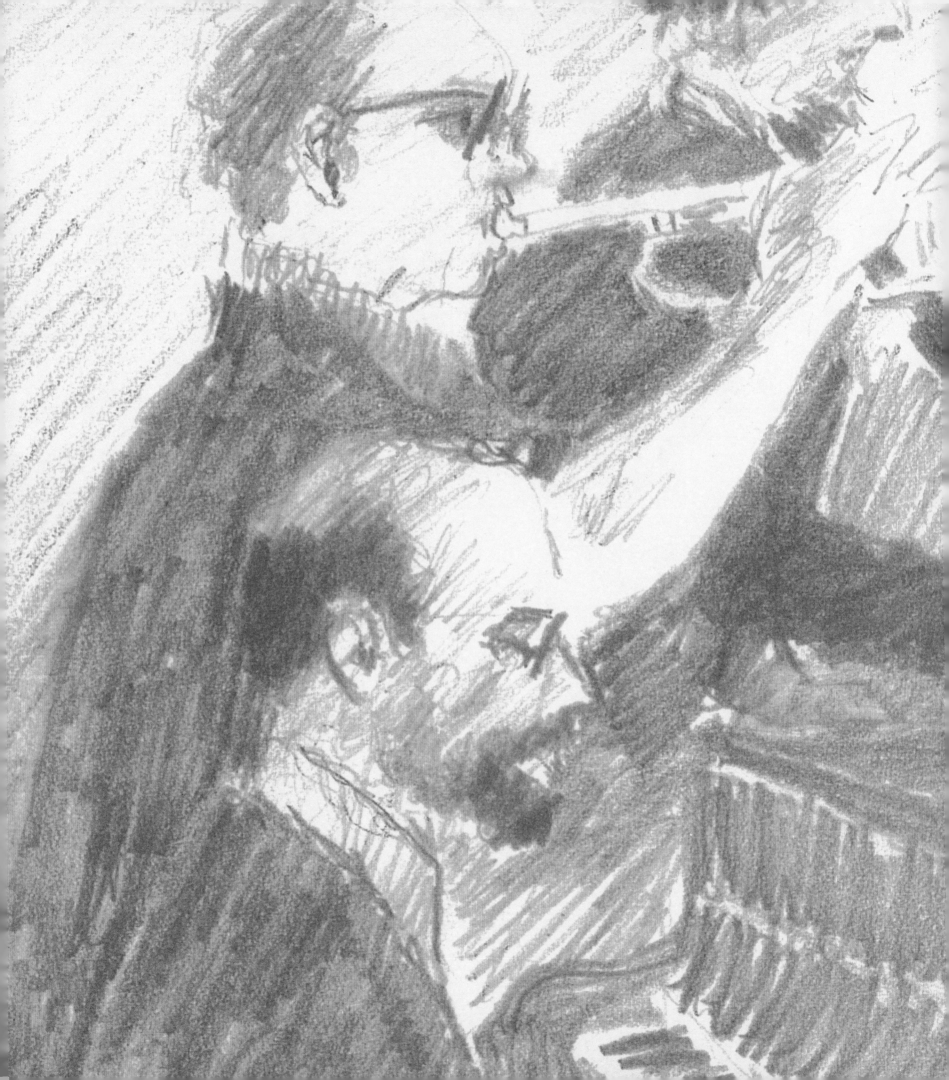